Sabine B. Vogel

Biennials –
Art on a Gl...

Edition Angewandte
Book Series of the University of Applied Arts Vienna

Edited by Gerald Bast, Rector

SpringerWienNewYork *edition:* ʌngewʌndtǝ

Contents

III. Conclusion:
Potential and Limitations of Biennials

Appendix

Introduction

International biennials or triennials take place in more than 52 countries all over the world. In some countries, like Germany, the United States, Australia or even South Korea, these events may even be hosted by several cities. Today, with more than 150 such exhibitions being held every few years, it is difficult to ascertain their exact number. Biennials can be short-lived and disappear from the scene unnoticed, or may even be reanimated.

"Biennial" is derived from the Latin word biennium, which designates a period of two years. Triennials are held every three years, quadriennials every four years. This framework can be applied not ontly to art exhibitions, but also to festivals and even conferences. Due to the influence of the first, most well-known exhibition of its kind, the Biennale di Venezia, the term is often used to refer to exhibitions of the visual arts – later it was also applied to film, music and architecture biennials when these were introduced in Venice and in São Paulo. In the following, the focus will be on visual art exhibitions, and "biennial" will be used as an umbrella term that also encompasses mega-shows that take place every three or four years.

The first biennial was inaugurated on April 30, 1885 in Venice, Italy. Several years later it was followed by events such as the Corcoran Biennial (1907) in Washington, USA and the Whitney Biennial (1932) in New York. However, unlike Venice, the latter had an exclusively national focus. It was only fifty years later that the original model was adopted again at the São Paulo Biennial, Brazil (1951). The economic and political changes that have taken place since the 1990's have given rise to a veritable boom, with new biennials appearing ever more frequently.

Biennials as a Unique Kind of Art Exhibition

Biennials are primarily group shows, usually on a large scale. What makes biennials unique is the fact that they take place on a regular basis and that art and politics are typically closely linked in these exhibitions. Unlike the annual presentations of the German artists associations and the French

salons in the 19th century, and the later shows at art institutions, art associations and museums, the purpose of biennials is not only to present art. These events also function as a political tool, with politics and business always interacting closely. Since they have always been influenced by current political developments and ideas, biennials aim at overcoming national, cultural and political isolation by creating international networks, demonstrating political openness and tolerance. They thus reinforce an incipient process of social emancipation and serve as a symbol of an enlightened society. Unlike mega-shows, biennials also target the local population and international experts. They are usually inaugurated by politicians and are also extensively reviewed by the local press. Whereas major exhibitions like *Westkunst* (1981) in Cologne or *Magiciens de la terre* (1989) in Paris hardly made any references to the city, biennials often take place in several temporary sites, sometimes leading visitors through the streets. Thematically, biennials address architecture and the history of the city, while the works shown often also deals with the geopolitical location of the Biennial venue which is always addressed by local artists. Biennials promise networking and in particular continuity.

Diplomacy

The group shows organized by artists associations or, more recently, by art museums usually serve as a platform for current art trends or thematic overviews. The focus here clearly lies on artists reflecting a national perspective. By contrast, the Biennale in Venice and the most significant regular exhibitions that have been modeled after it have had an explicitly international outlook. In the past museums and art associations usually invited artists, and salons would have a jury vet the works submitted by artists. By contrast, the organization of the first international biennials initially only took place via diplomatic channels. For the biennials in Venice, São Paulo, New Delhi and Cairo, invitations to participate were sent to the political representatives of befriended nations, who then appointed national commissioners to select the artists. Artists associations were responsible for selecting German contributions to the biennials until 1920 when a cultural section was established by the Foreign Office, which to this day continues to appoint leading representatives of museums to serve as commissioners. At the 27th São Paolo Biennial in 2006 head curator Lisette Lagnado broke with this rather controversial principle of national representation, and in New Delhi the system is to be restructured from 2010 on.

Thanks to the policy of diplomatic invitation, biennials also reflected the status of a country in the international network of politics and economics. At the same time the selection manifested the hegemony of Western modern art. Not only did the biennials in Western cities present almost exclusively Western art well into the 20th century. At the biennials in São Paolo, Tokyo, Sydney and Istanbul, there was also a division into First and Third World, which was politically motivated. One reason for this was that most of the Biennial curators came from Western countries or were educated there, but it was also because political interests were reflected in the expectations of the

public and in the emergence of canons. While "international" has figured in the title of all biennials, the term was in fact limited to Western nations and their allied countries. Only in the 1960's did the first biennials appear in non-Western countries, as in Rostock or Havana, contributing significantly to the development of a global art.

Political Alliances

Biennials have always served as a means to an end. Art here plays the role of an ambassador. One major function of biennial art exhibitions has been to create and assert a cultural identity at home and to convey the political alliances of the host country to the outside world. In 1983 the curatorial team of the Havana Biennial provocatively defined it as "third world", since it showed only artists from Latin American and African countries. *"It was the main goal of the Havana Biennial to be an explicit response to the hegemony of western art and bring together progressive artists from almost all countries of Latin America and to unite them to create a stronger anti-imperialist front"*,[1] Jutta Guerra Valdes stated. The Eastern European response to the documenta in Kassel (1955) was the Biennial of the Baltic Sea Countries held in Rostock (1965) in the former German Democratic Republic. It lost its raison d'etre after the end of the GDR, and the 13th edition in 1996 was also the final one. The Asia Pacific Triennial in Brisbane, Australia (1993) focused on the southeastern Asian region, while the DAK'Art in Senegal (1995) was the first regular exhibition to place its emphasis on African artists.

Often participation in biennials like the one in India has depended not only on the cultural agreements of the host country, but also on visa regulations that can limit the entry and the duration of stay for artists and guests. As will become clear later on, the Cairo biennial is strongly influenced by political factors, as the statutes prohibit the participation of Israeli artists.[2]

Biennials reflect political conditions and often also assume the role of a forerunner when they are used as a way to obtain more political tolerance and social freedom. Non-democratic regimes in particular employ the exhibitions to effectively signal openness to the media as can be seen in Sharjah, Emirates (1993), Shanghai (1994), Moscow (2005) or Singapore (2006).

Almost every biennial instrumentalizes art to construct national identity. National characteristics are asserted and accentuated as part of the coexistence of nations, and this happens mainly in recurrent, representative retrospectives, since such exhibitions suggest the existence of historical roots.

The principle of continuity ensures that everything the biennial stands for can come to fruition. The consistency ensures both permanence and change, as the biennial both constitutes a regular forum for contemporary art and provides a cultural infrastructure that can trigger lasting social changes.

1 Jutta Guerra Valdes (143) 1984, p. 568.

2 Cf. Iolanda Pensa, 9th Biennial Cairo, (193) 2004.

Local vs. global

Since biennials often are the first large, international contemporary group shows in a country, and thus also the first opportunity to display national artists in an international context, these events, unlike institutional exhibitions, have to negotiate both local and global aspirations. On the one hand, the national art scene can be networked with the outside world and, on the other, international attention can be directed to the country. In addition, there is the opportunity *"to challenge the status quo and create opportunities to see our world and ourselves differently"*,[3] as Paula Latos-Valier, Managing Director of the Sydney Biennial (1997 – 2006) put it. Thus biennials serve as both a local mirror and as an international – and, more recently, global – platform.

3 Paula Latos-Valier (85) p. 8.

When the first biennials were held, most hosting cities did not yet have museums and exhibition space for contemporary art. Due to a lack of infrastructure the biennials have often used a variety of temporary spaces, such as the Istanbul biennial, which expanded its programm to include historical sites like the Hagia Sophia or the Yerebatan cistern, or the 11th India Triennial 2005 in New Delhi, which also took place at locations such as the Lalit Kala Academy, the National Gallery, and in the courtyard of the Indira Gandhi National Centre for Arts. Such mixed or joint use of space and sites reveals how the museum as a place for presenting tradition is different from the biennial as a forum of art that is both critical of tradition and reflects radical social change.

Towards the end of the 20th century alternative exhibition venues located in different parts of a city became the common characteristic of a new biennial model. "Internationality" no longer reflects relations between friendly nations but is a way to link what is specific to a region or a city with global perspectives and themes.

Biennials and the Legacy of the Enlightenment

Change is reflected not just by the individual works shown at biennials. Each edition of a biennial signals a process of change. This is often accompanied by dramatic social transformations, which can be gleaned from the selection of curators and even from the reasons given for censorship. Many new developments have their roots in the ideas of European Enlightenment, most notably self-determination and secularization.

The Enlightenment began in the 17th century and was propagated in the 18th century in the philosophies of Herder, Kant, Hume and Montesquieu – to name just a few. From the outset it was primarily intellectuals who formulated the ideals of the Enlightenment in literature and art. In the 20th century the tool "Biennial" proved to be a perfect tool for disseminating these ideals to the rest of the world. The central dogma of belief in reason and rational argument instead of superstition and religion, the questioning of authority, and the tradition of self-reflection are Enlightenment principles still found

today in the works and themes of biennials. These exhibitions are expected to reflect and initiate changes, and to relate to what already exists but at the same time to break conventions. A good example of this is the 1st Singapore Biennial 2006, which was titled "Belief". It addressed the multi-religious structure of the city state, while at the same time making critical reference to the belief in the power of money. Singapore, the southeastern Asian financial center, is also known as the "Switzerland of the East." The biennial which took place here at the same time as the IMF conference,[4] showed first signs of an opening in a previously repressive city state. Now a critical film like <u>Bilger & Bergström's</u> "The Last Supper" could be screened without offending anyone. Here the artists interviewed the cooks of last meals prepared for prisoners who are about to be executed. The informative and critical video alluded directly to the high number of executions in Singapore.

4 Detailed elucidation of context can be found in the chapter on the 1st Singapore Biennale.

Enlightenment ideals are so evident in the exhibited works that it is possible to speak of Biennial art or "biennial culture", especially in the second phase. It is striking that artists often focus on local injustice and global poverty, comment on and document specifically regional problems and global links. At the 8th Sharjah Biennial 2007 in the United Emirates the viewers of <u>Michael Rakowitz's</u> wall diagram learn that of 30 million date palms only 3 million have survived the military ravages of the Gulf War. In Rakowitz's second contribution, signs indicate the origin of small cardboard objects displayed on a table. They are reproductions of the more than 7,000 treasures stolen from the Iraqi National Museum during the Iraq War. <u>Huda Saeed Saif's</u> video documentatary focuses on a mountain region in Sharjah which was flattened leaving behind only stone and rubble.

Biennials present not only enlightened and enlightening works. With their claim to 'internationality' the exhibitions also hold out the promise of being 'cosmopolitan' in a way that transcends a society fragmented by tradition and confession, social class and origin. The work exhibited at biennials demonstrates the beginning of individualism and a process of social emancipation which calls into question authority and examines traditions critically, speaks of tolerance instead of despotism and accords equal status to men and women. Biennials stand for the freedom of opinion and the press, and thus also for a democratic polis of politically mature and enlightened individuals. However, the necessary break with traditional values that results from Enlightenment has proven highly controversial, in particular for biennials in Islamic countries.

Globalization

Until 1989 not more than thirty biennials were founded. With the advent of globalization and the end of the Cold War, the dismantling of ideological, economic and communicative barriers, an enormous boom in biennials set in.

Whereas exhibitions in Western institutions in subsequent years still showed predominantly Western art, the history of biennials clearly reflects a new situation. The growing international networking of national markets and societies, the liberalization and the politics of deregulation, the technological advances in transport and communication created the prerequisites for a global export of the "biennial" model and an increasing exchange of art. With biennials rapidly spawning in Asia, Africa, South America and Australia, more and more biennial models are emerging but only very few are modelled on the original Italian one. Instead of diplomatic invitations, curators and teams of curators select the artists. These curators and curatorial teams, like Jack Persekian in Sharjah (United Emirates), are responsible for a number of exhibitons, adding a new team each time. Some exhibitions are held every two years in the same buildings as in Gwangiu, South Korea (1995) or Shanghai, China (1994) , while others take place in different locations throughout the city as in Istanbul, Turkey (1987) and Liverpool, England (1999) . There are those like the Beaufort Triennial for Contemporary Art on the Sea, Belgium (2003) that focus only on the surroundings or on a specific location like the Contour Biennial for Video Art, Belgium (2003). Biennials like the Emergency Biennale in Chechnya travel around the world as an exhibition in suitcase format or, as in the 3rd Riwaq Biennale 2009, send visitors on a four-day trip without showing any artworks at all. What all of these biennials have in common is the very close connection between art and politics, which is the dominant feature of these exhibitions. Thus the history of biennials must be read as a "history of art and politics".

The First Phase –
Biennials in the Age of Modernity

The Creation of the Biennale

"The City Council of Venice has taken on the initiative of this (the exhibition), since it is convinced that art as one of the most valuable elements of civilization offers both an unbiased development of the intellect and the fraternal association of all peoples." [5] With these words the history of the biennials begins. Riccardo Selvatico, the mayor of Venice at the time, formulated these high expectations that were placed in art on April 6, 1894, when he announced the foundation of the Biennale di Venezia.

5 Riccardo Selvatico, mayor of Venice, in a speech he gave on April 6, 1894, cited in Christoph Becker (94), p. 13.

It could hardly have been stated any more clearly. The Biennale was not to just serve artistic development or a local art scene like the French salons nor were there commercial interests as in the annual exhibitions in Germany. There were also no personal, self-aggrandizing aspirations as in the museums of princes. The Venice Biennale was also not intended to break cultural or political isolation which was the goal of so many events that were founded later. The exhibition was to have a political missionl: the *"unbiased development of the intellect"* and the *"fraternal association of all peoples."*

With these words Selvatico was referring to a basic principle of European Enlightenment in which the arts are seen as a means of asserting individual freedom and democratic rights, of referring to the equality of all human beings, of practicing religious tolerance and propagating openness for the new – in short: of revolutionizing society. *"The more the refined arts advance, the more forthcoming people will become. (…) When we view the matter in the right light, we notice that progress in the arts promotes freedom and shows the natural tendency to maintain a free rule, if not to create it,"* as David Hume wrote in his essay "Of Refinement in the Arts" [6] in 1752 – an observation that can be applied to both the first biennial at the end of the 19th century and the most recent biennials in the 21st century.

6 David Hume, "Of the Refinement of the Arts", cited from Dorinda Outram (41), p. 89.

European Enlightenment

The Enlightenment – or "Enlightenments" as J. G. A. Pocock underlines [7] – is seen as an ideological epoch or as a part of the history of ideas, for this

7 Cf. J.G.A. Pocock (42) p.12.

process has certainly not run the same course in every culture. As a development dating from the 17th and 18th centuries, it is an emancipatory process reflecting the desire for social reform, aspects of which can be traced to the present. Enlightenment in the historical sense is determined by the belief in the rule of reason by which the individual overcomes superstition and fanaticism and attains equality before the law and press freedom. It describes a period whose basic tendency was to *"transform everything given into an artifice"*, as Gernot Böhme[8] summarizes. To be enlightened meant to belong to a social class defined by erudition and the free exchange of ideas – which, while not open to everyone, was theoretically no longer dependent on religion, race, class, nation or sex.

"Freedom in society is inseparable from enlightened thought,"[9] Horkheimer and Adorno elaborated, while also pointing out that it was a strictly rational idea: *"What cannot meet the standards of calculability and utility is deemed suspicious by enlightenment."*[10] It was only a matter of time before doubts regarding the unconditional acceptance of reason[11] and of utility were voiced.

With the Enlightenment, there was great interest in encyclopedic knowledge, which was to be made accessible to the public. The synoptic presentation of knowledge and information also served as a model for the biennials. Another basic characteristic can be identified, namely the desire for a world community expressed in the enlightened works of authors such as Johann Gottfried Herder or Gotthold Ephraim Lessing and addressed again by Selvatic when he spoke of the *"fraternal association of all peoples."* At that time, however, both aspirations were still far from becoming reality as the 1880's were marked by the beginning of Imperialism in Europe. Thus neither world peace nor a synoptic view of the world was possible then. For a long time the "peoples" represented at the Venice Biennale were limited to Europe, the USA and a few friendly countries. The culture of the colonies was not included.

The notion of "peoples" can be associated with a further, central development of that period. In the 19th century nation states were founded in Europe. As an indirect consequence of the Enlightenment, the feudal form of rule with its division of rulers and subjects was called into question. The reaction to this development was the demand that all human beings be seen as equal. The idea of the people as a community of shared origin, culture and language – as a nation – emerged.

In this brief passage, Selvatic sums up in a compelling way the historical context in which the original Biennale was founded. The first biennial emerged at a time when the Enlightenment influenced intellectual life in Europe, globalization its economic life and politically Europe was marked by the self-cconfident development of nation states – all developments to be found again in many of the later biennials.

8 Gernot Böhme (13) chapter I, p. 2 – 6; cf. Zur Aufklärung in der Kunst (On Enlightenment in Art): Klaus Herding (25), p. 65f.

9 Max Horkheimer and Theodor W. Adorno (27) p. 3.

10 loc. cit., p. 12.

11 As Werner Busch (14) but also Klaus Herding (25) and Beat Wyss (56), have shown the Enlightenment is by no means free from mythology and esotericism as the free masons lodges and theosophy prove.

Europe

For Europe the 19th century was a time of turmoil and upheaval. Industrialization and urbanization transformed society, the population grew rapidly, the number of big cities grew exponentially, and new professions and new social classes emerged. For the new middle class composed of white-collar workers and an elite including factory owners, bankers and directors who did not own property[12] classical education was regarded as imperative for moving up the career and social ladder and for enhancing individual status. Technological innovations in transportation and communication like the first train line built in 1825, the telephone invented in 1876 and the Telex machine developed in 1914, intensified international traffic, news and trade. Speedier transport of goods and passengers and the improved means of communication ushered in the age of mass transport and the first wave of globalization. From the 1880's the beginnings of territorial expansion outside of Europe resulted in military imperialism as well as cultural domination of the colonies. English and French were introduced in the colonies along with the European educational system. Theodor Schieder, in his Handbuch der europäischen Geschichte, speaks of the "Europeanization of the World."[13] According to Hürten Europe was turned into the "regulator of world politics" thanks to its many treaties and regulatory bodies.[14] This early phase of globalization spawned multinational companies, international organizations and international standards in law, financial transactions and technology were now introduced beyond the borders of nation states.

Nation States

Political conditions were also changing in the European countries. Monarchy and colonial rule yielded to young nation states.[15] "Freedom, equality, fraternity" were demanded in the French Revolution of 1789, erasing the differences between the aristocracy and the people without rights, who were sovereign, embodying the idea of a nation. Ever since "nation" has been understood as *"a broad community that is held together neither by a common monarch or a common religious or class affiliation. A nation is independent of the vicissitudes of dynastic or military history."*[16] The boundaries of the nation converge with those of the state in the nation state.

Even if this form of state is completely taken for granted today, the path leading from territories of communities living under the rule of princes and kings to a nation is long and circuitous. The idea of a people as a nation did not exist yet and the apparent differences still had to be overcome by a common identity. This required symbols. The young European nations constructed founding myths and a national history that has reflected continuity throughout the centuries. National heroes were created to embody national values and schools consolidated a common identity, much to the detriment of many dialects by enforcing one language. National traditions, commemorative sites and historical monuments emerged along with *"the conception of ethnographic collections and an interest in the characteristic landscape pictures."* Flags, emblems,

12 loc. cit., p. 54.

13 Cf. Schieder (45) p. 3.

14 Cf. Hürten (29) p. 78.

15 "Before the revolution of the 18th century, in the history of ideas, there can be no talk of nation in a political sense." Anne-Marie Thiesse (52).

16 Cf. Thiesse (52).

17 Ibid.

18 Arjan Appadurai (2), p. 15f.
Cf. here also Benedict R.
Anderson, Die Erfindung der
Nation. Zur Karriere eines folgen-
reiches Konzepts, Frankfurt 1988,
Campus Verlag; James C. Scott,
Seeing Like a State: How Certain
Schemes to Improve the Human
Conditions Have Failed; New
Haven: Yale University Press 1996.

19 Hagen Schulze (48) p. 111.

20 Cf. Werner Plum (43), p. 9.

21 Also called Exposition Uni-
verselle Internationale, Exposition
Mondiale, Expo or World Fair.

"national dress, culinary specialties, and a heraldic animal" [17] were all ideally suited as *"representative elements of identification."* *"Repressive, streamlining measures of educational and language policy as well as the suppression of innumerous local and regional traditions,"* [18] however, served to construct and naturalize a national ethos.

World Expositions, Olympic Games

"Nations are founded on national consciousness" [19] – and, apart from the reinvented traditions, there is hardly any more effective way to assert and create national identity than well-staged, public celebrations. In the 19th century three events based on international competition, and still taking place today, were founded to foster national identity. In 1851 the first "world fair" took place, followed in 1896 by the resumption of the ancient Olympic games. That same year the mayor of Venice announced the establishment of the Biennale di Venezia. These three models pursued a common goal – in spite of significant differences in scope and budget – namely, to strengthen national identity in the context of international competition.

"Est etiam in magno quadam res publica mundo" can be read on the medals awarded at the first world fair which took place in London in 1851 – *"A community is flourishing all over the world."* [20] As later in Venice, this slogan reflects the desire for the peaceful fraternization of the world community but one limited to a specific number of participants.

Modeled on the then common regional trade and industrial exhibitions the world fair [21] was not just a market but first and foremost a place for (official) presentation. On Prince Albert's initiative in 1851, Joseph Paxon built the glass and iron "Crystal Palace" in London's Hyde Park to bring together all exhibitors under one roof – a compelling, symbolically laden decision but one that could not be adhered to subsequently because of the growing demand for space at the following events. Country-specific pavilions were created – a model that was later taken up by the Venice Biennale, along with the characteristic elements of the world expositions.

These events proved to be hugely successful with the public. From May 1 to October 11, 1851, 6 million people visited the first world exposition in London; 28 countries exhibited here. In Paris in 1867 there were 6.8 million visitors with 32 countries exhibiting and in 1878, in Paris again, there were as many as 16 million visitors. Like the biennials later, the world expositions were not just a presentation of goods but, at least as importantly, they also served as a place to meet. At the Paris world exposition in 1878 experts convened at thirty congresses, such as the postal services conference or the International Union of Telegraphic Administration to deliberate on international cooperation and regulation. Reflecting the rise of imperialism, a colonial village with indigenous inhabitants was exhibited at the exposition in Amsterdam in 1883 – something which was to become a standard feature of world expositions.

The commercial exchange of goods, the celebration of the most recent indus-
trial developments, the worldwide networking and, to top this all off, an event
park and spectacular architecture – the world expositions were one big fair-
ground showing the growing complexity and intertwined relationships of a
society which believed in the alliance of world trade and world peace. People
felt that they were citizens of the world, and long-distance travel was no lon-
ger reserved for the privileged. Indeed, with the world expositions it became
a new phenomenon. Thomas Cook's offers for travel to these events can be
seen as the beginnings of mass tourism; not surprisingly, this is where Reuters
news agency [22] had its origins. In 1849 Paul Julius Reuter (1816–1899) was
still running a news agency in Aachen with carrier pigeons. Inspired by the
London world exposition and the first undersea cable between England and
France, Reuters established a telegram office in London in 1851 and special-
ized in business and trade news between the European capitals.

Since 1928 world expositions were run by an official body (Bureau Inter-
national des Expositions, BIE). The International Olympic Committee (IOC)
also administered the Olympic games. In 1896 the Olympics took place for
the first time since antiquity, with athletes from 13 countries participating at
a "meeting of the world youth" to compete in athletics and to promote inter-
national understanding. Today 202 countries take part in the games – more
countries than represented in the United Nations. [23]

Characteristics of the world exposition such as the presentations financed
by individual nations, the commercial orientation, the specialized confer-
ences and the medals awarded for outstanding achievements can also be
found in the model of the Biennale di Venezia and the many biennales that
have sprung up in its wake. The participating nations also knew how to put
these events to work for their political interests. However, the organizational
structure of the biennales was very different from the world expositions
and Olympic Games. There is no committee that watches over the world-
wide biennales. The Institut für Auslandsbeziehungen (ifa) , or Institute for
Foreign Relations in Stuttgart, attempted, in 1998, to establish an "umbrella
organization" at a Biennale conference in Kassel in 2000 and to create
a "Biennial Codex"; a Biennale committee was to be established to help
develop quality standards. [24] This initiative, however, failed because of the
rhizomatic structure of biennials, as these events are not governed by any
rules.

22 Cf. Plum (43) p. 101.

23 At present 192 countries
are represented in the United
Nations. Puerto Rico, Bermuda,
Hongkong and Taiwan participated
in the Olympics.

24 Cf. Alfred Nemczek (101)
2000.

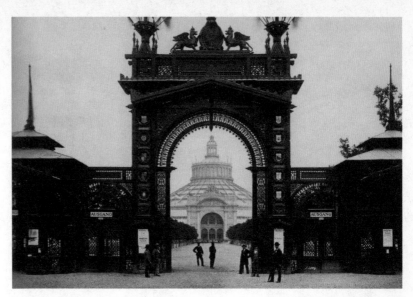

Entrance to the world exposition in 1873

19th Biennale di Venezia 1934
21st Biennale di Venezia 1938
25th Biennale di Venezia 1950

27th Biennale di Venezia 1954
29th Biennale di Venezia 1958
30th Biennale di Venezia 1960

2nd Biennale di Venezia 1953
3rd Biennale di Venezia 1955
4th Biennale di Venezia 1957

5th Biennale di Venezia 1959
7th Biennale di Venezia 1963
16th Biennale di Venezia 1981

An overview of biennial catalogues

21st Biennale São Paulo 1992
Carnegie International 1985
Carnegie International 1995

3rd Bienal Del Grabado 1974
1st Gwangju Biennale 1995
2nd Gwangju Biennale 1997

1st Biennal de la Habana 1984
3rd Biennal de la Habana 1989
8th Biennal de la Habana 2003

9th Cairo Biennale 2003/04
1st Echigo-Tsumari Art Triennial 2000
1st Yokohama Triennale 2001

La Biennale di Venezia

The basic structure of the Biennale di Venezia was modeled on the world expositions, even if in terms of scale and costs[25] the two events can hardly be compared. The Biennale also followed the example of the international annual exhibitions of German artists' associations[26] and Secessions that artists organized to to sell their works. The Venice Biennale officially began as part of the celebrations of the silver jubilee of the Italian royal couple Umberto and Margherita of Savoy. Up to the 1960's the Biennale also functioned as an art market but the commercial aspect was not central.

Historical Background

When the Biennale was founded, Italy was still a young nation. It was not until 1861 that the sovereign kingdoms became an independent nation with a constitutional monarch. The Vatican did not, however, recognize the "new Italy," and in 1874 Pope Pius IX prohibited all Italian Catholics from actively or passively taking part in democratic elections.[27] There were great cultural differences between the various regions on the peninsula and standard written Italian was not very widespread. The plea made by Massimo D'Azeglio at the first session of the pan-Italian parliament illustrates the situation at the time: *"We have created Italy, now we must create Italians!"*[28]

In the 1880's Italy's brief life as a colonial power began in Africa. *"Population explosion and the lack of land but also the desire to display its new status as a major power prompted Italy to seek colonial acquisitions in Africa almost immediately after it joined the Triple Alliance."*[29] In 1896 Italy suffered a major defeat near Adua and ended up losing its African colonies.

Early Beginnings

In this period of political turmoil the Biennale di Venezia was born out of the desire of a major power to put itself on the map. In the winter of 1894 construction began on a former concert building which stood on reclaimed land at the eastern end of the lagoon. The architect was the Venetian Enrico Trevisanato.

25 Cf. Jan Andreas May (91) p. 17: "The comparison with world expositions stands in disproportionate relation to the exhibition project which, at the beginning, was very modest without realizing its scale and costs."
26 Ibid.

27 On March 14, 1861, the Italian parliament decided to create a kingdom — at that time, still with Florence as the capital, since Rome was under the pope's rule. In 1870 Rome became the capital. The young nation was, however, still dominated by the pope's ban on voting which had been imposed on Catholics.
28 Cited from www.wikipedia.de, source: Eric Hobsbawm, Nationen und Nationalismus, Bonn, 2005, p. 58 (last visited on Nov. 10, 2008).
29 Hürten (29) p. 92f.

30 Founding commission: Bartolomeo Bezzi (painter), Antonio Dal Zarro, Marius de Maria (painter who went by the name of Marius Pictor), Antonio Fradeletto (was a member of the committee for eleven biennials), Pierro Fragiacorno, Michelangelo Guggenheim, Cesare Laurenti, Marco Levi, Emilio Marsili (sculptor), Giuseppe Minio (engineer), Nicolo Papadopoli, Augusto Sezanne (painter), Giovanni Stucky; subcommittee: Enrico Castelnuovo, Bartolomeo Bezzi, Marius De Maria, Antonio Fradeletto, Giuseppe Minio, Emilio Marsili, Augusto Sezanne (catalogue of the Biennale de Venezia, 1905).

31 Cf. A. Lagler (93) p. 243, note 23.

32 The 8th Biennale in 1909 was attended by 450,000 interested persons, a figure which was not exceded until 1976.

33 Cf. Alloway (90) p. 46.

34 Cf. Becker (94) p. 17.

Venetian artist Marius de Maria added an inconspicuous, neo-classicist façade to the building. The founding commission also included prominent citizens and artists from Venice.[30] On April 30, 1885 the first Biennale di Venezia was opened in the Giardini.

Initially, all nations exhibited in one building, which was first called "Pro Arte" and later, in 1932, at the beginning of the Fascist period, was redubbed "Italia". (To this day, the central, international group exhibition takes place here.) Detailed rules governed the exhibition of the works: the paintings were to be no higher or wider than 3 meters, the sculptures were not to weigh more than 4,000 kilos. There were rules for graphic works, medals and all manner of arts and crafts – even furniture. The first exhibitions resembled living rooms with chairs, colorful wallpaper, carpets and even potted plants. With 516 pieces the first exhibition was certainly full to bursting. A jury invited and selected the artists. The Biennale has charity to thank for its inception. Part of the money came from a denotion the royal couple had received. Mayor Selvatic dedicated 5,000 Lire of it to furnishing an orphanage and 10,000 Lire to financing a prize for the best artists of an exhibition yet to be planned – the Biennale.[31] Entry fees were charged from the second Biennale on, and the hosts no longer paid for transport and packaging. Each nation was expected to finance its own contribution to the exhibition and works were put up for sale – art and commerce did not yet form a contradiction.

224,000 persons attended the first show[32], and the typical visitor was more a curious onlooker than a real art aficionado; the international traveler with a real interest in art only emerged over many decades. The opening entailed a scandal, which reflected the tension that existed between church and state at that time: At Giacomo Grosso's "Il Supremo Convegno" (The Last Meeting), five naked girls were pictured danced around an open casket. The Catholic church reacted by demanding that the painting be withdrawn since it subverted public morals – which was rejected by a commission that was specially convened on this occasion.[33] The next clerical intervention by the head of the church was in 1905 when Max Liebermann's "Samson and Delilah" was exhibited. It was criticized for being too "permissive"[34], but the intervention was also rejected.

The Pavilions

Twelve to nineteen countries took part in the first eleven biennials. The number of participating artists grew, with a jury made up of Venetians making the selection. In the first twelve years all countries exhibited together in one building, but even then some of the nations had a separate hall. From 1907 on, countries began erecting their own permanent pavilions, similar to the temporary buildings at world expositions; each country had its own commission that was in charge of the pavilion.

Hungarian pavilion

In 1907 Belgium began to construct its pavilion near the main building; in 1909 Great Britain, Hungary and Germany followed suit. The symbolism of the single-story design of the Hungarian pavilion reflected the country's history. In the spirit of the nationalism predominant at the time the mosaics on the façade and the glass windowpanes depicted scenes from the life of Attila the Hun, the supposed forefather of the Magyars. In 1957/58 the roof was removed, the exhibition spaces arranged around an atrium and the decoration on the façade protected by a wall.[35] On the initiative of the Munich Secession the German pavilion was built by the Kingdom of Bavaria and initially called "Padiglione Bavarese", demonstrating their cultural and political autonomy from the German Empire. In 1912 Bavaria was forced to cancel its participation because of the cholera epidemic. The German contribution was organized by Italy and the pavilion was renamed "Padiglione della Germania". In 1938 the Nazis had Bruno Paul redesign the interior and alter the entrance. The slender Doric columns were replaced by square pillars to support the architrave, on which now "Germania" stands.

In 1912 Sweden (architect: Ferdinand Boberg) and France (architect: Umberto Bellotto) followed. At the next Biennale, however, Sweden ceded its building to the Dutch who, in 1953, had the building torn down and reconstructed. The USA did not join the Biennale until 1930. After years of negotiations, Austria participated for the first time in 1934. Its pavilion, still standing today, was designed by architect Josef Hoffmann. In 1912 Austria attempted to construct its own pavilion since it had only one hall in the Italian pavilion that it could use, but the beginning of World War I quickly put an end to this plan.

While Denmark had had its own building since 1932, it was not until 1954 that Finland participated for the first time. The Finns constructed a tent-like, prefab wooden building based on designs by Alvar Aalto. Originally planned for only one Biennale[36], Finland used the idiosyncratic building for two further exhibitions, until Finland, Sweden and Norway constructed the joint Northern Pavilion in 1962.

35 Cf. Laszlo Beke, Das Fenster zum Westen, in: Jahresringe 42 (95), p. 129.

36 Cf. Erik Kurskopf, The Story of the Aalto Pavilion, in: Framework no. 7/June 07, Helsinki 2007 (105), p. 49.

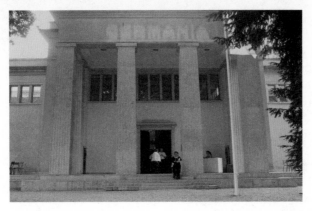

German pavilion

Half a century later, the Latin American countries were also able to erect their own buildings. In 1956 Venezuela erected a pavilion designed by Carlo Scarpa, who had also built the ticket office building at the entrance to the Giardini in 1952. The shape of the pavilion's roof is a leaf and alludes to the gardens. In 1964 Brazil joined the Biennale. Australia, which did not participate until 1987, constructed the last building. In 1995 Korea received its own pavilion.

Initially not all of the pavilions were under government control. The British pavilion, for instance, was initially financed entirely privately until it ran into financial straits in 1920. Spain was first asked whether it wanted to take over the building and then an offer was made to Italy to buy back the building. There was even the idea of using the building as a restaurant, which was not so far-fetched. The building had been erected in 1909 based on an existing design by Enrico Trevisanato since there was not enough time to develop a new project. Originally planned to serve as a café cum restaurant, the building was altered by the British architect Edwin Alfred Rickards, who added more exhibition rooms and a larger door.[37] In the end the pavilion was not sold and now still stands between the German, Canadian and French pavilions as it was originally designed.

37 Sophie Bowness (97) p. 24.

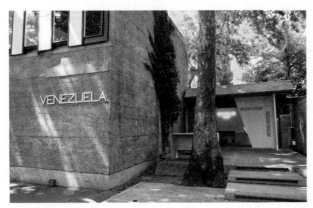

Venezuelan pavilion

List of the pavilions:

1907 Belgium (Leon Sneyers, completely renovated by
 Virgilio Vallot in 1948)
1909 Hungary (Geza Rintel Maroti, renovated by Agost Benkhard in 1958)
 Germany (Daniele Donghi, renovated by Ernst Haiger in 1938)
 Great Britain (Edwin Alfred Rickards)
1912 France (Faust Finci and Umberto Bollotto)
 Sweden (Gustav Ferdinand Boberg)
1914 Russia (Aleksej V. Scusev)
1922 Spain (Javier de Luque, façade renovated by
 Joaquin Vaguero Palacios in 1952)
1926 Republic of Czechoslovakia (Otakar Novotn; extended by
 Boguslav Rychlinch in 1970),
 Denmark (Carl Brummer; extended by Peter Koch in 1958)
1930 USA (Chester Holmes Aldrich, William Adams Delano)
1932 Venezia building for exhibitions by Yugoslavia,
 Romania and Poland (Benno Del Giudice)
1934 Greece (M. Papandreaou and Benno del Guidice)
 Austria (Joseph Hoffmann, renovated by Hans Hollein in 1984)
1938 Romania and Yugoslavia
1951 Ticket shop (Carlos Scarpa)
1952 Israel (Zeev Rechter, altered by Fredrik Fogh in 1966)
 Switzerland (Bruno Giacometti) Egypt
1954 Netherlands (Gustav Ferdinand Boberg,
 rebuilt by Gerrit Rietveld in 1954)
1956 Finland (Alvar Aalto, 1976–1982, renovated by
 Fredrik Fogh and Elsa Makiniemi)
 Japan (Takamasa Yoshizaka)
 Iceland (used the former Finnish pavilion)
 Venezuela (Carlo Scarpa)
1958 Canada (BBPR Group – Gian Luigi Banfi, Ludovico Barbiano di
 Belgiojoso, Enrico Peressutti, Ernesto Nathan Rogers)
1960 Uruguay (former storage building of the Biennale until 1958)
1962 Northern/Scandinavian countries (Norway, Sweden, Finland;
 Sverre Fehn, extended by Fredrik Fogh in 1987)
1964 Brazil (Amerigo Marchesin)
1987 Australia (Philip Cox)
1991 Bookshop Pavilion (James Stirling)
1995 Korea (Seok Chul Kim and Franco Mancuso)

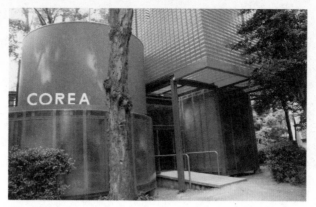

Korean pavilion

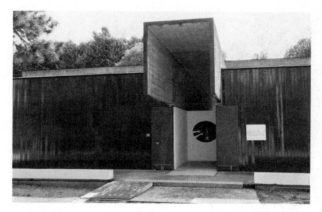

Brazilian pavilion

US pavilion

Pavilion of the Nordic countries

Danish pavilion

Finnish pavilion

British pavilon

Today there are 29 pavilions in the park. At the 53rd Biennial in 2009 fifteen nations were housed in a separate pavilion on the Arsenale grounds or in churches and palazzi all over the city, in addition to 44 multi-lateral exhibitions. Switzerland regularly organizes presentations in the Baroque church San Stae. For years other nations have been pressing for their own building in the gardens. Participating in the Biennale di Venezia is seen as a must for any nation with a sense of pride and identity. For a big power it is just as important as winning gold medals at the Olympic games.

The Biennale di Venezia as a Political Platform

Up until World War 1 art was for the most part able to fulfill the desire for "fraternal unity". This changed with the 12th Biennale in 1920 when, for the first time, the national identity of an artist was significant, even controversial, and art came to represent international conflict. Because of his Swiss citizenship it was, for instance, impossible to dedicate a retrospective to <u>Arnold Böcklin</u> at the German pavilion.[38] In 1904, there was first talk of state funding for art and of preventing political intervention. In 1920 a cultural section was created by Germany's Foreign Office. The selection of German artists was no longer at the discretion of artists' associations but was now the task of the cultural section. Ever since a museum director has had the sole responsibility of serving as commissioner of a country – as opposed to the organizational pluralism that existed until 1920.

From the very beginning the Biennale di Venezia was not simply an art exhibition and art fair – it was also a platform for propaganda. This saved the Biennale from floundering when the first ten biennials sank to the level of salon art. However, the nations remained convinced of the importance of the event – notwithstanding the decline in quality. At the same time, being instrumentalized for party political purposes proved to be almost disastrous for the Biennale in the fascist 1930's when "decency" and "morals"[39] became the selection criteria and critical art was no longer permitted ever since the Biennale had become a political tool.

38 Cf. Becker (94) p. 23.

39 loc. cit., (94) p. 24.

This development is also reflected in the fact that in 1933 the "Referat für Bildende Kunst" (Section for Visual Arts) in the Auswärtiges Amt was incorporated in the "Reich Ministry for Volk Enlightenment and Propaganda".

In 1930 the first music biennial was held, which was followed by biennials for film in 1932, theater in 1934, and architecture in 1975. In 1930, too, the biennial was by royal decree given the status of an autonomous administrative structure (Act no. 33 of Jan. 13, 1930) and was thus no longer controlled by Venice but by the fascist state of Italy. Giuseppe Volpi, Mussolini's minister of finance and economic advisor, was president of the Biennale. The official prizes that were awarded from the beginning now followed themes such as "Poetry of Work", "Depicting Motherhood" and "Portrait of a Prominent Italian".[40] The prizes were sponsored by Italy's National Fascist Party, Italy's Rotary Club, the Adriatic Electricity Society, the Industrial Port of Venice, so it hardly comes as a surprise that all prizes went to Italians.

40 Cf. Becker (94) p. 26; Alloway (90) p. 104.

The selection of the countries participating in the Venice Biennale also reflects the politics of a given time. Russia, for instance, ended its participation in 1934 because of political differences and it was not until 1954 that it took part again. In 1934 the Austrian pavilion stood empty: *"Reflecting Austria's political anschluss to Germany artists from Austria are exhibiting in the German pavilion; the Austrian biennale building should be ceded to another country."*[41]

41 J. Hoffmann p. 67, in: Becker (94).

In 1940 – England and France were already at war – approx. 3,000 works of art reached Venice before Italy entered the war. In June as many as 87,000 people were still able to visit the 22nd Biennale, in which both the USA and Germany participated. The political instrumentalization of art was at its peak with the Biennial showing almost only fascist art. The "wartime biennial" that took place in the middle of the war in 1942 still attracted 76,000 visitors. *"The world war perceived as competition and the Biennial as a reflection of their confidence in victory, that's how the visitors experienced the work by German painters and sculptors,"* Christoph Becker wrote referring to the German contribution in Venice.[42]

42 Cf. Becker (94) p. 32.

The Biennale di Venezia still stands for the cultural and political understanding between the participating nations. This rapprochement figured prominently in the wake of two world wars. The first post-war biennial in 1948[43] ushered in the age of retrospectives – used deliberately to erase the years of fascism from art history by establishing the continuity of the avant-garde, integrating the individual -isms of nations in a supranational, common context and thus reinforcing the western "project of modernism". After a major exhibition of Impressionism, a a retrospective of Picasso, cubism and futurism, there were nowsystematic bi-annual explorations of all genres of "classical modernism" in the national pavilions and in the international Italian building. After this display of a supranational cultural mission, the individual countries also began printing their own catalogues (distributed free), thereby presenting themselves as nations with their own identity. Germany, in particular, has been very good at instrumentalizing its (Venice) contributions

43 During the war two film companies used the pavilions, first as storage space and then as film studios. Cf. Alloway (90) p. 115.

as a way of making political amends and reinterpreting what was to be seen as "German" as, for example, when <u>Ernst Barlach</u> and <u>Max Beckmann</u> were explicitly labeled unheroic advocates of the creation of a "modern state" by means of "modern art".[44]

44 Cf. Peter Joch, Die Ära der Retrospektiven 1948–1962. Wiedergutmachung, Rekonstruktion und Archäologie des Progressiven, (94) p. 37f.

The Venice Biennale in Crisis

In the 1960's the Venice Biennale suffered a severe crisis. Critics from all participating countries accused the event of being antiquated – the period of retrospectives seemed to have ended. Indeed this period came to a close at the 32nd Biennial in 1964 when the main prize was awarded to the young pop artist Robert Rauschenberg. In 1968 there were student protests in Venice for a university reform, the repercussions of which were soon felt at the Biennale. The 34th Biennale di Venezia went down in history as the "police biennale". Armed soldiers set up their main base in the central Italian pavilion[45], and in response to this artists covered their works, turned them around or did not allow their exhibitions to be opened. <u>David Lamellas</u> set up a news agency on the Vietnam War, and because of the protests or for fear of attracting attention no Biennale prizes were awarded.[46] But also in a completely different sense the "Biennale" model threatened by obsolescence, since the galleries, art associations, the art institutions springing up all over Europe and the art expositions in Cologne and Basle as exhibition venues of contemporary international art meant serious competition for Venice.

45 Cf. Olle Granatz, in "Jahresring 42" (95) p. 119ff.

46 Cf. Alloway (90) p. 27.

At the 34rd Venice biennale in 1968 the general themes, which to this day are binding for the exhibition in the Italian pavilion were introduced to counterbalance the mixed offerings found in the country pavilions. The first theme was "Lines of Research", and in 1972 "Work or Behavior" followed. The theme of the 1974 biennale was supposed to be "Democratic and Anti-fascist Art" but given the loud protests the exhibition was cancelled. The Biennale was subsequently restructured to free the Biennale from being politically dependent. Now there was only one government representative on the board of directors, with five advisors from the cultural sector. In addition, the artistic orientation, which had been criticized as being overly traditional, was undermined by context-specific installations of younger artists, individual presentations in the pavilions and venues all over the city. Decentralization, participation and identification had become the new buzzwords.

The 37th biennial in 1976, which was titled "Biennale of Dissent", was seen as a reform-oriented biennial. For the first time the Biennale also included the palazzi of the city as exhibition venues. The public was mesmerized by <u>Jannis Kounellis'</u> live horses, <u>Sol LeWitt's</u> wall drawings, <u>Dan Graham's</u> mirror-clad space, but also by the reconstructions of <u>El Lissitzky's</u> "Proun" room of 1920, <u>Vassily Kandinsky's</u> "Music Room" and <u>Theo von Doesburg's</u> "Café Aubette", a white room by <u>Maria Nordman</u> and black rooms by <u>Lucio Fontana</u> in the central exhibition curated by Cermano Celant.

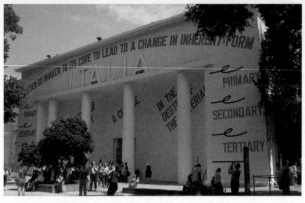

52nd Biennale di Venezia 2007, Italian pavillon, Lawrence Wiener, Primary secondary tertiary

The Venice Biennale was able to regain its status as the leading exhibition of contemporary art. Today it is still regarded as being exemplary and influential but at the same time it has come under attack. Points of contention have been been the hegemonic claim of Western art and its central forum, the biennale, its nationality principle and the elitist Giardini grounds. At the 1999 Venice Biennale Rirkrit Tiranvanija, a Thai artist living in New York, addressed the role of the country pavilions on the Giardini grounds when he erected a wooden platform between the bookshop pavilion and the US pavilion and declared it to be the "Thai Pavilion". (The Italian government owns the Giardini grounds, whereas the individual countries are responsible for organizing and financing their own buildings.) Referring to Tiravanija's work in the catalogue Biennale curator Harald Szeeman stated that the pavilion in question already enjoyed diplomatic protection. If the country pavilions actually had extraterritorial status, then they would be places of refuge like embassies. In reality the cultural institutes in other countries serve as the cultural outposts of a given embassy and have diplomatic status. The Biennale pavilion, however, is an exhibition venue without any privileges. Tiravanija's symbolic architecture was still relevant as a politically symbolic gesture, since its position alluded to the proximity of the USA and Denmark symbolizing Europe's prosperity – in other words, between "bombs and butter" (R. Tiravanija).[47]

47 Cf. Sabine B. Vogel, 48th Biennale di Venezia (278) 1999.

Biennials at the Beginning of the 20ᵗʰ Century

Art communication and education has traditionally been a national concern. As long as there were hardly any art journals and galleries, and art fairs did not exist yet, only a fraction of the artists became known beyond the borders of their respective country. Up until the middle of the 20ᵗʰ century the main forums providing information were exhibitions in bourgeois art associations, public institutions, salons and Secessions. Even if the work shown included art from classical modernist movements ranging from Impressionism to artist groups such as Der Blaue Reiter or Der Sturm, these forums remained largely national, often even regionally oriented. The Biennale di Venezia, by contrast, was from its very inception an international forum. In 1895 more than half of the works were by foreign artists. However, this proportion varied from biennial to biennial. At the sixth Biennale in 1905, only 78 international artists were present,[48] while at the 7ᵗʰ in 1907, only 127 of the 766 artists who participated were international artists. In spite of all these fluctuations the Biennale di Venezia was able to establish itself as an international forum and the "Biennale" model came to stand for the internationalization of art.

"International" is, however, politically charged, and this reflects the colonial dominance of Europe and the USA. The Venice Biennale has reflected the legacy of modernity and modernism in the sense that non-Western countries figure in modern art only as a projection surface, motif or reference. "Modern" is synonymous with "progressive", with the latter referring to the social developments of this period, i.e., secularization, an emphasis on subjective experience as opposed to traditional knowledge, breaks in tradition and a spirit of innovation. The colonies and many other countries, in contrast, were seen as "non-civilized" and thus not considered cultures on a par with the dominant Euro-centric art discourse. To this very day, the Biennale di Venezia is still regarded as the essence of Western modernism, and as such is often imitated but also severely criticized.

48 Press note in: Kunstchronik (269) 1907, p. 237.

The modernism is not a monolithic entity – neither in terms of definition nor time. Some identify the first signs of modernity in the 15th century but the history of ideas sees its beginnings in the Enlightenment. Politically, modernism begins with the French Revolution in the late 18th century and socially with the Industrial Revolution in the 19th century. Art historically, its roots are to be found in 19th century Impressionism.

Terms such as modern, modernity and modernism do not mean the same, even if they are sometimes used synonymously. Modernity refers to an awareness of all changes taking place in the modern world, the experience of the consequences of modernization – that is, the technical, economic and political processes that took place in the wake of the Industrial Revolution, and innovations and their effects. As a noun, modernité was first used in 1848 in Chateaubriand's writings in a derogatory sense. Charles Baudelaire's well-known text "The Painter of Modern Life" first appeared in 1863, and in German Eugen Wolff used the expression "die Moderne" for the first time in 1887 to refer to art. In a lecture titled "The Modern Painter's World" he gave in Massachusetts on August 10, 1944, American artist Robert Motherwell put it as follows: *"The expression 'modern' refers more or less to the last hundred years. Perhaps one could describe Eugene Delacroix as the first modern artist."* [49]

[49] Robert Motherwell, cited in: Kunst/Theorie vol. II, (33) p. 773.

All of the western avant-garde movements of the late 19th century and of the 20th century renounced naturalist art. As Clemens Greenberg put it: *"Realist or naturalist art tended to deny the medium. Its goal was to cover over art by means of art. Modernism wanted to use art to draw attention to art. (…) Whereas with an old master one usually sees what is happening in the picture, before one actually looks at the painting, a modernist painting is first seen as a picture."* [50] This first required a break with (art) traditions and a liberation from religious themes – even if this was not true to the same extent for all nations. In her text titled "acceptera! Der schwedische Modernismus am Scheideweg" (Swedish modernism at the crossroads), Helena Mattsson points out that modernism in *"its Swedish version (…) was not equally perceived as a break with tradition as this was the case with the European avant-garde but rather as a program for linking traditional values with contemporary developments. (…) Also the question of how a link could be established between consumer goods and individual tastes and preferences played an important role in Swedish debates, whereas representatives of European modernism generally did not think highly of consumer culture."* [51]

[50] Clemens Greenberg (22) p. 267.

[51] Helena Mattsson, in: Documenta Magazine no. 1, (16) p. 62f.

Art is significantly influenced by subjective experience, which can no longer be expressed by means of an emblematic system but only by individual systems of order. Authenticity and self-reflection are sources of form and content. [52] Abstraction and later reduction became the formal trademarks of modernism. Historically, modernity/modernism is a European and US-American project. In recent years a new, often contradictory reception of modernity from a non-European perspective has emerged. Rasheed

[52] Cf. Harrison, Modernismus, (24) p. 18.

53 Rasheed Araeen (born 1935) emigrated from Pakistan to London in 1964. He lives there as an artist, curator and theoretician. Since 1987 he has published the influential "Third Text. The Third World Perspectives on Contemporary Art and Culture".

54 Rasheed Araeen, Im Würgegriff des Westens?, in: Documenta Magazine (16) p. 127.
55 Gao Minglu is a Chinese critic and curator.

56 Gao Minglu, Bestimmter Ort, konkrete Zeit, meine Wahrheit. Moderne und Avantgarde in China, in: Documenta Magazine (16) p. 167.
57 Ibid.

Araeen[53], for instance, sees modernity as a development that has already ended: *"The history of modernity is more than a synopsis of various trends and their most important representatives. It also stands for a number of philosophical ideas that back and legitimize its inherent Euro-centrism. (…) It would be easy enough to criticize these philosophies and to reveal them to be pawns of colonialist ideology but that would not help us much. Even if Africa succeeds in creating the academic conditions for appreciating a work of an artist such as Mancoba, and even if it is able to develop its own modern identity out of this, this by no means secures it a place in the established history of modernity."*[54] Gao Minglu[55], by contrast writes: *"On the one hand, the term 'modernity is no absolute, generally valid concept that clearly describes a value but rather a multi-facetted, practical concept. On the other hand, the essence of modernity can only be located in the interaction between cultural differences: there is no such thing as a static, international or generally valid modernity."*[56] Gao Minglu concedes that modernity has its beginnings in Europe, it would be *"inconceivable without Enlightenment and colonialism"* and that it refers to a *"modern, largely European influenced model of thinking."*[57] At the same time, he underlines the *"pluralist, diverse character of modernity"* in the different cultural regions.

The dominance of modernity is also reflected in the history of biennials. In the first phase, the worldwide retrospectives of the European avant-garde movements revealed the hegemonic position of a period influenced by the West, while in the second phase, the biennials manifest the end of modernity and the emergence of global art.

Whitney Museum New York 2007, Wikipedia

National Biennials in the USA

While the Venice Biennale was establishing itself as a form of national delineation and international competition representing both internationalism and patriotism, two biennials emerged in the USA – in 1907 the Corcoran Biennial in Washington and in 1932 the Whitney Biennial in New York. Unlike the Venice Biennale, both events were initiated by private museums to offer a forum for and an overview of only contemporary US-American

painting. As a result the reception of these biennials was also solely regional for decades. The Corcoran Biennial was founded by the Corcoran Gallery, a museum that had been created for the private collection of William Wilson Corcoran (1798–1888). The Whitney Biennial was organized by the Whitney Museum of American Art, which was based on Gertrude Vanderbilt Whitney's involvement for American artists. Only the Carnegie International in Pittsburgh Pennsylvania,[58] also organized by a museum and founded in 1896 as an annual exhibition, its orientation was international from the very outset. Exclusively national in focus from 1940 to 1949, it became a biennial in 1950 and was renamed Pittsburgh International. From 1955 it was continued as a triennial and it was not until 1982 that it was given its original name again.

These three early American biennials were easily integrated in the existing institutional structures. They were organized by permanent museum teams in established spaces and financed as part of annual programs. By contrast, the biennials that were founded worldwide from the fifties on had increasingly very different structures and functions and at the same time they had no existing infrastructure to draw on. These new events were oriented towards internationalism and networking and served to break cultural isolation and to connect with – western – modernity. Whereas the early US American biennials strengthened national art at home, the international biennials that began in the fifties ushered in the age of the global export hit known as "Modernism".

58 "While most art museums founded at the turn of the century focused on collections of old masters, Andrew Carnegie envisioned a museum collection consisting of the 'Old Masters of Tomorrow'. In 1896 he initiated a series of exhibitions of contemporary art and proposed that the museum's paintings collection be formed through purchases from this series. Carnegie, thereby, founded what is arguably the first museum of modern art in the United States. Early acquisitions of works by artists such as Winslow Homer, James McNeill Whistler, is distinguished in American art from the mid-nineteenth century to the present, in French impressionist and Post-impressionist paintings, and in significant late-twentieth-century works." (museum press release)

Biennials of the 1950's

After World War 2, the Western nations looked to the past, with a major Impressionism exhibition, a <u>Picasso</u> retrospective and a survey of metaphysical art, to assert an unbroken continuation of pre-war modernism. In his text "The Era of Retrospectives 1948 – 1962" Peter Joch writes that the goal was to *"credibly reconstruct modernism as a lost age."* [59] At the same time the first international successor models also appeared, and the hegemony of the Biennale di Venezia began to crumble.

In 1952, Japan participated for the first time [60] and that same year the Tokyo Biennale was founded by the daily paper Mainichi News Paper Co. This, together with the Biennale de Paris (1959, France), was one of the two leading exhibition forums for young artists. The two young art critics Yusuke Nakahara and Toshiaki Minemura toured the "When Attitudes Become Form" exhibition at the Kunsthalle Berne in 1969 and then presented most of the artists they had seen there in Tokyo at the 10th Tokyo Biennale in 1971 in an exhibition titled "Between Man & Matter." [61] Thanks to this show the biennial became known outside of Japan. The Biennale de Paris, by contrast, was founded on the initiative of André Malraux, [62] who as French Minister of Cultural Affairs at the time dedicated this forum to artists between the age of twenty and thirty-five.

The Tokyo Biennale ended after its 18th edition in 1990 and the Paris Biennale after the 14th "Nouvelle Biennale de Paris" in 1985. Artist Alexanre Gurita used the name Biennale de Paris again in 2004 but the exhibition received no state support, had almost no budget, announced works that were not actually shown and hardly received any national recognition and went unnoticed internationally.

59 Cf. Peter Joch, (94) p. 35ff.

60 See Asian Art Archive (4).

61 I am indebted to Fumio Nanjo, director of the Mori Art Museum in Tokyo for this information.
62 Writer André Malraux (1901 – 1976) was French Minister of Cultural Affairs from 1959 to 1969.

Documenta

The documenta in Kassel is the best-known regular exhibition founded in the 1950's. Arnold Bode conceived this large-scale show in 1955 not as a periodical exhibition in its own right but as part of the program of the Federal Horiocultural Show. It was supposed to serve as a one-time forum for coming to terms with historical events and to make it possible to reconnect with the history of modernism that had been so aburptly interrupted by the Nazis. For this reason the focus of the exhibition was initially on works from before 1933. In the catalogue of the 2nd documenta in 1959 Friedrich Bayle wrote: *"The documenta satisfies one of the most important intellectual desires to catch up with new developments"* – a statement that also applies for other exhibitions such as the equally internationally oriented park exhibition Sonsbeek in Arnheim, Holland, which initially took place as a triennial. The first of the latter exhibition in 1949, attracted 125,000 visitors [63] – a figure that could never be reached even closely in Arnheim.[64]

63 Brochure of the Historical Museum of Arnheim, Sonsbeek (84)
64 In 1949 the Sonsbeek Park in the Dutch border town of Arnheim showed 88 artists with 199 artworks; in 1952 it was already 128 artists with 220 works, which were seen by 103,000 people. In 1995 the number of visitors dropped to 94,431 and in 1971 to 20,000. (Information from the Sonsbeek exhibition, Municipal Museum Sonsbeek September 2008.)

Developments were different with the documenta though. While the 2nd documenta attracted only 120,000 visitors, in 1964 the number grew to 200,000 and by 1977 there were already 355,000 visitors. The 12th documenta in 2007 had more than 750,000 visitors. One can only speculate on the reasons for the enormous increase in visitors in Kassel and the strong decline in Arnheim. To be sure, the fact that the former took place regularly and thus had a steady presence in the media certainly played a role apart from the sheer quantity and quality of the art exhibited. The number of accredited journalists in Kassel – as well as in Venice – thus continued to rise, whereas in Sonsbeek not much more than the local media and the local public could be reached.

Documenta 1992, Temporäre Bauten, Wikipedia

The name documenta is also programmatic. The first exhibitions until 1972 documented modern art with expressive and abstract works from before 1933 and after 1945. It was only with the 5th documenta directed by Harald Szeemann and his team that the exhibition became a forum of contemporary art with the "Exploring reality – pictorial worlds today". In his concept Szeemann declared programmatically: "Knowing as a form of social work means changing reality by changing its representation and its instruments of knowledge." Szeemann presented a leitmotif encountered again and again in the biennials founded in the following decades – the demand that art initiate and support social change. Art thus already assumed the role of an emissary or an agent of social processes at virtually all biennials taking place inKassel and Sonsbeck.

Sonsbeek Biennale 2008

Bienal de São Paulo

What was initiated rather clearly at the documenta in Kassel was repeated in almost identical form in most of the following biennials. The first exhibitions were characterized by retrospectives in which the nations, in particular the hosting ones, were able to ascertain their historical identity and to inscribe it in an international (art) history – as a *"reassertion of its historical identity and a metaphor for political power"* [65], as Margarete Garlake put it in her study on the São Paulo Biennale.

65 Margarete Garlake (19) p. 13.

In 1946 industrialists Yolando Penteado and Francisco "Ciccillo" Matarazzo Sobrinho founded the "Museu de Arte Moderna de São Paulo". Two years later, at the 24th Biennale in Venice in 1948, the industrialist who had Italian background, served as Brazilian commissioner in Venice. In 1951, thanks to Sobrinho's interest and with the financial backing of the US American Rockefeller Foundation, the "Bienal Internacional de Arte de São Paulo" was established, along with the umbrella organization "Fundacao Bienal de São Paulo"; Sobrinho was its president until 1975. The goal of this biennial was to reinforce São Paulo's role as the capital of Brazilian industry as opposed to the former imperial capital of Rio de Janeiro and to establish it as a center of contemporary art and to thus integrate Brazilian art in international art.[66] Later, in 1963, the Museu de Arte Contemporanea da USP (or MAC) was founded. It emerged from the Matarazzo Collection and included the works that had received awards at the Biennale. Until the new building on the Campus of the USP (University of São Paulo) opened in 1992 the MAC was located on the 3rd floor of the Biennale building at the Ibirapuera Park.

66 On this see also: Michael Asbury, The Bienal de São Paulo: Between nationalism and inter-nationalism, (3).

Today São Paulo – unlike Venice – serves as the center of Brazilian art and culture with the largest number of concert halls, theaters, museums and educational institutions for art in Brazil.

The São Paulo Biennale is the first international biennial that was founded outside the cultural hegemony of the Western centers. Yet instead of reinforcing

São Paulo Biennale 2004, Leo Schatzl, Autorotation São Paulo

this forerunner role with large-scale presentations of non-Western art, the first biennales were dominated by retrospectives, one-person and survey exhibitions of Western European avant-garde artists. In 1951 Ferdinand Leger and Picasso, works from the Bauhaus and expressionism to Max Ernst and George Grosz were shown. These retrospectives secured the attention of the West and the financial backing of the participating nations for the young biennial. But at the same time the superior position of Europe and the USA was reinforced – and it was this circumstance that prompted the founding of the Havana Biennale responded twenty-two years later.

At the 2nd edition in 1953 Picasso's "Guernica" was shown for the first time, Henry Moore represented England, George Morandi Italy and de Kooning the USA. Italy as well as Austria took part in almost every biennial. It was not until 1961 that the prizes awarded here began going to Latin American artists and not just European artists.

Country Participation

Brazil extended its invitations to diplomatic representatives or state institutions and, of course, these invitations were bound to the country's political and economic interests. Initially, the nations that were officially invited showed all of their works together and not separately, as in the Venetian pavilions, *"proclaiming Brazil's party with the international community"*, as Margarete Garlake noted in her essay on "Britain and the São Paulo Biennial 1951–1991".[67] In the first decades there were obstructive partitions and the windows were blocked. Until 1980 all of the countries were assigned clearly delineated areas, with *"sensitivity to size, prominence and placement: the experience of the Bienial has often been at odds with the symbolism of unity."*[68]

67 Ibid., p. 18.

68 Ibid.

From the outset the São Paulo Biennale had an international, even global orientation going far beyond the small circle of western nations. Here the gaze was directed to those countries that went unnoticed in Kassel and Venice until the end of the 20th century. Even in the 1950's both in São Paulo and a striking number of non-Western nations the *"opening towards world art and a renunciation of west art"* [69] began, as Alfons Hug put it. Indonesia, Israel and Egypt were represented at the 2nd biennial in 1954. Many recently founded or independent nations participated at the following exhibitions. In 1947 India became independent and took part for the first time in 1959; Lebanon, independent in 1941, participated in 1967 for the first time; the Philippines, independent in 1946, was on the roster of nations in São Paulo for the first time in 1965; Indonesia, independent in 1949 as a federation, became a centralized state on August 17, 1950, participating as the "Republic of Indonesia" in São Paulo as early as 1953 and then again in 1959. Senegal became independent in 1960 and participated for the first time in 1961. Vietnam was represented in São Paulo for the first time in 1955, at a time when the country had been divided into North and South Vietnam for three years – a fact that was not reflected in the country's designation at the biennial.

69 Alfons Hug, interview on the 26th São Paulo Biennale 2004 (229).

By participating in the Biennale the young nations confidently presented their "own" culture in a self-assured way, while entering international art history – even if Western art hardly took note of this. For the first time the artworks did not speak the language of reduced, modern art and there was also no Western critics, artists, art dealers and museum directors who showed interest in their art – something that began to change only at the end of the 1980's.

In 1957, Taiwan, listed as "China", participated for the first time at the 5th biennial, with an exhibition of historic Chinese art. The "Republic of China" was one of the fifty-one founding nations of the UNO in 1945. In 1952 Taiwan's right of self-determination was laid down in the Peace Treaty of San Francisco; in 1978 the USA broke off diplomatic ties with Taiwan in the course of its rapprochement with China. To this day Taiwan's status remains politically problematic, which is also evident at the biennials. At the 25th biennial in 2002 Chien-Chi Chang was invited to represent Taiwan – this met with opposition from China, since Taiwan was not recognized as an independent state and was regarded as occupied territory. Following a threat by the Chinese to withdraw their contribution, Alfons Hug, chief curator of the biennial, changed Chang's provenance to "Taipei Fine Arts Museum". The artist then refused to show his work. This strange policy of ascribing an artist to a museum instead of a nation can be found again and again – and this will certainly be the case as long as Taiwan's political status remains uncertain.

Boycott of the Biennale

In the wake of the military coup d'état of 1964, the São Paulo Biennale experienced a crisis. Artists from countries such as Vietnam, Tunisia and Trinidad-Tobago, all of which had been independent for only for a few years took part in group presentations at the 10th biennial in 1969. Artists from Holland and Sweden withdrew their contributions and the USA "arranged replacement exhibitions."[70] While Canada, Sweden, Holland and the US boycotted the 11th biennial, France only exhibited porcelain animal figures and in 1973 even the British cancelled their participation, which until then, for diplomatic reasons, was upheld due to economic ties. The British ambassador pleaded that his country continue its participation *"on the grounds of commercial expediency; trade with Brazil was expanding and commercial relationships with the military government (…) were particularly affable."*[71]

70 Garlake (19) p. 25.

71 loc.cit., p. 23.

In 1975 the boycott ended but in the meantime the biennale had become a largely Latin American affair. At the 16th and 17th exhibitions in 1981/83 Walter Zanini, art historian and chief curator of the São Paulo Biennale, did away with national representation, and proceeded to invite individual artists. The exhibition catalogue no longer listed nations, only the artists in alphabetic order. The first free elections took place again in 1985. Since the 18th exhibition the São Paulo Biennale has once again one of the most important stops on the international Biennial world map, a fact which is reflected in the national budgets and the international reviews. Ever since then the biennial, now under the leadership of Sheila Leirner, has resumed the system of national representation, ultimately also for financial reasons and introduced for the first time themes such as "Man and Life" and then in 1987 "Utopia vs. Reality".[72]

72 Cf. list for information of biennial themes, p. 120.

São Paulo Biennale 2004, Artur Barrio, Fortaleza-Lisboa

Biennials of the 1960's and 1970's

In the 1990's the São Paulo Biennale met with rivalry from further non-Western forums. The Eastern European Biennale der Ostseeländer (Biennial of the Baltic Sea Countries) was founded in 1995 in response to West Germany's documenta. As a result of the new political conditions following the end of the communist bloc it became defunct with the 15th biennial in 1996.

Triennale India

In 1968 the India Triennale was launched in New Delhi and organized by the Lalit Kala Academy to this day. Fifty-one artists from thirty-one countries showed their work at the first triennial, and since 1975 the selection of countries has been limited to those that have signed a cultural agreement with India. At the 9th triennial in 1997 this applied to 48 countries, and at the 11th triennial in 2005 to 34. The selection of Indian artists is based on parity and all parts of the country must be more or less equally represented. The international contributions, by contrast, are chosen via diplomatic channels with country commissioners being officially invited as in Venice.

Since most of the national contributions usually represent religious themes in an academic tradition, the difference to the contributions from western countries is particularly striking here. At the 11th triennial in 2005, Indian artists who exhibit internationally boycotted the event[73] and instead organized a symposium with the goal of establishing a new New Delhi Biennale which was to have a less traditional face – a plan which, however, was given up all in 2009, since it proved impossible to organize such an event. The existing India Triennale is now being restructured for the 12th exhibition in 2011.

A central criticism of the triennial was not just its conservative orientation but also having artists represent their country. In both New Delhi and São Paulo it was, however, precisely this principle that secured financing for this event. Moreover, since the 1960's the India Triennale has shown works by

73 Cf. Sabine B. Vogel, 11th Triennial India (264).

India Triennale 2005, Indira Ghandi House

international and national artists who would otherwise find no venues to exhibit their work in India since to this day the country lacks state-supported infrastructure for contemporary art.[74]

74 Sabine B. Vogel, "New Spirit: Indien", (265).

Biennale of Sydney

It was not until 1973 that another biennial of comparable international quality and significance as the one in Venice and São Paulo emerged, namely the Sydney Biennale. Here, too, it was an entrepreneur from an Italian family who took the initiative – Franco Belgiorno-Nettis, who was born in Italy in 1915 and emigrated to Australia in the 1950's. Belgiorno-Nettis financed the Biennale of Sydney until his death in summer of 2006. Inspired by the Venice Biennale, he decided to break Australia's cultural isolation with this bi-annual exhibition. *"How to break the isolation of Australia? How do you inject that flavor of international extravaganza, originality and explosive vision that you see at gatherings in Venice?"*, he asked. To create a *"link to the world"* and *"to break the tyranny of distance"* he first founded the "Transfield Art Prize" and then the Biennale.[75] Not only is the Sydney Biennale one of the best-known events of its type, which has been freuqently copied in Australia, it has certainly contributed to reducing the isolation of the Australian art scene. The Biennale has also clearly influenced the local museum scene. The Art Gallery of New South Wales has time and again purchased central works from the Biennale exhibitions, as, for instance, Richard Deacon, Jannis Kounellis and William Tucker.

75 See Founding Governour's Report 1973, Sydney Biennale (262).

Contrary to Venice and São Paulo, the Biennale of Sydney has from the very outset had one artistic director. Regardless of a country's diplomatic or economic ties this person invites the artists directly and not via diplomatic channels. Luca Belgiorno-Nettis, the founder's son, noted a further distinction: *"And finally, this is strictly a show – no prizes, no sales, no Leone d'Oro."*[76] By dispensing with prizes and a "Golden Lion", which are symbolic for the Biennale di Venezia, the affinity with a world exposition, international

76 Sydney Biennale 2006 (85), p. 6.

competition is also undermined. Instead of a comparison between nations there is a regular bi-annual, privately sponsored group exhibition, for which, in contrast to Venice and São Paulo, a permanent, fixed team is responsible.

The first biennial took place in 1973 at the exhibition hall of the newly opened Sydney Opera House, signaling the advent of a new cultural age. It was the first major exhibition of international art in Australia, with the focus initially being on artists from the Asian and Pacific region with artists from a few western European countries and the USA.[77] This orientation and the desire to keep in touch with Western art has remained central to the Sydney Biennale to this day. At the 2nd biennial in 1976 eighty artists from only ten, largely Western European countries were invited to show in the Art Gallery

77 The 37 artists of the 1st Sydney Biennale came from fifteen countries: Australia, Bangladesh, Indonesia, Italy, Japan, Korea, Malaysia, Mexico, New Zealand, Philippines, Spain, Thailand, GB, USA, West Germany.

Sydney Biennale 2003, Antony Gormley, Asian Field

of New South Wales, "since the tight travel budget of the British director hardly permitted any extensive research."[78] Since then the number of countries listed has increased. At the 8th biennial in 1990, curated by René Block, there were 148 artists from twenty-eight countries and the following event featured 126 artists from thirty-three countries. In 2006 there were 85 artists from forty-four countries. As at most other biennials here, too, the participating countries[79] were largely responsible for financing their own artists and by extension also the Biennale.

78 Cf. curatorial statement by artistic director Thomas G. McCullough (262).

79 Funding was provided by institutions such as the Mondrian Foundation in Holland, the National Commission for Culture and the Arts of the Philippines, the Modern Museet in Sweden, the ifa in Germany as well as the Australia Israel Cultural Exchange in Israel.

80 Cf. curators' statement (262).

On many occasions, the artistic directors in Sydney underscored the significance of the biennial as a place of exchange. In his statement curator Thomas G. McCullough wrote: "(…) *the biennale is like an international meeting place or living conference of artists and critics.*"[80] At the 8th biennial in 1990 René Block admitted: "*I view a biennale as a workshop, a specific place where artists from different countries come together, show their works and find out about the works of*

fellow artists. Something like a fair of ideas." [81] And Charles Merewether selected as central theme at the 15th Biennale of Sydney 2006 "Zones of Contact". The aspect of exchange had already been put forth in the founding declaration of 1973. The focus was no longer on "fraternal association" as in Venice but on calling into question one's own identity in an international context. Similar to the second phase of the Venice Biennale, retrospectives served this purpose here. In 1988 Nick Waterlow presented "A View of World Art 1940–1998", while René Block focused on "Certain Relations in 20th Century Art."

Both the artists and the artistic directors came mainly from Western Europe and the USA so that as a remote outpost the Sydney Biennale manifested the hegemonic status of the Biennale as a forum of Western modernity. As the theme of the 3rd biennial Nick Waterlow selected "European Dialogue", thereby questioning the cultural dominance of New York and trying to uncover a direct link between European and Australian art. Strong resistance subsequently mounted against the disproportionately large number of European[82] and US-American[83] artists and the disproportionately small number of Australian artists (especially females) that were represented. There were demonstrations and protest marches, and calls for a fixed percentage of Australian art. In response to these demands the 4th biennial in 1982 was accompanied by a public program with lectures, performances and discussions, related exhibitions and workshops, with the goal of establishing contact with the public and the local art scene. For the first time an enormous "sand painting" by the Aboriginal Walpiri Group from Lajamanu was also presented. Since then works by the indigenous people have become a fixed feature of the biennial events. One highlight of the 6th Biennale in 1986 was the Aboriginal Memorial composed of 200 coffins, each marking one year of occupation by the white population.

The Biennale as a tool for bringing about cultural change continues to play a role even in the biennials that were founded later. For most biennials "cultural change" means an emancipatory process in the Enlightenment sense, a model of actively engaged intellectuals contributing to social change. This can be based on worldwide networks as in Sydney or on shifts in national orientation or, as only a few years later in Havana, on the construction of an anti-imperialist front in the field of art.

81 Ibid.

82 Including Marcel Broodthaers, Gerhard Richter, Hanne Darboven, Mario Merz, A.R. Penck, VALIE EXPORT, Daniel Buren, Heinz Mack, Arnulf Rainer, Daniel Spoerri, Tinguely, Günther Uecker.
83 Including George Brecht, Victor Burgin, Krystof Wodiczko.

Biennials of the 1980's

The Biennale di Venezia and the documenta were already noticeably influenced by post-modernity in the 1980's. Site-specific installations became more common, a growing number of countries participated in Venice and there were more and more artists in Kassel. With the creation of further biennials worldwide, the West was for the first time no longer able to claim for itself the sole right to art centers. A 'global art' was making its first quiet appearance. Some new biennials initially set themselves the goal of strengthening the region, like the regionally oriented Asian Art Biennale Bangladesh, Dhaka/Bangladesch (1981) founded ten years after the country obtained its independence or the Bienale de l'Art Bantu Contemporain Gabon (1985). In the West, more and more media-specific exhibition forms were being developed like the Foto Triennale in Esslingen, Germany (1989) or the Triennale of Small Sculpture in Fellbach, Germany (1983), which, in 1993, became the model for the Small Sculpture Triennale Seoul which took place twice at the Walker Hill Art Center in South Korea. Similar to the India Triennale, the Cairo Biennale Egypt (1984) was, by contrast, a clearly political instrument used to reveal existing traditions and academic structures. The most important new biennials to this day are, however, the Bienal de la Habana, Cuba (1983) and the International Istanbul Biennial, Turkey (1987). Whereas the Havana Biennale was intended to serve as a counterweight to Western culture, the Istanbul Biennale was supposed to assert or reinforce the geographical and cultural links between Europe and Asia.

Cairo Biennale

The Cairo International Biennale of Arab Art, which was founded in 1964, was preceded by the Alexandria International Biennale for Mediterranean Countries (1955). Even though the latter had an international orientation from the very outset, featuring artists from Spain, Italy and France, this biennial is hardly known today. Eight nations participated at the first exhibition in 1955; Albania, Morocco and Syria joined in 1957, followed by Palestine in 1968, Turkey in 1972 and Libya in 1982. At the 21st biennial in 2001 as

many as fifteen countries from the region participated. However, the exhibiting countries did not include any artists who may otherwise be found in museum exhibitions, international biennials and in the art market.

The Cairo Biennial is dominated by official, academically influenced art. Both events are still today organized by the Foreign Ministry and serve to demonstrate and consolidate what is deemed to be 'Egyptian art'. Since the biennial was opened up to international art at the 2nd exhibition in 1986, more than fifty nations have participated regularly, including USA, Switzerland and Austria, Germany, Argentine and Italy.

Modeled after Venice, the Cairo Biennial extends invitations to international ambassadors or cultural sections of foreign affairs departments and the exhibitors are shown in national pavilions or sections, located in three different exhibition buildings. Similar to Venice, participation is financed by the countries which, in turn, select the participants. In addition, "honorary guests" are also invited and special invitations issued – both decided upon by the Egyptian "Highest Committee".

The policy of extending invitations is subject to strict rules. Artists from Israel, for instance, are excluded by the Biennial Charter: *"In agreement with the UN Charter, international law and the charter of the Arab League, states that violate the sovereignty of other countries, occupy foreign territory by force or tolerate invader or occupying forces are not permitted to participate in the International Cairo Biennial."* [84]

At the 3rd Cairo biennial Egyptian artist Ahmed Fouad Selim received the "Great Nile Award". Since the 6th biennial he has served as general commissioner of this exhibition, focusing on academic-abstract painting and sculpture. In a review Iolanda Pensa explains: *"The organizers of the Cairo Biennial are more or less the same folks who always run the Egyptian pavilions at the biennials in Venice and São Paulo and sometimes are themselves featured."* [85]
At the 9th edition in 2005 Lilly Wei noted the enormous contrast between the official biennial and the much more lively satellite exhibitions. [86] Carey Lovelace summed it up in the following way: *"The overall quality was something like a sidewalk crafts fair – nearly everything was alarmingly provincial, academic or derivative."* [87]

Critic and curator, co-founder of the independent Alexandria Contemporary Arts Forum (ACAF) Bassam El Baroni even refers to the two Egyptian biennials as "kitsch biennials". *"It is also apparent that this kitsch factor is the result of their usage of political, geographical and mythological histories that simulate the past but don't seriously negotiate with the present. Rather than structuring frameworks that deal with issues of identity and globalization, the Biennales address these complex issues through off-centered and imposed cultural-political outlooks that are nationalistically impulsive."* [88]

In 1990, the biennial was cancelled as a show of solidarity with Kuwait following the invasion of Iranian troops. [89]

84 Iolanda Pensa, 9th Cairo Biennale, (194) 2004.

85 Ibid.

86 Lilly Wei, (193) 2004.

87 Carey Lovelace, 9th Cairo Biennale, (195) 2003.

88 Bassam El Baroni, Remodeling Required: Official Biennale in Egypt and international biennale culture, (5) p. 2.

89 Cf. The Manifesta Decade (23), p. 27.

10th Havana Biennale 2006, Terminal Ferroviaria La Coubre

Bienal de la Habana

In 1983 the Bienal de la Habana was founded in the República de Cuba, marking the 25th anniversary of the revolution. Thematically it was explicitly conceived as a 'Biennial of the 3rd World'. The founding of the Havana Biennale is intimately linked to the political situation of the small island state. After a failed attempt at a coup in 1953, Fidel Castro and his troops succeeded, on January 1, 1959, in liberating the country from Batistas's military dictatorship and US-American dominance. This marked the end of 500 years of turbulent colonial history. In 1961 the government launched an extensive literacy campaign, suppressed the influence of the church in education, obtained the political and economical support of the USSR and nationalized the property of big North American landowners. In 1962 the USA intensified the economic blockade in response to the construction of a missile-launching base constructed by the USSR. The trade embargo was briefly lifted in 1975 following Cuba's military involvement in Angola and Ethiopia. The embargo has remained in place to this day.

As a result of US sanctions and Cuba's political ties with Russia, the island republic is extremely isolated both economically and culturally from the West. Other Latin American countries joined the embargo in the wake of a diplomatic note from Foreign Minister Olney in1895. The communication stated that the United States "practically" regarded itself as sovereign (power) of the entire continent and that its will was "law to its inhabitants." As a way to break its political and cultural isolation and to strengthen the young nation, Fidel Castro decided to establish a number of cultural festivals in the realms of art, music and film which were always *"linked to an international star from Cuba"*[90]: the guitar festival featured Leo Brouwer, the ballet festival Alicia Alonso, the jazz festival Chucho Valdés, the film festival Castro's friend Garcia Marquez and the biennial the artist Wilfredo Lam.

Even though the Instituto Superior de Arte had existed since 1967, offering training for actors, musicians and artists and Cuban artists had participated

90 Gerhard Haupt in a private letter dated July 10, 2007.

in first São Paulo Biennale in Brazil, the Cuban art scene was almost unknown in the West as well as in the rest of Latin America. The Bienal de la Habanna was founded in response to these circumstances, an *"answer to the need for a forum to initiate a dialogue among artists from the 3rd World,"*[91] as Lilian Llanes, long-standing director of the Wilfredo Lam Center and the biennial put it. *"The goal of the Havanna biennial was to pave the way for a better understanding of contemporary art from 3rd world countries and to facilitate an interpretation of these works which integrated the context in which they evolved in their interpretation."*[92]

91 Lilian Llanes, Die 5. Bien-
nale von Havana, (63) p. 12

92 Ibid.

Hardly any other biennial emerged which was so politically influenced and continues to be so as the Havana Biennial. This is reflected in the organizational structure, the invitation policy, the central themes, the special exhibitions and conferences. This is also visible in the limitations imposed on artists who have to ask for permission to make visits and in the censorship of the works. The selection of artists is under direct political supervision, and no single curator has the authority to make a decision – except for a committee which was led until the 7th biennial in 2000 by Lilian Llanes.

The first biennial in Havana featured 800 artists with 2,000 works, all of which originated in Latin America and the Caribbean. This biennial was strictly limited to artists from this region. At the 2nd biennial in 1986 Cuban cultural minister Armando Hard stated: The cultural context of this biennial was a struggle of the 3rd world against imperialism, the *"development of cultural survival for cultural decolonization and integration of our spiritual values and an interest in the way the cogs of our world turn."*[93] Describing the preparations of the third

10th Havana Biennale 2006, Kcho (Alexis Levya)

biennial in 1989 which showed 300 artists from 41 countries, Nelson Herrera Ysla, director of the Wilfredo Lam-Center, reminisced: *"We learned to understand forms of expression better, which in some aspects are able to resist the hegemonic tendencies of power centers, which do not succumb to the sirens of the market or do not go along with the subtle manipulations of certain 'developed' cultural institutions."*[94] Following this biennial one of the founding fathers Gerardo Mosquera left the organization. In the lecture he gave at the Bergen Biennial Conference 2009[95] in Norway he explained that the Havana Biennial had been founded with the goal of "radical cultural renovations", more as a network or organism than as a traditional exhibition "for transforming international relations." But as a result of political instrumentalization this approach had been lost.

93 Armando Hart, cited from
Paolo Bianchi, Kunstforum vol. 139
(157), p. 418.

94 Ibid., p. 191.

95 Bergen Biennial Confe-
rence. To Biennial or not to Bien-
nial? September 17 – 20, 2009.

96 The affinity with Africa has ethnic and political motives. On November 10, 1975, Castro sent troops to Angola. On February 14, 1988, his troops defeated the South African troops – this marked the beginning of Apartheid. In 1991 Nelson Mandela traveled to Havana to thank Castro.

97 Press release on the 10th edition titled "Integration and resistance in the global age" (166). At this biennial Tania Bruguera actually succeeded in doing a performance that was staged as a platform for free expression of opinion: Cubans and biennial guests were given a chance to speak freely at a podium. The blogger Yoani Sanchez was the first to avail herself of this opportunity and spoke about the growing blogger scene in Cuba (cf. Knut Henkel, Kunstperformance mit Folgen, taz, April 2, 2009).

98 Catalogue of the 5th Havana Biennale, (63) Wolfgang Becker, p. 9.

The strict limitation to art from Africa[96] and Asia was only lifted from the 3rd biennial on, but to the present the focus is on Cuba and the Caribbean, even if Castro's political withdrawal promised an opening at the 10th biennial in 2009.[97] The organizers provocatively titled the 3rd exhibition in 1989 "Biennial of the 3rd World." [98] The 4th biennial of 1991 addressed the "challege of colonialization" and invited artists from the West, albeit only those from ethnic minorities or with migrant backgrounds. Black American artist Adrian Piper participated in the 2nd exhibition in 1986 and a retrospective of Jean Michel Basquiat was on view at the Casa de las Americas at the 7th exhibition in 2000. There were retrospectives, too, of Carlos Saura and Spencer Tunick were shown at the Wilfredo Lam Center at the 9th biennial.

It is one of the trademarks of this biennial that the team and director are not appointed for every exhibition. As part of the Wilfredo Lam-Center staff they remain in charge as experts of individual countries and thus are able to gather an overview of the art scenes in the countries involved. The Havana Biennale has again and again backed the artists' search for their own identity and their own roots which, of course, also include African influences. The 3rd biennial in 1989, dedicated to the theme of "Tradition and Contemporaneity", featured African wire toys, Arabic calligraphy and Latin American textile art. A group exhibition titled "Applied Popular Art from Brazil" was presented at the 4th biennial in 1991. It is also characteristic of the Havana Biennale that it does not exclude or marginalize arts and crafts or popular art.

The Power of Politics

A problem of – not only – the Havana Biennale is government censorship, meaning not only that a selection is usually made beforehand but that exhibits can also be interfered with. This occurred, for instance, at the 1994 biennial where photo-portraits with interviews of Cuban artists who emigrated to Mexico were displayed by Mexican artist Lourdes Groubet or pictures of women taken from porno journals were shown by Ecuadorian artist Marcos Alvarado. This was also the case at 7th biennial in 2000 which featured the installation by Tania Bruguera: a long corridor, the floor of which was covered with milled sugar cane and at the end stood a television set showing Castro soundlessly giving a speech. When the viewers turned around they were able to see the shadows of naked persons – the next day the performance was stopped.

99 This information stems from a conversation with Gerhard Haupt and Pat Binder.

A decisive development in the history of the Havana Biennial took place in March 2003, concurrently with the opening of the 8th biennial, when Fidel Castro had three kidnappers of a ferry executed after a summary procedure and 75 dissidents arrested. In reaction to this, international sponsors withdrew their funding and a number of artists and critics began boycotting the biennial.[99] But even the less dramatic decisions made by Castro have made visiting the Havana biennial ever more difficult. After it became legal in 1993 to possess US dollars, prostitution began to assume alarming dimensions in Cuba – a fact that was addressed in almost every review of the 7th biennial

in 1997. At the end of 2003 Castro replaced the US dollar with the 'peso convertible' a currency reserved for tourists only and out of the reach for Cubans, as a result of which prostitution declined noticeably. At the 9th Biennial in 2006 Castro cracked down again on all previously relaxed measures. In 2006, for instance, American citizens were only allowed to enter the country for "humanitarian purposes". As a consequence, many collectors who had traveled to the country since the 6th biennial in 1997 to buy up Cuban paintings were no longer able to enter the country.

In spite of these developments the Havana Biennial is still one of the most important institutions for contemporary art in Latin America. It has contributed significantly to making Cuban art known in the international art scene since the 1980's and has turned Cuba into a "cultural leader within the third world." [100] At the 8th biennial in 2003, two thirds of the 150 artists were from Asia, Africa and South America and the Caribbean. Thus, notwithstanding the developments of globalization it still features an unusually large number of artists from non-western countries.

100 P. Leon Dermis, Artjournal, winter 2001 (159).

The success and structure of the Havana Biennial have certainly contributed to the Biennale model being adopted by more and more countries on the periphery of the western cultural scene. A hope that often accompanies the development is summarized as follows by Rachel Weiss in her report on the 6th biennial in 1997: *"It (Havana Biennial) occupied the role of antidote to the homogenizing forces of the marketplace and potential model for alternative practise. As the only biennial operated by a Socialist country, it stood for anti-commercialism and solidarity among artists, a challenge to the cultural hegemony of the (Yankee) mainstream."* [101]

101 Rachel Weiss, Art Nexus 1997 (156).

As opposed to most biennials the goal of the one in Havana is not to show art in a Western, elitist style but to bring it to the streets and to the people. At the 8th biennial in 2003 Mohamed Abla, a young Egyptian artist, remarked in a discussion with the Cuban minister of cultural affairs: *"Compared with Havana Venice is nothing but a commercial supermarket. The Biennial is the only one that gives us young artists the space we need. Havana is the opposite of Venice."* [102]

102 Henky Hentschel, 8th Havana Biennale (163).

International Istanbul Biennial

The International Istanbul Biennial (called IB for short), founded in 1987, has a completely different structure. Similar to São Paulo and Sydney the Istanbul exhibition began as the initiative of an industrialist who was reacting to cultural isolation. On the 50th anniversary of the birth of the Turkish Republic in 1973 Nejat F. Eczacibasi[103], founded the Istanbul Foundation for Culture and Art (IFCA), which has organized and provided most of the funding for the biennial, including the first one in 1987. It was preceded a year earlier by the first and only edition of the International Asian-European Art Biennale took place in Istanbul, which, *"however, ended as a flop after several*

103 Dr. Nejat F. Eczacibasi founded his company in 1942. Today it is a holding with 37 companies that produce pharmaceuticals, construction material, consumer goods and even information technology. The Eczacibasi famiy is also the founder of the "Istanbul Modern" Museum whose president is Oya Eczacibasi.

Istanbul Biennale 2005

artworks had been removed from the exhibition at the order of the state leader allegedly because of obscene contents," as Ahu Anatmen recalls in his essay on the IB.[104]

104 Ahu Antmen, "Die Bien-
nale von Istanbul", in: "Das Lied
von der Erde" (100) p. 15.

As Istanbul is not Turkey's political capital, it is its financial and economic center and the focus of its cultural life. The special geopolitical and cultural location on the Bosporus makes it a 'bridge' between Europe and Asia and again and again this has been used as a metaphor by the artistic directors of the IB. The city as a historically rich site is also reflected in the selection of exhibition venues. The motto up to the 9th biennial in 2005 was: "Contemporary Art in Traditional Spaces" – which according to Antmen goes back to a suggestion made by Germano Celant, a member of the advisory commission of the first two biennials.[105] The biennial featured tourist sites such as the Hagia Eirene Museum, the Yerebatan-Zisterne, the imperial Mint Complex at the Topkai Palace in 1997 or even the Beylerbeyi Palast in 2001. This selection of historical buildings for contemporary art made the best out of an obvious shortcoming: at the time there were no suitable exhibition buildings, no institutions for contemporary art. An art center such as Platform Garanti was founded in 2001 by the private bank Garanti Bank and its exhibitions organized by Vasif Kortun. The first museum for modern art, Istanbul Modern, was only opened in 2005 – this time, too, as an initiative of the Eczacibasi family.

105 Ibid.

At the 3rd Istanbul Biennale in 1992 Vasif Kortun broke, for the first time, with the practice of using historical sites and having an east-west orientation: *"When I did the third Biennial I wanted to be treated equally. There's a French term "Bon pour l'Orient" or good enough for the Orient. I didn't want that attitude. That was fundamental. Second, I didn't want to use the historical sites for exhibitions because they serve a touristic cognition. The historical town, the Theodosian city is not where the people of the city go. I was very tired of this idea of contemporary art in historical sites, it was over done all over Europe. I had to re-orient the intellectual position of Istanbul. For example, Turkey's proximity to the Balkans and the north used to be overlooked by the vertical order of culture. Under bureaucratic socialism there was a wall between us but we had shared so much past. I felt that the biennial*

must take account of the Balkans and Russians. Also, the reality of the city is that at that time it was full of Romanians and Bulgarians. They came here in the logic of an underground, barter economy, bringing things in their suitcases. This must have its intellectual counterpart, I believed. So, we included Romania, Bulgaria, Russia and tried to include Slovakia, and with the war just beginning in Sarajevo, Bosnia was negotiated but was not possible." [106]

106 Vasif Kortun interviewed by Carole Thea, 2001 http:// vasif-kortun-eng.blogspot. com/2001/10/interview.html (last visited on September 22, 2009)

The 3rd edition was postponed by a year because of the Gulf War and also the 4th biennial took place one year later than scheduled. Whereas Kortun still invited nations to do country presentations, René Block did away this practic at the 4th IB in 1995 and invited artists directly.

Crisis Biennale

"Istanbul began without an ideological or political suprastructure which was decisive for the founding of other more remote biennials," Antment writes. He cites the Johannesburg Biennale (1995, South Africa) as exemplary in addressing questions such as absence/end of Apartheid, Gwangju Biennale (1995, South Korea) for being a kind of catharsis following the student massacre, Tirana Biennale (2001, Albania) for its dialogue. *"Initially, the IB only harbored the hope of coming one step closer to some kind of integration in the West" or to "bring the West to Istanbul."* [107]

107 Antmen (100) p. 16.

The orientation referred to above was unexpectedly reversed at the 6th biennial in 1999 curated by Paolo Colombo, director of the Centre d'Art Contemporain Genf. He named it "Tutku ve dalga", "Passion and Wave" (Passion and the Wave), which was of great symbolic importance for the expectations raised by the 'Biennale'. Sakir Eczacibasi, head of the IFCA, described this exhibition in his preface as the "earthquake biennial." On August 17, 1999 a devastating earthquake destroyed streets, buildings, port and industrial facilities around the Marmara Sea to the southeast of Istanbul. The organizers of the biennial decided to still go ahead: *"Now, more than ever, we are convinced there is a need for the solidarity and solace given by the arts, the pleasure they provide and the confidence they engender,"* Eczacibasi wrote in his preface.[108] And in the official press release he expressed his hope *"that such efforts would contribute to the reconstruction and development efforts needed in the areas struck by the earthquake."*

108 Sakir Eczacibasi, preface to the catalogue of the 6th IB 1999 (64) p. 5.

It can hardly be expressed more clearly. Art served neither self-complacent pleasure nor the desire to know, nor was there any trading with art as initially in Venice, nor was any communication with the outside world sought as in Sydney, Havana and at many other biennial sites. This 6th biennial stood in the service of concrete, national expectation: a sign of solidarity and a beacon of hope, a source of trust and even a gleam of light in the economic crisis. At the same time these expectations were too diffuse to ever be questioned, especially as the Istanbul Biennale initially only had an average of 30,000 to 50,000 visitors. The mission cited above is thus symbolic in a double sense – both in terms of concrete acts and results and in terms of the public addressed. Thus it has been less the curatorial concepts and the selected

works that have been decisive for the continuation of the biennale than the expectations projected onto the event and the functions of local decision-makers.

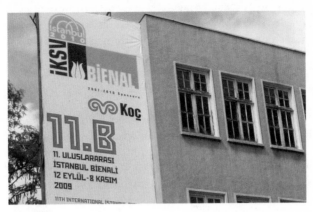

11th Istanbul Biennale 2009, Greek school

The Tulip in the Logo

The concrete expectations are also reflected in the published interpretations of the IFCA logo, an abstract tulip which was also used for the biennale: "*No other logo could have been better suited for IFCA and the Istanbul Festivals, including the Istanbul Biennial. The stylish tulip symbolizes not only the finesse and dignity with which artists from all cultures are embraced in the warm sea of encounters in Istanbul, but also reminds everyone of our passionate belief in the power of art and culture. It is this power, that leads to the crashing of barriers, to the appreciation of 'differences' as 'the riches of our common human heritage', and to a speedy advance from 'the national/local' to 'the universal'*" Melih Fereli, general director of the Istanbul Foundation for Culture and Arts, wrote in the preface to the catalogue.[109] In marked contrast to this emphasis of the "universal" the tulip alludes most notably to the national myths. Fereli relates the ancient saga from Central Anatolia. Ferhad wanted to marry Shirin but to do had to first fetch water from the other side of the mountains (Elmadag). The story has a tragic end since Ferhard learns of Shirin's death and fatally wounds himself. "From this blood, tulips sprang up!" Ever since the tulip has been seen as the flower of passion. Five centuries later Ottoman Sultan became 'enamored' of this flower. Thus the flower to this day has a fixed place in the everyday life of Turks.

109 Melhi Fereli, preface to the catalogue of the 6th IB 1999 (64), p. 7.

Recourse to ancient sagas and acts give the "Passion and Wave" theme and the logo a clear message. The Biennale reinforced national identity and this especially in trying situations. In the afterword the tulip is incorporated in the future of the nation: "*The next time you see a tulip, please take a moment to remember Istanbul and allow yourself a huge ride on the waves of passion this great city inspires.*"

Thus the image of the flower replaces the memory of the earthquake. The threatening 'wave' had been purged of the associations linked to the natural catastrophe and the Biennale inscribed is in an old tradition. This, as opposed to the Venice Biennale, is a central characteristic of the non-Western biennals. It is not the modern breaking with tradition but it rather a continuity is aspired, which is reflected by the historic sites and the tulip logo. However, the appropriation of such symbols hardly lasts due to the pause of two years and the changing directors, themes and exhibition venues.

Istanbul Biennale in the 21ˢᵗ Century

The 7ᵗʰ IB 2001 once again found itself surrounded by crisis. Enormous economic problems, high unemployment and inflation beleaguered the nation. Japanese director Yuko Hasegawa reacted to this by focusing on 'Community' and gave the event a cryptic title: "EGOFUGAL: Fugue from Ego for the next Emergence". Hasegawa addressed issues of globalization, ethnic conflicts, environmental catastrophes and wars, publicly debated questions such as the need for new ways of living and interacting, "co-existence", "collective consciousness", "collective intelligence" and "common dependency" – as an appeal for "co-existent" as opposed to ego-centric ways of living and interaction.

No concrete answers are given to these questions – neither in the conferences nor in the artists contributions. However, it becomes evident that the Istanbul Biennale functions as a forum of public discussion on topical political issues. Increasingly, this exhibition is viewed as the most acclaimed and popular biennial after Venice, which can gleaned from the number of accredited journalists, international guests and worldwide reviews. The IB 2001 attracted 68,000 visitors; in 2005 it was 51,000, and in 2007 91,000 persons visited the 10ᵗʰ IB. The Istanbul Biennale has increasingly established itself as a center of global art that addresses current themes between the poles of politics and economy. In keeping with this partly local, partly global political orientation, the 8ᵗʰ biennial in 2003, curated by Dan Cameron and titled "Poetic Justice", included for the first time Antrepo, a former warehouse, in addition to the historical venues.

Istanbul is no longer a backdrop for exhibitions but a thematic point of departure and reference for the works of art shown here. For the 9ᵗʰ IB in 2005 Vasif Kortun and Charles Esche completely rejected the principle of historical sites as reflecting a 'romanticizing attitude'. Even if this exhibition had the title "Istanbul", there was opposition to an "Istanbulism" that shifts the city's past to the center of perception. Instead, they positioned Istanbul as *"a real, lived place and not a label in the race of competing marketable cities. This biennial is not a tool for selling the city to global capitalism but an agency for presenting it to its citizens and others with eyes turned away."* [110] For this biennial both curators selected seven vacant residences, offices and warehouses, leading the visitors straight through Beyoglu, which was once an embassy neighborhood. More than half of the 53 artists were invited to spend several weeks or even

110 Esche/Kortun, "The World is yours", Katalog 9.IB 2005 (68) p. 24.

months in Istanbul and to develop site-specific projects. In his 80-minute film "Murat and Ismail" Italian artist Mario Rizzi develops a complex portrait of Istanbul in dialogues between a shoe salesman and his adult son. It reflects the changing professions, the inter-generational conflicts, the rapid changes in social values and goals. Comic scenes ranging from the humorous to acerbic were drawn directly on walls by Romanian artist Dan Perjovschi based on detailed observations of specific political issues like the question of the Turkish accession to the EU or tourists rushing to the bazaar and many small, pointed prejudices to which everyone could in some way relate.

As the 9th biennial took place in private and commercial spaces or abandoned buildings, the topic of public space was addressed. In the catalogue Ugur Tanyeli,[111] professor of architecture, elaborates on the dichotomy between private and public in Turkey or in the Ottoman Empire which has its own tradition. For a long time the 'public' was understood more as an extension of the 'inside' of the home to the 'outside' world. While the average man would go to the neighborhood coffeehouses in their slippers, the upper class man would have extra rooms built as an intermediate area between the private chambers and the public space outside or would introduce the profession of an "indoor clerk", a mix between household help and office employee in the home. The imprecise distinction between public and private was also reflected in the "Tanzimat reform" of 1893 when a first attempt was made to protect private property from government interference. At the end of the 19th century the first parks and promenades were built as new places for public social interaction. *"As a result, the fragile balance between the inside and the outside that expanded from the most intimate core in the centre of the house towards the outside, layer by layer gradually to the less intimate zone, to urban space, began to be destroyed."* [112] Yet the following still holds true: *"Public space – by definition – is the ground which is dominated and controlled by the state."* *"Since public space does not belong to everybody, but is a no-man's land, it can be easily diminished in numerous ways."* *"In recent years, almost all the parks in Istanbul und Turkey have become increasingly full of buildings of public use, rather than plants and tress. (…) Limited paths, walking routes, recesses and buildings rigidly control the area. Every activity must be done in the appropriate zone, thus, the public space is disciplined with the tools of architecture."* [113]

The orientation of Hou Hanru's 10th biennial in 2007, which was titled "It's not only possible, but also necessary – optimism in the age of global war" was no longer local but purely global. At the 'Atatürk Kültür Merkez' – a cultural center built in the 1930's located on Taksim Square, which was threatened by demolition in 2007 but renovated in 2009 in preparation for Istanbul becoming cultural capital in 2010, questions of modernity were up for debate. At a center which had many small shops selling textiles, the artworks addressed today's conditions of production and economic developments, and at Antrepo No. 3 the opportunities and dangers of globalization were discussed. Here Hanru succeeded in reproducing the hectic bustle of the metropolis with a loud and dense presentation, showing numerous works full of aggression – e.g., Hamra Abbas' Kamasutra figures with guns, Adel Abdessemed's

111 Cf. Ugur Tanyeli, Public Space/Privat Space: The Invention of a conceptual Dichotomy in Turkey, in: catalogue of the 10th Istanbul Biennale 2007 (69), p. 210 ff.

112 Ibid., p. 218

113 Ibid., p. 220.

sculptures made of knives, <u>David Ter-Oganyn's</u> simulations of time bombs or <u>AES+F's</u> photo stagings of homocidal and suicidal scenes of androgynous teenagers. Over it all lies the sound carpet of <u>Cao Fei's</u> multi-media installation of a new city for 'Second Life' and <u>Fikret Atay's</u> wild roll of drums beating over the roofs of Istanbul.

10th Istanbul Biennale 2004, Fikret Atay, Tinica

Similar themes presented virtually in contradiction of one another characterize the 11th edition of 2009. Instead of extending their view to the entire world, the four Croation curators of the WHW[114] team limited it to the neighboring geographical region. In the catalogue[115] we read that the seventy, largely unknown artists came from a total of forty countries: 26% were from Eastern Europe, 14% from Western Europe, 39% from the Near East, 7% from Central Asia, 4% from Caucasus, 1% from South America, 6% from North America, 1% from the Far East and 1% from Australia. 5% of the total budget of € 2,050,299 went to expenses incurred by the curators; 5% for publications, only 14% to the artists, 27% to operational and advertising expenses, 49% to the exhibition; € 20,000 were spent on cleaning during the exhibition, € 45,000 were the most spent on transport and € 10 the smallest amount spent on insurance. A number of figures and statistics are depicted in the style of the pictorial language developed by Austrian philosopher and sociologist Otto Neurath and German graphic designer Gerd Arntz in the 1920's to take a critical look at the complicated relations in society. The curatorial team used the pictorial language as a reference to the class struggle methods of the 1920's, like the title "What keeps mankind alive?", which is based on Berthold Brecht's question from the Dreigroschenoper "Wovon lebt der Mensch" (What does mankind live on?) At the three exhibition venues – a former tobacco warehouse which had already been used at the 9th biennial; a Greek school which had been closed in 2003 because there weren't enough children; Antrepo No. 3 at the port – gender issues, critique of capitalism,

114 Curators collective WHW (What, How and For Whom) Ivet Curlin, Ana Devic, Natasa Ilic, Sabina Sabolovic.
115 Catalogue from the 11th Istanbul Biennale 2009 (71), p. 26ff.

war and suppression of language were addressed. <u>Zeina Maasri</u> dealt with the civil war in Lebanon, <u>Larissa Sansour</u> had six young men and women discuss the occupation of Palestine while eating Mloukhieh;

<u>Wendelin van Oldenborgh</u> used a film mise-en-scène to reconstruct Holland's responsibility in Indonesia's colonial history and <u>Rena Effendi</u> produced photographs documenting the dismal life along the Baku-Tiflis-Ceyhan Pipeline. <u>K.P.Brehmers</u> visualization of "Soul and Feelings of a Worker" stemmed from the 1970's. One of the highlights was <u>Artur Zmijewski's</u> video installation "Democracia", which shows various gatherings of people on twelve monitors – from football fans, military to Jörg Haider's funeral and border checks in Gaza. Here Zmijewski questioned the boundaries of democratic freedom. In spite of the traditional notion of politics, which the curatorial team used as one point of departure, in the title and in graphics, the exhibition was also able to make good on what is perhaps the greatest promise of biennials in the 21st century. Here we see artworks, unaffected by the western art market, finding strong imagery for profound social issues and changes.

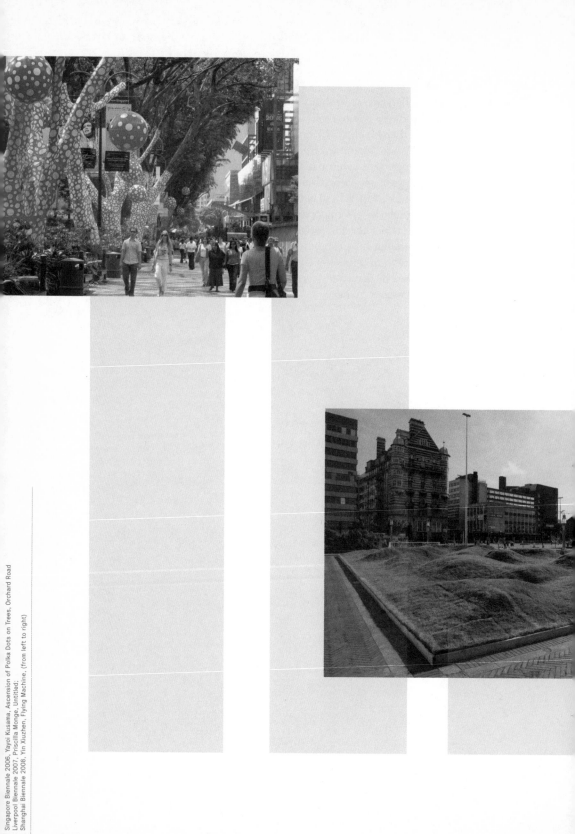

Singapore Biennale 2006, Yayoi Kusama, Ascension of Polka Dots on Trees, Orchard Road
Liverpool Biennale 2007, Priscilla Monge, Untitled;
Shanghai Biennale 2008, Yin Xiuzhen, Flying Machine; (from left to right)

The Second Phase –
Biennials in the Age of
Globalization

New Social and Political Developments

As the most important exhibitions created after the Biennale di Venezia – São Paulo, Sydney, Havana and Istanbul – clearly demonstrate, political aspirations (of the city, the nation, even the curators) influenced not only the idea of the biennial but also each edition. One thing the four biennials had in common was the hope placed in them that these art shows could break a country's cultural isolation. While the exhibitions alone could not bring about such sweeping change, biennials were actually able to overcome "subjective isolation." These events conveyed the impression that a worldwide network exists by promising that national art is part of the latest trends and most recent thinking – a factor that has become even more important in the second phase of the biennials when humanity seems to be growing together to a "world community".

The Enlightenment and the founding of nation states were decisive for the creation of the Biennale di Venezia. For the first biennials that followed in São Paulo and Sydney it was modernity as a hegemonic culture. The second phase in the history of the biennials has thus been politically influenced by globalization and culturally marked by postmodernity.

Postmodernity

The term "postmodernity" designates a state of Western culture and art "after" modernity. The term was first employed in the theory of architecture to refer to the end of strictly functionl architecture and the emergence of playful, hedonist forms of expression. Even if architects meanwhile speak of the "end of postmodernity", their term is still used in the new millennium to describe the current epoch. It is sometimes also called "second modernity" (Heinrich Klotz, Ulrich Beck) or"alter-modernity" (Nicolas Bourriaud).

In the postmodern age the prevailing isms of modernity have yielded to heterogeneity and plurality as a result of multiculturalism, deconstruction and sampling. In art this means negotiating a fine line between local and global contexts, in short, an artistic practice that addresses the context of production and presentation, comes to terms with its own history, does commemorative work and deals with questions of cultural identity, gender and race discrimination, postcolonialism, migration and globalization – all postmodern themes par excellence. The biennials now serve less to construct a reality than to question a cultural identity, no longer manifesting "fraternal unity" or a common canon but allowing for a pluralism of values, ideas and convictions to emerge. In place of modernity's radical breaks with tradition, postmodernity's central question is how to link up with tradition, how retrospectives and contemporaneity can be reconciled. Instead of an enlightened belief in progress with the future serving as a beacon of hope, both the present and the past are seen as reservoirs of themes and ideas. The demand for change and revolution is no longer central. Now the search for certainty and security is front-stage. Processing and research are predominant as artistic methods, and documentary strategies are used to confirm existing and commemorative work as a way to relate to the past. "Context art", which emerged in the 1990's, focused on the historical, architectural and the socio-political circumstances of art and their presentation, exploring how these are constitutive for the works on view. This term appeared in the early 1990's when the stock market crisis resulted in the collapse of the art market and a new form of art emerged from the commercial vacuum. Here everything from the social to the historical and even the architectural context – was declared part of the artwork and socio-political themes were addressed with artistic means. The premise now was that production, information and distribution were all equivalent. Tables displaying catalogues and accompanying literature have since then become part of the repertory of exhibitions as well as lectures, symposia and discussion rounds.

In postmodernity reality increasingly comes into focus; it is documented, researched, archived and constructed. Artists and artists groups such as Hans Haacke or Group Material practice political enlightenment and commemorative work. The Viennese artist group Wochenklausur has expanded social work to also function as art. The term "works" has been replaced by "artistic work" or "artistic practice." Installations integrating the immediate surroundings have transcended the notion of artwork as a coherent formulation. Research and documentation have become artistic methods; text, photography and video now serve as chief tools facilitating new methods of artistic expression. Art is no longer expected to explore new terrain as "avant-garde", to set new trends and to break with the past. Rather, it increasingly goes about reflecting the existing, commemorating the past and creating new connections. In this sense an art presentation is no longer simply a show of the (best) works but rather a tool used to raise awareness.

Liverpool Biennial, Echigo-Tsumari Triennial

One consequence of this radical change in exhibition practice is reflected in the Liverpool Biennale, England (1999) and the Echigo-Tsumari Triennale, Japan (2000). In Liverpool the strategy is to not exhibit works that have been selected in advance but to invite artists to create in-situ projects in direct response to local problems such as migration and drug consumption, high unemployment, crime and entire city blocks of vacant, largely derelict buildings. At the 2nd biennial in 2002 Lewis Biggs noted that Liverpool is one the poorest cities in the EU. In the catalogue of the 3rd edition in 2004, Ronaldo Munck, director of the section for "Globalisation and Social Exclusion" at the University of Liverpool stated: *"Going beyond all the rhetoric of 'participation' and 'social inclusion', the people of Liverpool have not lost hope in a better future and have the political imagination to reinvent the city if conditions allow."* [116] One biennial later Jun Yang refers to this sustained hope in his video installation "For a better tomorrow". The Chinese-born artist who lives in Austria compares the relationships between architecture and migration. The videos show buildings and streets in Liverpool, while the off-screen voice tells the story of Yang's Chinese parents who live in China again and have realized their dream of owning a home. The video ends with the question whether this tomorrow will be global, homogenous – "Are we all dreaming the same dream?" Yang presents mainly the standard two-story workers' tenement buildings. What the artist left out here were the altogether 2,500 magnificent representative buildings that can be found all over Liverpool as vestiges of the former wealth and fame of the city. Directly facing the main train station there are two enormous stone lions in front of the classicist St. Georg's Hall. Rigo 23, an artist living in the USA, had a cage built around the two guards – a compelling image of a city caught between past and present. Humberto Vélez who lives in England addresses a delicate issue in his performance "The Welcoming", in which he has a group of gaily dessed people disembark and go on shore to the beat of drums and the sound of laughter – as a stark reminder of slave trade in Liverpool in earlier times and also reflecting the desire for an affirmative stance on current migration. [117] Several contributions stuck to urban space such as Jorge Pardo's "Penelope" at Woltenholme Square. In the past the ropes of ships used to be put out to dry here – today it is a nightclub district. Pardo placed his playfully decorative sculpture in the center of the square at the 2nd biennial.

What can artists do for a city like Liverpool? They certainly cannot change the economic misery but by addressing historical and topical aspects, by disseminating non-conformist ideas they add unexpected and non-conformist imagery to the dream of a better tomorrow.

A similar desire to create an awareness of regional situation can be found in the Echigo-Tsumari Triennial which takes place in a rural area marked by rural exodus and heavy snowfall in winter. *"The Echigo-Tsumari Art Triennials must be one of the most challenging open-air art projects that attempt to involve international artists in contributing to regional revitalization and rejuvenation. (…)*

116 Ronaldo Munck, catalogue from the Liverpool Biennale 2004 (72), p. 154.

117 Sabine B. Vogel "4th Liverpool Biennale 2006" (119).

So that contemporary art can play a vital part in the rediscovery of human as part of nature. (...) When artworks become catalysts for awareness of space between life and community they become attractions for art journeys that cut across political, religious and racial divides",[118] as Apinan Poshyananda wrote in the catalogue of the 1st Triennial. In keeping with this, Kazuo Katase built a rectangle out of white stones as a reminder of snow in summer. The structures were collected by school chidren and people living in the area. Christian Boltanski hung worn white shirts in a vegetable field to recall all those who once lived here; Alfredo Jaar created a "Culture Box" as the world's smallest art museum in which a Haiku and traditional snow shovels were exhibited together with local photographs. At a winter workshop, Simon Beer built six snowmen, which were then exhibited in refrigerators at a pavilion during the triennial and then subsequently "liberated" to melt away.

118 Apinan Poshyananda, "When Art Journey becomes Pilgramage", in: Echigo-Tsumari Triennale (58) p. 185.

In postmodernity, art makes inroads into public space thanks to such participatory methods. This marks the clear end to a modernity based on abstraction and reduction, which excludes traditions and narratives, thus opening up the visual arts to art and cultural scenes that have until now gone unnoticed. Biennials now no longer serve only as a means to present top artistic achievements, they are also ways to produce and disseminate knowledge.

Globalization

A further significant development in the second phase of biennials is globalization. The political and economic liberalization of many nations, the opening up of international trade relations and capital transactions, the acceleration of communication and transportation through new technologies – all of these aspects have contributed to the enormous biennial boom since 1989.

For all the differences in the definition of "globalization", there is a consensus in literature that it refers to a *"process of accelerated world economic opening"* [119] or an *"increasing worldwide networking of national markets and societies on the basis of technological advances in the realms of information, communication, transportation, traffic and capital as well as the growing liberalization of world trade."* [120] Some authors locate the beginnings of globalization in 13th century Asia or associate it with Columbus and the conquest of the world by Europeans at the end of the 15th century; with the Industrial Revolution in the 19th century or with the collapse of the Eastern Bloc in 1989 when the bipolar world order was overcome, ending the Cold War. According to Peter E. Fässler, globalization is not only predicated on the "erosion of political-ideological barrier of interaction socialism/capitalism", the "erosion of barriers of interaction in the world economy" (inter alia, the WTO – world trade organization) and the "erosion of the barriers of information and communication" (Internet, radio networks) but also on "mass emigration, emergence of a transnational discourse of globalization, globalized entrepreneurial strategies and nation state strategies of regionalization." [121]

119 Marta Stypa (51), p. 9.

120 See Bundeszentrale für politische Bildung (57).

121 Peter E. Fässler (18), p. 155f.

Globalization has both advantages and disadvantages. Referring to an emergent global culture, Gerardo Mosquera stated: *"The greater interest shown by centers in art of the peripheries is a consequence of the demographic processes, globalization and decolonization."* [122] Mosquera speaks of a "global westernization". *"The degree of diffusion of this 'westernization' is concomitant with its own weakening, for it is connected with an adaptation. The power strategy today does not consist of suppressing the differences and homogenizing them but of controlling them. In the wake of the Cold War culture takes place between two poles where there is a power struggle between hegemonic and subaltern forces."* In the new millenium this "power play" is clearly reflected in the art market when at auction houses one national art scene after the other is presented as a new sales hit. After China came India, then art from Iran and shortly afterwards art from the "Middle East" region. In this same period the biennials, by contrast, reflect an ever greater awareness for regions: at the Sharjah Biennale in 2008 the focus was on Southeast Asia, at the 53rd Venice Biennial a central Asian country pavilion participated and the curators for the 11th Istanbul Biennial invited artists from the region around Turkey ranging from Eastern Europe to the Middle East.

Mosquera makes a case for *"changing the system of circulation of exhibitions, which means active participation of peripheries in propagating their own art, against the dominant centralism"* as Peter E. Fässler noted.[123] Precisely this is possible with biennials since they are not conceived as being one or the other, either center or periphery, regional or global, but are pluralistic in a postmodern sense, that is to say, they only function between the poles of center and periphery, local and global. This applies equally to countries and cities, as the development of biennials in the second phase has led to a global art that is neither limited to Western centers nor to political and/or cultural capitals.

Locality

Arjun Appadurai also addresses the tension alluded to above, introducing the term "locality" to the discussion. *"The problems of cultural reproduction in a globalized world are only partly describable in terms of problems of race and class, gender and power, although all of these issues are certainly crucial. An even more primordial fact is that the production of locality which, as I have argued, has always been a fragile and difficult achievement, is now more than ever shot through with contradictions, destabilized by human motion, and displaced by the formation of new kinds of virtual neighborhoods."* [124] Hou Hanru takes up the term in his contribution "Towards a new locality: Biennials and 'global art'" and describes "locality" as a "product of the confrontation and negotiation of the locale for the neighborhood with the global (the 'Other')."[125] In "locality" he sees a challenge: *"The process is automatically one of breaking down and reestablishing territorial borders as well as cultural boundaries at large, whether they have been recently politically determined or historically granted."* [126] Herein lies a central distinction with the art of modernity, which on the one hand aims at radical breaks, but on the other manifests the hegemony of a geopolitical region and thus establishes political boundaries in culture as well. Global art, by contrast negates, ignores

122 Gerardo Mosquera (114) 1995, p. 41.

123 Ibid., p.45

124 Arjun Appadurai, "Modernity at Large: Cultural Dimensions of Globalization", Minneapolis, University of Minnesota Press, 1996, p. 198, quoted from Hou Hanru, "Towards a new locality: Biennials and 'global art'", in: Manifesta Decade (23) p. 58.
125 Hanru (23), p. 58.
126 Ibid.

and destabilizes boundaries drawn by a state – recall the confusion caused by the participation of Taiwan and Palestine in São Paulo and Venice, where, for political reasons, they were not permitted to have "country pavilions". Moreover, the transnationality of artists blurs their cultural and political affiliation.

For biennials the following applies: *"Events like contemporary art biennials, initiated by local authorities to promote the position of locales on the global map, are then global events by nature, while they claim to be locally meaningful and productive in terms of new localities. (…) The new localities that have emerged are definitively impure, hybrid, and therefore innovative. Accordingly, the question of culture identity is no longer based on the logic of the nation-state. Instead, it is about transnationalism, and identities themselves continuously transform."* [127] For all his criticism of globalization, Hanru views biennials with guarded optimism as a forum of a "new global culture".

"Locality" can also be seen as a bridge between tradition and the present day. "Local" here is the context which international curators thematically link with global aspects. Ever more frequently regional and international artists are invited to create commissioned works which address an existing situation as in Liverpool or at the Echigo-Tsumari region. Jack Persekian went one step further in this direction in the 9th Sharjah Biennale in 2009. Following a public call for projects the curatorial team [128] selected 29 projects from the 250 works submitted; they were subsequently financed and produced by the Biennale. The decisive criteria for selection of the works was not how well-known the artist in question was but rather the quality of the work and the way the location related to the concept.

Transnationality

Whereas the invention of the biennial was influenced by the formation of nation states, the second phase is marked to a growing extent by a massive criticism of nations and the very concept of of nationality. In the first phase of the history of biennials the artists were regarded as representatives, like athletes, and their works were seen as serving the function of an ambassador. In the second phase, however, this status has come under attack. And the idea that a country is sovereign as far as its economy is concerned has become an illusion in the face of the global nature of the economic forces at work.

In his introduction to the catalogue of the 8th Istanbul Biennale Dan Cameron speaks of the transnationality of artists whom he describes by recourse to *"the notion of global citizenship."* [129] In sociology, transnationality refers to the diversity of cross-border social, economic and cultural connections that migrants maintain in the host country and in their country of origin, *"which neither the state nor any sort of larger institution (such as confession or corporation) can represent."* [130] "Transnational" is thus applied mainly to relationships between private individuals. "International", on the other hand, refers to the

127 Ibid., p. 59.

128 Jack Persekian (artistic director), Isabel Carlos (curator, exhibition "Provisions for the Future"), Tarek Abou El Tetouh (curator, performance and film, "Past of the Coming Days").

129 Dan Cameron, catalogue of the 8th Istanbul Biennale 2003 (66), p. 20.

130 Paloma F. de la Hoz (28), p. 8.

connection between states, whereas "multinational" refers to the relations between large universal institutions such as churches or corporations.

Since most biennials require that an artist's nationality be named, the changes referred to above can easily lead to the identity of an artist becoming blurred. This can happen when immigrant artists act as representatives of their country and perhaps even address this fact in work, while actually living in a different country and addressing their national culture as reflected in their transnational situation.

The work of Shirin Neshat (Iran/USA) or Lida Abdul (Afghanistan/England) is based on transnationality. The preoccupation with questions of cultural identity also often forms the basis of their formal and thematic repertory. Shirin Neshat's films focus again and again on the social rituals, problems and constraints of her home country. Lida Abdul responds directly to the political situation in Afghanistan when she paints the ruins of a building white and then has it torn it down brick by brick – in symbolic allusion to her home country. *"In my work, I try to juxtapose the space of politics with the space of reverie, the space of shelter with the that of the desert; in all of this I try to perform the 'blank spaces' that are formed when everything is taken away from people,"*[131] Lida Abdul wrote referring to her video "White Snow" in the catalogue published on the occasion of the Gwangju Biennale in 2005. She summarized the position of transnational artists as follows: *"These artists are the wandering souls of the world who move from one place to another making art that witnesses, challenges and possibly mediates in ways that escape the typical military logic that works perfectly with global capitalism. (…) A certain nomadism affords them perspectives that bring out the fault lines of the fictive identities that nations continue to create."* [132]

131 Gwangju Biennale 2004, (62) p. 136.

132 Ibid.

Global Art and Contemporary Art

Considering the importance of globalization for the history of the bienni-als, the often addressed oppositions of center vs. periphery, global vs. local, which are so central to the second phase of this type of exhibition, it seems appropriate to adopt a new terminology that does not make a geographic and geopolitical distinction between Western and non-Western contemporary art.

Since the 1990's 'global art' or 'global culture', 'world contemporary art' or 'world art' have become new catchwords. Even during the Enlighten-ment there was talk of 'world literature', which referred to a literature that was known beyond regional and national borders. In his dialogues with Eckermann in 1827, Johann Wolfgang Goethe declared all works created in a supranational, cosmopolitan spirit to be "world literature". Accord-ing to Claus Volkenandt "world art" was mentioned for the first time in the eponymous German art journal (Weltkunst) in the 1930's. However, in his introduction to "Kunstgeschichte und Weltgegenwartskunst" (Art History and Contemporary World Art)[133] Volkenandt questions the term's claim to universality. He objects less to 'world' than to the 'transcultural ideal' of 'art', which represents one uniform idea that has been shaped by the West. Refer-ring to Hans Belting, he argues that non-Western cultures and their art have been viewed "always in the mode of a Western understanding of art".[134] Here "art is employed as a sort of hypervalue." The West's notion of art is insepa-rably linked to the Western understanding of culture and western value sys-tems – the idea of an "ars una" is thus always a kind of cultural appropriation: the "universalization of an idea shaped by the West."[135]

Volkenand speaks instead of "contemporary art as seen from a world per-spective." In the same volume Kitty Zijlmans[136] expresses the same idea with similar reserve, when she makes the case for an "art history in global per-spective" with a focus on an interdisciplinary approach. Markus Brüderlin[137] in contrast sees in the notion of "world contemporary art" an opportunity for globalism and localism to relate in a dialectic way.

133 Kunstgeschchte und Welt-gegenwartskunst (34), pp. 11-30.

134 Ibid., p. 18.

135 Ibid., p. 19.

136 Kitty Zijlmans, "Die Welt im Blickfeld. Unterwegs zu einer global orientierten Kunstge-schichte", in: Kunstgeschichte und Weltgegenstandskunst (34), p. 243 ff.
137 Markus Brüderlin, "West-kunst – Weltkunst. Wie lässt sich der Dialog der Kulturen im Aus-stellungskontext inszenieren?", in: Kunstgeschichte und Weltgegen-wartskunst (34), p. 121 ff.

Here the notion of "world" can also be quite problematic. Niklas Luhmann, for instance, emphasizes the non-observability of the world.[138] The term 'world music' coined at the end of the 20th century was supposed to refer to non-Western music. In the visual arts, "world" can lead to misunderstanding, since this term is intended to do away with the polarity of West vs. non-West and to reflect the end of the hegemonic position of Western art or culture. By contrast, the term "global art" is associated with globalization and its opportunities and disadvantages. "Global art" also points directly to a development that is significant for art shown at biennials, one that Bernd Wagner has called a "non-traditional renaissance of the local." *"In the process of de-localization through global art and re-localization in which a new link is created with the past, local cultures dissolve their fixation on a specific place without completely breaking the connection and become elements of global art offerings."* [139]

Hans Belting takes a critical stance in his text titled "Eine globale Kunstszene?" (A Global Art Scene?) ,which was published in an issue of the art journal nbk (neue bildende kunst) with the title Das Marco Polo Syndrom (The Marco Polo Syndrome) in 1995. Belting is skeptical of the idea of *"universal art"*, because *"it is only a liberal variant of the old hegemony in a western usage. There is no universal conceptual scheme for the diversity of cultures because each conceptual scheme is shaped by culture, in particular in the West where one still believes that one can cite other cultures because one has invented the idea of humanity."* [140] In his contribution "Hybride Kunst? Ein Blick hinter die globale Fassade" (Hybrid Art? A look behind the global façade) published in the catalogue Kunst Welten im Dialog. Von Gauguin zur globalen Gegenwart[141] he elaborates on this point, adding *"because each conceptual scheme is culturally, that is to say locally bound"* and speaks of the *"world as a global marketing area"* as a result of capitalism.[142] Belting questions whether we are willing to deal with non-Western art or even take it seriously – this touches on *"principal decisions of cultural practice and the art market."* [143] How do people approach non-western art in our museums? *"The museums of ethnography provide in-depth information on the conditions and context of a collection piece, while the art museums limit their information to artists ant titles of works."* [144] Don't we "subject" non-Western art to our Western mode of presentation? *"Yet we still obliviously view 'art' as a transcultural ideal on the basis of which we can measure all cultures under the same conditions."* Here Belting points to the difference between our static presentation of art, between museums as *"cemeteries where corpses are venerated as art"*, and the African *"thing-oriented practice"* which invites the visitors to actively participate. *"It is not just a question of the meaning of art production but also of the meaning of an art exhibition in Africa."* [145]

Not only is there a lack of agreement about the concept of global art but the expectations placed in a global art and its possibilities are also viewed critically. Hans Belting states that the central problem of "global art" is that *"our art"* is defined by a *"thoroughly idiomatic art history that is lacking in other cultures, just as modernity does not have a history or at least a different culture there. Seen superficially it thus seems that in other cultures art can only be made in a western sense or no art at all."* [146] The question of the existence of a modernity in

138 Niklas Luhmann, "Weltkunst" (37), p. 7-45.

139 Niklas Luhmann, "Weltkunst" (37), p. 7-45.

140 Hans Belting, "Eine globale Kunstszene? Marco Polo und die anderen Kulturen", in: nbk (9), p. 13.
141 Belting, in: "Kunst-Welten im Dialog" (10).

142 Hans Belting, (10) p. 324.

143 Ibid.

144 Ibid.

145 Ibid., p. 326.

146 Hans Belting (8) p. 51.

different, non-western cultures is certainly also a question of the dissemination of information, since as soon as exhibitions and publications are globally available, their "history" can be studied everywhere.

How is non-Western art presented in the West? Two exhibitions at the end of the 20th century are significant here: Primitivism which was shown in New York in 1984 and Magiciens de la terre which took place in Paris in 1989. Both exhibitions represent the hegemonic status of art in the West and the beginnings of global art. Whereas with *Primitivism in the 20th century art: Affinity of the tribal and the modern, New York* (1984) an attempt was made to confirm the old order one last time, *Magiciens de la terre at the Centre Pompidou in Paris* (1989) tried to find a path to a new global order.

Primitivism and Magiciens de la terre

A very controversial exhibition took place at the Museum of Modern Art in 1984. In *Primitivism in 20th century art*: Affinity of the tribal and the modern,, the prejudiced gaze of modernity was once again on prominent display. Curator William Rubin[147] traced affinities between tribal culture, represented by 200 objects, and modernism, with approx. 150 works, for the sole purpose of asserting the dominant role of modern Western art.[148] Rubin thus confirmed the worldview expressed by Karl Woermann as early as 1904 in *"Geschichte der Kunst aller Völker und Zeiten"* (History of Art of all Peoples and Times)[149].

Magiciens de la terre

Woermann distinguished between natural and cultural peoples, between inferior applied and folkloric art as opposed to the more appreciated Western art which is self-reflexive and autonomous. The author ascribed mainly religious functions to art from outside of Europe – a view shared by ethnology and anthropology from which the manner of presentation was adopted. Non-western objects were exhibited without any reference to the artist except for location and tribe. Geographic or tribal ascriptions were cited and several objects were depicted in the catalogue like historical findings in small format on just one page. In his book "Negerplastik"(1915), Carl Einstein, though, did show appreciation for the aesthetic qualities of primitive sculptures, and Eduard Trier, too, tried in his text "Moderne Plastik von Auguste Rodin to Marino Marini" (Modern Sculpture from Auguste Rodin to Marino Marini)[150], published in 1954, to apply the criteria of art history. However, both always used examples from the past, which were also seen as representative of their respective countries of origin. The authors were not familiar with any modern art from outside of the Europe and if it was not from Europe it did not interest them.

147 William Rubin (1927-2006) was chief curator (from 1967) and later director of MOMA New York.
148 Cf. extensive reviews and critique by Ludy R. Lippard, Kunstforum, vol. 118 (105) p. 162; Thomas McEvilley, Kunstforum, vol. 118 (118) p. 176 ff.
149 Karl Woermann (55).

150 Eduard Trier (53).

The first exhibition in the West where non-Western art was exhibited on a par with Western art was Magiciens de la terre held at the Paris Centre Pompidou in 1989. It was to be both internationally recognized and influential. After four years of preparation the curator of Magiciens, art historian and director of the Centre Pompidou Jean-Hubert Martin, presented more than a hundred "world artists" from Alaska and Australia, Arizona and China, West Africa and South America. While Lucy Lippard wondered whether it was an "*exploitation of global art*," [151] Thomas McEvilley, in the same volume of Kunstforum, stated that Magiciens had "*embodied the hope of finding a post-colonial way to exhibit works of artists from the First and Third World in one show, a way that would not entail projections on hierarchy or on a goal-oriented history.*" [152] Fifty Western and fifty non-Western artist were exhibited without any overriding cultural value judgments, and contrary to Primitivism the artists were not anonymous, nor were the works undated but exhibited on a par with other art and identified. For the first time, this did not mean that these works were simply a footnote to Western culture. Martin, however, did not base his selection and presentation on a thematic concept, but only underlined formal similarities. Co-existence on the basis of thematic affinity was only found at the international biennials that were beginning to take place in different parts of the world.

Contemporary Art

Three years later Vasif Kortun explicitly cited the Magiciens as the first postcolonialist mega-exhibition on the occasion of the 3rd Istanbul Biennale he curated in 1992. In an interview he gave several years later he criticized J.-H. Martin's selection process: "*You know, not all cultural translations in the so-called third world are colonialists, self-colonizing agents, or culturally dominant elites. There are people you can trust, they totally overlooked this fact. As if post-colonial thinking can only be perceived by Europeans and Americans! Secondly, they chose all their magician 'others' from non-urban situations or paradigms. Hey, the so-called third world is the new urbanism!*" [153] This disequilibrium stemmed from modernity's way of thinking. In global art, by contrast, the poles – center and periphery, east and west, etc. – are no longer seen as significant or have lost their hierarchical status. This development is encapsulated in the short expression 'contemporary art'. Since then almost every biennial has added this epithet to their title.

'Contemporary' means much more than a measure of time. It has a programmatic function. In a conversation with artist <u>Akram Zaatari</u> and curator Tirdad Zolghadr about the exhibition Ethnic Marketing, Iranian filmmaker Hassan Khan said the following: "*Yes, but you're still implying art and artists from 'other places'. (…) If contemporary art is an absolutist term, which it is, then there are no 'other places' to begin with. To frame them as such is to push them out of the actual production of knowledge.*" [154]

The epithet 'contemporary' tacitly implies "international" and clearly separates itself from "modern art", which is geographically limited to centers

151 Lucy Lippard, Kunstforum (105) p. 163.

152 Cf. McEvilley, Kunstforum (105) p. 175.

153 Vasif Kortun, interview with Carole Thea 2001, http://vasif-kortun-eng.blogspot.com/2001/10/interview.html (last visited on September 22, 2009).

154 Conversation between Hassan Khan and Akram Zaatari and Tirdad Zolghadr, Ethnic Marketing (17) p. 89f.

in Western Europe and the USA. It adheres to a strict formal canon on the basis of which all works are assessed and too many are excluded for being derivative. 'Contemporary art' also requires cultural decentralization, since artworks and artists are part of global development. It also alludes to an overcoming of the "archaeological gaze", which is focused on exotic discoveries instead of exchange and dialogue. *"The visual arts today have a global, social meaning that is completely independent of formal aesthetic views. The visual tradition of a culture embodies the image that it has of itself. In addition (…) art (…) the feeling of a society, for its identity, and makes its value and place in the world visible. Seen in this light, art aims at much more than aesthetics,"* [155] as Thomas McEvilley writes in his essay "Weltkunst – interkulturelle Ausstellungen"(World Art – Intercultural Exhibitions), which was first published in the American art journal Artforum in 1990 and then translated into German in 1992 for the Kunstforum volume on "Globalkultur". Art addressing society – it is precisely this aspect that becomes manifest in the biennials of the second phase, when their focus started shifting towards raising awareness and transferring knowledge.

155 Thomas McEvilley, Kunstforum (105), p. 280.

Biennials of the 1990's

In the 1990's the field of contemporary art changed dramatically. Not only did the number of art dealers, museums, art centers, art markets and auctioning houses rise steeply, but also the number of art journals and exhibition reviews in daily papers. The 'art world' continued to grow, there were ever more players, venues and visitors. Video and photography were becoming artistic media in their own right and were increasingly taken for granted as an integral part of each exhibition. This, in turn, enabled many artists to critically respond to social and political issues with documentaries or docufictions. These new media whose use could be easily learned, the exhibition of installations created on-site, and the sensitization for minorities – read political correctness – all contributed to the ongoing biennial boom of the 1990's. The intricate interconnections, however, would merit a separate discussion; in the following we will take a closer look at the basic underlying structures of these developments.

Biennials in Africa

DAK'ART

The DAK'ART in Senegal and the Johannesburg Biennale in South Africa were founded in the early 1990's – in a period marked by the end of apartheid. The "Convention for Combatting the Crime of Apartheid" was established as early as 1976 but it was only in the early 1990's that the remaining discriminating laws of racial segregation were abolished. In a popular referendum held in March 1992, 68.7% of the white population endorsed the abolishment of racial segregation, and in April 1994 the first elections took place. On May 10 of the same year Nelson Mandela assumed office as South Africa's first black president.

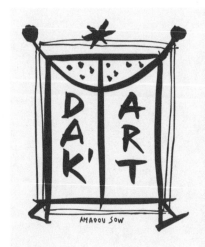

Logo DAK'ART

In 1992 the Biennale de l'art africain contemporain à Dakar, Sénégal, DAK'ART for short, was founded. As so often, this biennale, too, aimed at establishing national art on the international art market. The themes of the first biennials which took place at the Musée de l'IFAN Place Soweto, were "African Art – Continuity and Change" and "Encounters with African art". DAK'ART is a pan-African biennial. Secretary general Amadou Lamine Sall compared the event, not without some irony, to the carnival in Rio de Janeiro.[156] He invited artists from Senegal only and with a budget of 3.3 millon French Francs limited participation to "two works and two square meters per artist." Subsequent editions the DAK'ART have been open to artists from other African countries.

156 Interview with Amadoi Lamine Sall, (125) p. 353.

Unlike most other biennials, the curators do not travel to countries to find artists. Instead, in addition to specific invitations, there is an open competition to which any artist of African nationality can submit his or her own material, which is vetted by an international jury. Seven curators were invited to the 4th biennial – five of whom were from Europe – and from the 300 works submitted only twenty-one artists were selected. In addition to the exhibitions and honorary exhibitions there was a salon for African design and at the 6th biennial in 2004 there was also exhibitions organized on private initiative in the DAK'ART OFF.

Senegal was under French colonial rule before it became autonomous in 1958 and independent on June 18, 1960. The first freely elected president was Léopold Sédar Senghor who introduced an ideology of "negritude" which was "a reassessment and recognition of the Black race and of the 'African soul',[157] a reflection of pre-colonial history and culture. Some of its offshoots were the establishment of a national school of visual arts, a national gallery for contemporary art and the Musée Dynamique, in which alternating exhibitions of contemporary art take place. Since Senghor stepped down in 1980, art has been less controlled by the state, but it also received less support. A similar "state art" is endorsed in Zaria, where artists are trained in academies "which represent the image of a liberated country at home and to the world public".[158] In socialistically oriented countries of Angola, Ethiopia, Mozambique, by contrast, the influence of socialist realism prevails, and art students are sent to the "Eastern bloc" or to China. Thus the artists are caught between conformity and experimentation, between promotion and secure prospects in their own country and the insecurity of pursuing their individual paths.

157 Jutta Ströter-Bender (50) p. 138ff.

158 Ibid., p. 23.

This "state art" co-exists with so-called "Airport Art" – objects of traditional cultures that are created as souvenirs for travelers, reduced to the size of a handbag. As both references to cultural-historical manifestations as well as secularization and profanization of religious and cultural-historical models, one finds Ethiopian popular painting, glass painting in Senegal as a reaction to the ban on Islamic devotional pictures that was imposed by the French at the beginning of the 20th century; the Makonde carvings and square-format painting from East Africa, the Massai masks in Kenya – *"traditionally the*

Massai were not familiar with mask carving art." [159] This mix of state-dictated "tradition" and commercially successful handicrafts has produced an image of African art which also Hans Belting takes recourse to when he writes: *"In art the theme of other cultures cannot be separated from the question of indigenous traditions which, in the case of Africa or Polynesia, we have classified as primitive or tribal art."*[160]

In reality – and this can be clearly seen at the DAK'ART – contemporary artists oppose such ascriptions and do not want to accept how we as western observers perceive the artists there. Similar to Latin America, Asia and Europe *"the artists analyze their present identity and describe it as a collage of disparate fragments of tradition, fading memories as well as ethnic reflexes some of which are as foreign to them as to a western onlooker,"* as Lydia Haustein wrote in her review of the 45th DAK'ART.[161] As she observed: *"With the assemblages of diverse materials that are put together out of found or manufactured objects, historical pieces and pictures or masks, they address the reciprocal relations between racism and sexism, forms of poverty and omnipresent violence."* [162]

Johannesburg Biennale

The 1st Johannesburg Biennale was announced four months prior to the first elections and opened in 1995, one year after the elections. In his catalogue text, Arthur C. Danto wrote about the first biennale as follows: *"The exhibition of art has made itself available as part of the symbolic language of political gesture in the international sphere."* [163]

As so often before, the desire to break political and cultural isolation and to step out of a marginal position into the "art arena" was central here as well. As the press release stated the Johannesburg art exhibition was to *"celebrate South Africa's long overdue re-entry into the international visual arts arena"* and *"to establish Johannesburg as a world-class city."* And Christopher Till, director of the Biennale and of the Greater Johannesburg Transitional Metropolitan Councils, expressed the expectations in his preface: *"The biennale will bring to South Africa's shores the debates, arguments and examples which characterize the nature of contemporary art. It is hoped that the concerns and works of artists on the so-called margins will make a strong impact at an event which attempts to move the margins into mainstream."* [164] And Lorna Ferguson, coordinator of the Biennale and former art dealer put it as follows: *"The notion that art should find its place not within artificial constructs of politics but between the street and the museum is a prime intention of the biennale."* [165]

300 artists from 62 countries were invited to participate. Most countries financed and curated their own contributions. Australia featured the exhibition "Mistaken Identities", Cuba "A Cuban battle…", Chile "Without Frontiers", India "Dispossession", and Taiwan "Controversy with the Golden Sun". According to the Biennale Report the event garnered 150 international press releases and yields of R. 15 mill in foreign currencies.

159 Ibid., p. 39.

160 Belting (10), p. 328.

161 Lydia Haustein, (126) p. 74f.

162 Ibid.

163 Arthur C. Danto, catalogue of the 1st Johannesburg Biennale 1995, cited from McEvilley (189).

164 Christopher Till, catalogue of the 1st JB 1995 (p. 7), cited from McEvilley (189).

165 Lorna Ferguson, cat. 1st JB 1995 (p. 11), cited from McEvilley (189).

Yet notwithstanding such success stories the event was broken off the second time it took place and discontinued.

Okwui Enwezor, who, in 2002, became director of the 11th documenta, was responsible for the 2nd Johannesburg Biennale in 1997. In the show he titled "Trade Routes – History and Geography", he did away with the national presentations and invited five international curators to become part of his team. After a month of showing the exhibition was closed "due to financial problems of the City of Johannesburg", as was officially stated. No further biennials followed and the office that had organized the biennale, the Africus Institute for Contemporary Art (AICA) was also closed.

"The power of the Biennale also resides in the dimension of the conflict potential in South Africa. Thus Johannesburg seemed to be ideally suited for focusing on the problems of globalization," [166] as Armin Medosch described the special relevance of this Biennale. By the same token, this also implied the danger of overly high expectations – since the biennial was to serve as a platform both for African artists and for dealing with historical and political issues. Manthia Diawara addressed the general fear of a homogenization *"and totalizing tendencies in contemporary conceptual art and video"* [167] and Medosch criticized the lack of communication between the Biennale and the city of Johannesburg on problems of poverty and street crime. In spite of this criticism and the fact that it ultimately failed, the Johannesburg Biennale became one of the best-known exhibitions, which in the final analysis was certainly thanks to Enwezor's 2nd biennale. It ushered in a debate on post-colonialism in contemporary art – and with this the "question of meaning" raised by Belting is finally answered: it is less a question of the mode of presentation than one of necessity.

In the first catalogue of the 1st Johannesburg Biennale in 1995, Thomas McEvilley stated that these exhibitions were a signal for *"the emergence of previously marginalized cultures into the international discourse – a signal that they are beginning to see themselves not as margins but as centers"* [168], and he proceeded to analyze the function of art: *"First, art digs into the taboo and repressed materials of its culture's history and identity, drags them to the visual or semiotic surface, and forces a confrontation with them; this might be called its psychoanalytic function. Second, it analyzes, critiques and redefines the communal identity around these images and issues; this might be called its social function. And finally, through a mechanism like the international biennial exhibition, it presents this critiqued and redefined persona to the outside world in a kind of ambassadorial function."*

Art playing the role of an emissary – this was the mission of culture from the very first biennial. However, in the second phase these "ambassadors" no longer stood in the service of nations but of a mission – that of global art. This art, which was defined in neither national nor geographical terms, did not try to join forces as in modernity/modernism (in a nation, a group of artists, a stylistic movement). Rather, it allowed for polarities, by underscoring the interplay between local and global issues and cultures, between traditions and the present day.

166 Armin Medosch (190).

167 Manthia Diawara, "Moving Company: the Second Johannesburg Biennale", in: Artforum (191).

168 Thomas McEvilley (189).

Whereas the African biennials had an international orientation from the very outset, albeit with a regional focus, the biennales in Sharjah, Taipeh, Shanghai and Gwangju were at first purely national.

Sharjah Biennial

Approx. four million people live in the Emirates on an barely 84,000 sq. km., 90% of it desert. 70% (some say even 90%) are foreign workers without any legal rights. Thanks to its enormous petroleum and natural gas resources, the former Beduins, fishermen and pearl divers have succeeded in transforming the Emirates of Dubai, Abu Dhabi and Sharjah into attractive holiday destinations. Tourism began in the 1970's in Sharjah which is rich in history. Ten years later the Saudi king imposed a strict ban on alcohol – still valid today – which led to a massive drop in tourism.

Sharjah is the third-largest of the seven autonomous emirates which have merged since 1971 to form the United Arab Emirates. As early as the late 1960's the ruler of Sharjah, H. H. Sheikh Dr. Sultan Bin Mohammed Al Qasami began to put the emirate on the cultural map, when he had a well over 100-year-old fort reconstructed. Today Sharjah has more than 32 museums and a rebuilt historical "city center". Apart from an interest in its own history, shown in a collection of black-and-white photographs from the 1930's, the period of British occupation, and establishing the Museum for his collection of Oriental art, the Sheik also supported the Sharjah Biennale founded in 1993. At the beginning local art based primarily on classical genres was shown, but since the 5th biennial in 2002, the Sheik's young daughter has lifted the event to an international level. Sheikha Hoor Al-Qasimi, trained in London as art historian, invited Brigitte Schenk, an art dealer from Cologne, Germany and Peter Lewis, professor at Goldsmiths College in London, to serve as curators of the biennials in 2002 and 2003, respectively. Since 2005 the biennial has been curated by Jack Persekian, founder and director of the Al-Ma'mal Foundation for Contemporary Art in East Jerusalem, an institution for contemporary Palestinian art.

From its inception on the biennial was held at the Sharjah Art Museum and at other locations, like the fair hall. For the 7th biennale, Persekian, together with his team, selected as theme "Belonging (Where do I belong?)" [169] The 69 participating artists addressed issues such as dislocation, diaspora, emigration, inclusion or exclusion mainly on the basis of a documentary approach. Various persons relate their traumatic fate that os symptomatic for individuals in diaspora in the video projections of Italian artist Mario Rizzi. In his video, Canadian artist Jayce Salloum. Solvey Dufours asked Danes why they supported Palestine with a benefit dinner. Maja Bajevic photographed building and streets in Sarajevo that appear innocuous in Christmas lighting but are marked by the ravages of war.

169 Sabine B. Vogel, "7th Sharjah Biennale", Spike (247) and www.artnet.de (241)

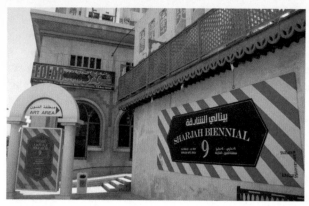

9th Sharjah Biennale 2009

As the theme of the 8th biennial Sheikha Hoor Al-Qasimi selected "Environment, art and ecology". Jack Persekian and his team invited 79 artists, most of them from non-Western countries, who produced their works especially for this biennale. "Art that matters" was the title that the local daily "Time Out" gave its report on the Biennial on April 5, 2007, thus capturing the essence of this event. What was presented was highly compelling imagery and the most striking motif was destruction. Peter Fend addressed the pollution of the Persian Gulf, Cornelia Parker hung burnt branches from a forest fire in the space, Michael Rakowitz's wall diagram on the destruction of date palms, Mona Hatoum's steel world globe "Hot Spot" with red neon that depicted the world as a danger zone. As both stock-taking and critique, Huda Saeed Saif documented a mountain region in Sharjah that had been leveled for stone and rubble. Maha Mustafa presented a large, frozen surface titled "Landscape Minus 37" where even the slightest touch left behind traces. As a response to the dilemma that as a form of elitist art tourism biennials are by no means a model of ecology, Tea Mäkipää who arrived by bus, train and boat, created her "10 Rules for the 21st Century", which are directed against automobile and plane traffic, plastic products, non-recycled waste and air conditioning.

Competition in Dubai and Abu Dhabi

Sharjah Biennale provides instructional material for school children. Here art history is founded and studied, an art scene created – and this invariably triggers demands for social freedoms and changes. In his text on the 8th biennial Werner Bloch reported on an art student at the Academy of Sharjah who *"submitted her final project on bulimic models – a painting that was entirely body-focused"* [170] – and was not censored. A further change had to do with the positioning of the Emirates. While the 6th Sharjah Biennale was almost totally unknown as the only forum for contemporary art in the Emirates, the exhibition met with massive competition at the 8th biennial in 2007. Dubai and Abu Dhabi also corrected their profile, which was geared to shopping and beach tourism and began to create an infrastructure for contemporary art. The Gulf Art Fair opened in Dubai in 2007 and in no time at all time it was able

170 Werner Bloch,
Süddeutsche Zeitung (245).

to establish itself as one of the leading art fairs with its exceptional blend of galleries from old western and new-western art centers. In Dubai the number of galleries quadrupled in little time and for the first time a gallery district for contemporary art emerged. At Abu Dhabi's luxury hotel Emirates Palace where in November 2007 a – albeit hardly noticed – art fair (in collaboration with the French art fair FIAC) also took place in November 2007. In 2008 the cooperation with the Paris Louvre was announced and plans for a spectacular project presented. On the natural Saadiyat Island, construction of five large museums is planned by 2012, in addition to the many hotels and villa subdivisions. Initial plans for 19 biennale pavilions, however, soon had to be given up. At the 54th Biennale di Venezia in 2009, Abu Dhabi announced its first-time participation with two presentations. Placed prominently on the Arsenale grounds, Abu Dhabi financed the national "UAE Pavilion" curated by Tirdad Zolghadr, with an exhibition titled "It's Not You, It's Me" featuring work by artists from the United Emirates, and the "ADACH Platform for Venice" (Abu Dhabi Authority for Culture & Heritage) curated by French curator Catherine David. Zolghadr, who had also collaborated in the team of the 7th Sharjah Biennale, also presented a planning model of the Saadiyat Island.[171] Here it could be seen that in the meantime only four museums were still planned – the Maritime Museum by architect Tadao Ando, the Guggenheim Abu Dhabi by Frank Gehry, the Saadiyat's Performing Arts Centre by Zaha Hadid, the Classical Museum previously also known as Louvre Abu Dhabi, by Jean Nouvel. The National Museum has been omitted. 400 mill euro alone has been approved just for the Classical Museum, in which works from the Paris Louvre will be presented in the desert city. Abu Dhabi's close collaboration with France is based both on culturaland military interests. Decided on at the beginning of 2008 and opened in May 2009, a naval base is now being maintained by France in Abu Dhabi.

171 Cf. Sabine B. Vogel, 53rd Biennale di Venezia (285).

2nd Art Dubai 2007, Subodh Kerkar

Whereas Abu Dhabi seeks to use its double participation at the Biennale di Venezia to present itself to the public in the West, the Sharjah Biennale aims at expanding its presence in the region. The works shown at the 8th biennial addressed global issues with a regional reference; Persekian intensified this focus at the following biennial. Exhibition venues were once again the Sharjah Art Museum, along with the Serkal House in the Arts & Heritage Area across from the museum and the nearby Sharjah Contemporary Arab Arts Museum. The event was preceded by a public call for projects; of the 250 submissions Persekian and his team selected 29 proposals that were specially produced for the Biennial and are presented together with 28 further invited artists. Their selection concentrated on artists from the MENASA region (Middle East, North Africa,

South Asia) – projects and works that largely addressed regional issues and crises: Rem Al Ghaith (Dubai) staged Dubai as a sprawling construction site; Jawad Al Malhi (Palestine) presented claustrophobically narrow photographs of the Shufhat Camp in the occupied part of Jerusalem. Also Samira Badran's (Libya/Spain) sculpture reflected the prison-like situation of Palestine with its ominously narrow turnstile, which obviously referred to the checkpoint between Ramallah and Jerusalem. Sharif Waked (Palestine) had an armed speaker read "Fairytales from 1001 nights" in the style of a "living martyr" video and in his installation "Westbank Butterfly" Nida Sinnokrot (USA/Algeria) mirrored the map of the Israeli "administered" West Jordanian West Bank as a butterfly which flapped like a vulnerable object in the breeze of a ventilator. For the first time, the old port of Sharjah was also included. On a wooden Arab sailboat, or dhow, which sails between here and Somalia CAMP[172] (Shaina Anand, Nida Ghouse, Hakimuddin Lilyawala, Ashok Sukumaran) installed a pirate transmitter at the opening. For three days, its programs could be received on portable radios. To this end, the roof across from the Sharjah Arts Museum was temporarily turned into a place to meet and furnished with tables and chairs. The dhows were built in Gujurat/India and sail – usually under Indian flag – loaded with used goods to Somalia. "WHARF-AGE (leaving Sharjah)" addressed trade as a "space of conflict", and the freight lists in the accompanying book challenged one to see the quaint boats not as a photo motif for tourists but rather in the global context of the goods, the working conditions and limited rights of the sailors. CAMP received the jury's main prize for this project.

The emotional imagery in these projects left a lasting impression of the region. All contributions in 2009 were clearly selected on the basis of local or regional points of reference, be it poetic or straightforward, documentary or symbolic. At the press conference that took place on March 17, 2009, Persekian declared that the biennale was no longer to function as an exhibition, certainly not for Western "superstars" but rather as a forum for shifting the focus to MENASA region, for promoting and strengthening regional art, building Arab networks, providing the institutions knowledge on creating infrastructure and to address the region – knowledge transfer and production instead of city marketing.[173] There was a series of lectures titled "March Meeting" and a "curators' workshop" with 24 curators from the region that addressed the following three themes: "Commissioning Artists and Artworks", "Building Institutions" and "Dialogue and Exchange".

Even if only 21,000 visitors saw the 9th biennial, it was, according to a press release on May 21, twice as many in 2009 as in 2007, Sharjah is still clearly one step ahead of the neighboring emirates with its art fairs, museum projects and participation in Venice. Here it not so much an image is being honed, there are also structural changes taking place. To this end the Biennale is a highly effective instrument because it does not just raise awareness but also has an impact on local knowledge. A solid foundation was created with the decision to create a world community not out of an alliance of nations as in Venice, but out of a region. Their members can live anywhere,

172 "CAMP is not an artists' collective but a workshop gathering ideas, sensibilities and energies. Its project centre around an ability to work infrastructurally, to produce configurations of technology, space and time that locate human agency in the midst of networks." Catalogue Wharfage, Sharjah Creek 2008-2009, Mumbai 2009, preface (81).

173 Cf. Sabine B. Vogel, 9th Sharjah Biennale (246 and 247)

and their affiliation is often based on mental resolve. For Biennales this means not inviting artists according to national borders but banking on cultural alliances. The goal of the Biennale is thus no longer representation but the active contribution to shaping one's own image and the outside image of the region.

Riwaq Biennale

Palestinian artist Khalil Rabah founded a highly unusual biennial in Ramallah in 2005. At first it was only a statement printed on T-shirts and banners: "Biennale Riwaq 2005. Architecture Installations Interventions" no more than a slogan. For the 2nd biennial artists were invited to a conference in 2007 and asked to develop projects for – and on – the West Bank. One result was Olaf Nicolais's 2009 contribution, in which he had Sigmund Freud's text "Mourning and Melancholy" translated into Arabic for the first time, distributed as a brochure and read on the radio.[174]

In 2009 the 3rd biennial was part of the exhibition "Palesteine c/o Venice" mounted during the Venice Biennale with the title "3rd Riwaq Biennale. A Geography: 50 Villages," Khalil presented postcards and a map of 50 historical buildings in the West Bank. Several weeks later this 3rd biennial resulted in a five-day trip to several of these places.[175]

"Riwaq", a term taken from Islamic architecture, also serves as the name of the "Center for Architectural Conservation" founded in Ramallah in 1991. It is also involved in the renovation of buildings in the fifty villages documented in the postcard series, the destinations of this Biennale excursion. The Riwaq Biennale is not an art exhibition as such but rather an artists' project. Similar to Rabah's "Palestinian Museum of Natural History and Humankind", which he showed at the Liverpool Biennale in 2008, the 9th Istanbul Biennale in 2005 and at the Athens Biennale in 2009. Built up around an olive tree that symbolizes Palestinian history, the biennale is a construction to create an awarenewss for Palestine's political situation. Both projects historically serve to generate national identity, which is precisely what Rabah had in mind. Palestine, however, does not exist. The autonomous Palestinian areas on the West Bank and Gaza are actually occupied by the Israelis. And what is more: It is tantamount to a political act to speak of "Palestine". Ever since Barack Obama mentioned the word "Palestine" for the first time in a speech he gave in Cairo in June 2009, this expression has gained acceptance but is still highly provocative.

Only against this backdrop does it become clear how topical and explosive Rabah's projects really are. In this region archaeology and architecture are weapons used by Israel to legitimize illegal settlements on the West Bank and by Palestine to assert claims to having its own culture – instrumentalized by both to substantiate their historical roots in the country. In Venice, Rabah's postcards were seen as much more than nice views, they also served

174 Olaf Nicolai's project will be realized at the 3rd Riwaq Biennale in co-production with the Al-Ma'mal Foundation and the "Jerusalem Show".

175 After the Venice presentation Rabah spontaneously decided, together with co-curator Charles Esche, to organize the 3rd edition as a trip to several selected destinations.

Riwaq Biennale 2009, Dar Khalil Palace

as political reminders. The Biennale trip also stopped at the most historically significant places – on October 12, the historical old city of Birzeit, on the second day the old city of Jerusalem, or, alternatively, Bethlehem, on October 14, 2009, then further north, at Nablus, Jamma'een, Sabastiyah and Arrabeh, and on October 15, south to Hebron. The reconstructions is a way of presenting normality and of protecting memories while the route is planned as one for all those who do not want to visit just the Israeli side of the Holy Land.

Taipei Biennale

While the Sharjah Biennale was the first biennial in the Arab region, it was the Taipei Biennale in Taiwan that assumed the forerunner role in Southeast Asia. In 1975 the Hong Kong Art Biennale was founded, followed in 1981 by the Asian Art Biennale Bangladesh, but unlike the Taipei Biennale these two biennials are to this day regionally oriented and hardly known beyond the borders of their countries.

For four decades the Kuomintang government ruled the authoritarian one-party state on the small island off the Chinese mainland. Once martial law was abolished in 1987, the first opposition party was founded. Five years later the 1ˢᵗ Taipei Biennale took place. Like the Sharjah Biennale it had a purely local orientation.

From the beginning the exhibitions took place at the Taipei Fine Arts Museum, which opened in 1983. At the 1ˢᵗ biennale in 1992 a jury still did the selecting, but starting in 1996 the artists were selected by a group of curators from Taiwan. Fumio Nanjo, who was invited to curate the 3ʳᵈ edition in 1998, selected artists from East Asia to present their works in "Site of Desire" and thus explicitly aimed at strengthening the region. *"We believe the Biennial will lead to a reaffirmation of the historical and cultural ties shared by the different parts of Northeast Asia, which have formed unique cultures under the strong influence of modern West and the heritage of Asian thoughts, as well as promote*

6th Taipeh Biennale 2008, Internacional Errorista

further mutual understanding and cooperation among these regions," he stated. Ten years later Fumio Nanjo was to continue this focus on an Asian region at the 2nd Singapore Biennale.

As the Taipei Biennale of 1998 was the first to have an international orientation, it soon came to be regarded as the first one so that "The Sky is the Limit" of 2000, curated by Jerome Sans and Manray Hsu, is in fact seen as the 2nd biennial.[176] Since then the practice of appointing both a local and an international curator has been adhered to. At the 3rd biennale in 2002 Barmomeu Mari and Chia Chi Jason Wang organized "Great Theatre of the World" and at the next one in 2004 Barbara Vanderlinden and Amy Cheng presented "Do You Believe in Reality?". The 5th in 2006 was organized by Amy Cheng together with Dan Cameron who did an exhibition titled "Dirty Yoga". The 6th in 2008 was put together by Manray Hsu and Vasif Kortun who did not select a title and staged the biennale as a forum for political issues of a global nature such as migration, globalization, micro-nations, war and the possibilities of responding and reacting to them. The Biennale was supposed to sensitize the visitors to these issues. A group of activist artists called International Errorista distributed flyers at the entrance of the museum, appealing to the power of error; Burak Delier supported an indigenous group in Taiwan with his "Counter Attack". Oliver Ressler put together an exhibition addressing anti-globalization strategies and a group of Spanish artists Democracia presented the 4-channel video "Smash the Ghetto". However, new tendencies and global highlights, as are so often shown in group exhibitions, were absent here. Here the focus was on raising awareness – a task for which biennials are perfectly suited to negotiate the gap between international demands and local orientation.

176 I am grateful to Manray Hsu for these details about the Taipeh Biennale.

Shanghai Biennale

The Shanghai Biennale also began as a national event in 1996, first showing traditional Chinese oil painting and later ink paintings and watercolors. It was founded on the initiative of Fang Zengxian, director of the Shanghai Art Museum since 1983 and himself a master of ink painting. From the 3rd biennial in 2000 the exhibition became internationally oriented in terms of the curators and artists, but the basic direction of the Shanghai Biennale has stayed the same to this day – with a specifically national, Chinese orientation. The Biennale helps assert the identity Chinese art especially where it is confronted with non-Chinese art.

The founding of this biennale was preceded by a tentative economic and political opening of China. At the 14th party conference on October 18, 1992 the Communist Party decided to introduce a Socialist market economy, opening up the economy and promoting foreign investment and later decentralizing administrative competences. Thus the foundations were laid for an opening of contemporary art, which was also reflected in survey shows of Chinese contemporary art in the West. "China Avantgarde" (Haus der Kulturen der Welt, Berlin 1993), "China!" (Kunstmuseum Bonn 1996) and "Die Hälfte des Himmels" (FrauenMuseum 1998). In 1997 Harald Szeemann was the first to invite several Chinese artists to his international event, the Lyon Biennale. And at the 48th Venice Biennale the Swiss curator prominently exhibited work by eighteen artists in a group exhibition titled "depertutto" at the Arsenale. In the following year the 3rd Shanghai Biennale was international for the first time, both in terms of curators and artists, ending the marginalization of Chinese contemporary art even

6th Shanghai Biennale, Zhan Wang, Buddhist Pharmacdy (detail), 2006

at home. How much the situation in China had changed was also reflected in the many, self-organized exhibitions that took place parallel to the 3rd edition – albeit much to the displeasure of the political apparatschiks, who at the 4th edition in 2002/03 ordered that all private exhibitions in Shanghai during the Biennale period be examined beforehand.

The exhibition venue was the Shanghai Art Museum, which is located in a building with a rich history. The building, designed in 1926 and finished in 1933, first served as clubhouse of the British racing club; during the Pacific War of 1941, it was occupied by the Japanese and later by the US Army. It was used by the Shanghai Museum and by the Shanghai Library from 1949 to 1959. In the 1990's the building was reconstructed. In 1959 the museum moved to the former Zhonghi Building on 16 S. Henan Road, which used to be an insurance and bank building. Since 1992 the museum is once again based at People's Square.

The 4th biennial in 2002/2003 was organized by Fan Di'an, vice-director of the Central Academy of Fine Arts in Beijing, backed by an international team of curators. The theme was "Urban Creation" and 67 artists and architects were invited, 31 of them from China. The Shanghai Biennale has adhered to the concept of a curatorial team to this day. The 5th biennial in 2004 had the theme "Ying Xiang Sheng Cun", which can be translated as "Techniques of the Visible", with a focus on the close links between art, science and technologies in China, *in particular how art has revealed the interdependent social and political forces that produce and subject technology and humanity*". The title stems from the old Chinese philosophy of "ying xiang" indicating *that artistic practise engaging with 'technology' is inherently placing itself within a historical continuum, where cultural metaphor becomes critical to its understanding.*" (press release Shanghai Biennale). The 6th biennial in 2006 also addressed a specific feature of Chinese culture again with the title "Hyperdesign". It is a neologism that is supposed to refer to a signpost towards the future with historical roots. Traditionally, Chinese culture knows no hierarchical distinction between applied and free arts. A hundred artists from twenty-five countries were invited. Shi Jinsong's modified tractors that worked like real ones and looked like futuristic motorcycles were placed in front of the museum. There was also a garage out of which music blared, beginning with Buddhist temple chants and ending with hard rock. This clash of tradition and the present was typical of many of the contributions. Zhang Wang filled transparent Buddha figures with tablets and Qui Anxiong related the connection between the extraction of petroleum, pipelines and bombs by means of traditional ink painting. Tanks symbolized by elephants, pipelines digging their way through the countryside like worms and ascending angels becoming deadly planes – "The New Sutra of the mountain and the ocean", as the title reads.[177]

177 Sabine B. Vogel, 6th Shanghai Biennale 2006, www.artnet.de (235) and 7th Shanghai Biennale 2008, Die Presse (237).

After the culturally oriented, more formal focal themes, the 7th biennial in 2008 turned to more topical political issues subsumed under the title "People and the City". The "world at large" is known as Shanghai in China. 85% of the 20 million inhabitants come from rural China, with the tendency continuing to rise. The following sections were announced: "Outsiders/urbanites/population movement in the context of urbanization", "Transients/hosts/identity crises in the urbanization process" and "Migrants/citizens/understandings of home in urban life and urban culture." The curatorial team, once again directed by Zhang Qing, selected the title "Translocalmotion". The original plan was to have a part of the biennale take place in public space,

on the "People's Square" in front of the museum, which, however, proved impossible to implement. 25 of the altogether 62 artists and artists' groups addressed the context, presenting some of their works around the museum as for instance, shining horses (Yu Fan) in allusion to the race club, the dove tower (Zhang Qing) and ants in bright colors (Chen Zhiguang) as a metaphor for migration, rice plants (Lin Chuanchu) as a recollection of the village that was once located here. For the first time, the Biennale also featured works that critically and documentarily addressed everyday life in China. Yang Shaobin filmed the life of miners and Zhang Weijie zoomed in on the crowds of people who travel back to their home villages every year during the "Spring Rush". In a conversation about his experiences as curator of the 7th biennial, Julian Heynen remarked that this "spring rush" is a scene in a film by Ulrike Ottinger, *"which she produced in China in the 1980's. At the time it met with great opposition of the authorities. (…) If one thinks in the huge time spans of a Biennale, then one realizes that there is an opening, one that is also explicitly calling for critical art – but at the same time there also has, of course, to be a balance between 'critical' and 'neutral' art, as the Chinese colleagues put it."* [178]

178 Cf. "Kunst-Interview" with Julian Heynen, conducted by Sabine B. Vogel, September 2008, www.kunstundbuecher.at (238)

Gwangju Biennale

Whereas the biennials in Sharjah and Shanghai initially served mainly as a sign of political opening, the Gwangju Biennale, first spelled "Kwangju", in Southern Korea was explicitly founded as a political marketing instrument.

The venue is the industrial town of Gwangju located 200 kilometers to the south of Seoul. This art exhibition was intended to help improve the damaged reputation of the town, to offset the memories of the massacre, which took place in 1980, with a positive event. In 1980 the military had brutally suppressed an anti-regime demonstration in which students had demanded more civil rights, free presidential elections and more democracy. Even if the exact figure is still contested today, it is estimated that up to 2,000 people lost their lives in the massacre. This tragic event is seen as the beginning of the process of democratization in South Korea, even if democracy did not take hold until much later and it was not until 1992 that Gwangju had its first civil government.

Mayor Song Eon-jong, who was also director of the Biennale, expressed his desire in the opening speech that the *"Biennale will serve to clarify misconceptions regarding the history of Kwangju (…) a city of light that uses art to brighten the dark reality of Korean separation."* [179] At the opening of the 2nd Gwangju Biennale Yu Sune-sang, chairman of the Gwangju Biennale organizational committee stated: *"The successful continuation (of the Gwangju Biennale) is an important factor in conveying Asia's cultural potential to the world community and securing the vital role for the region in shaping a global culture in the 21st century."* [180]

179 Press release on Gwangju Biennale.

180 Yu June-sang, chairman of the Kwangju Biennale organizational committee, cited from Thomas Wulffen, (137)

6th Gwangju Biennale 2006, Chiharu Shiota, In Silence

This desire to break the political and cultural isolation, which has informed so many new biennials, was also central in the case of South Korea – as was the hope *"to create a balanced history of East and West, to create an active Asian culture in the 21ˢᵗ century and to form a cultural community in the Pacific Rim."* [181]

181 Cited from: Jason Edward Kaufman, The Art Newspaper (134).

The 1ˢᵗ Biennale in 1995 was the first art festival in the Asian region that had an international orientation from the very outset. Earlier shows such as the Taipei Biennale and the Asia Pacific Triennial (1993, Brisbane, Australia) had first focused on the Asian-Pacific region. With an exceptionally big budget of 23 million dollars the 1ˢᵗ Kwangju Biennale in 1995 presented a selection that was both historical and contemporary. By way of comparison: the budget of the Biennale di Venezia in 1997 curated by Germano Celant was 4.6 million dollars, the 2ⁿᵈ Moscow Biennale in 2007 4 million dollars, half of which was raised by sponsors, and the 1ˢᵗ Athens Biennale in 2007 was organized with a budget of 1.3 million euros.

The central exhibition of the Biennale was "Art as Resistance" showing, on the one hand, Western trends of political art in "Art as Witness", featuring Tatlin, Picasso, Duchamp, Beuys, Boltanski to Kienholz, Wilfredo Lam, Kabakov and Andreas Serrano, and on the other hand, its Eastern or Korean counterpart: Minjoong (People's Art) in a section titled "The Spirit of Kwangju: Resistance in May". "Minjoong" is a 'protest art movement' that emerged as a result of the Kwangju massacre of 1980. In the nine exhibitions that followed 660 artists from 60 countries with 1,228 works were presented as part of a show titled "Beyond the Borders". 1.6 million visitors saw this first biennial. The 2ⁿᵈ biennial in 1997 that focused on "Unmapping the Earth", which had a budget of 11 million dollars, attracted 900,000 visitors. By way of comparison: the 1997 documenta in Kassel had 631,000 visitors. At the 3ʳᵈ Gwangju biennial in 2000, titled "Man + Space", the budget and the

number of visitors continued to decline and there were only 246 artists from 46 countries. Two years before, Asia had been hit by a severe financial crisis so for the biennial there were only 7.2 million dollars. 614,000 people visited the biennial. The 4th biennial, curated by Hou Hanru and Charles Esche, took place not only at the "Biennale Halle" as previously but also in a former military prison, in which citizens had been held during the military dictatorship between 1962 and 1987. Ever since, the building has been used as a site to commemorate the massacre.

Commemorative work is certainly a central theme of many biennials. Eleven years after this biennial was founded the director Kim Hong-hee and her team, however, decided to reverse this orientation, now turning to the future. "Fever Variations", the ominous and poetic title selected, refers to an ever-more widespread re-interpretation of international contemporary art from an Asian perspective.[182] What is this "Asian" perspective? To answer this question Kim Hong-hee designed the biennial structured like a book between "First Chapter_Trace Root: Unfolding Asian Stories" and the "Last Chapter_Trace Route: Remapping Global Cities". Reflecting an awareness of the immensely complex continent with its highly diverse cultures the biennial also suggests two perspectives – tradition-conscious Asia and cosmopolitan Asia – that were revealed on a tour of gods and myths, works on migration and a concluding critique of US hegemony. With these two poles the biennial reflects a strong Asian self-awareness, which addresses both West-East and East-West influences and asserts their perspective and 'visibility' in the international discourse of contemporary art.[183]

Biennials in Europe

In Europe the new biennials in the second phase were also initially national and regional forums. This includes the Lyon Biennale, France (1991), which repositioned the former industrial town with an exhibition featuring French artists, the Triennial of Contemporary Oberschwaben am Bodensee, Germany (1996), and the Periferic Biennale launched in Iasci, Romania in 1997, which was first a regional performance festival lasting only a few days. Everywhere the focus was first the local situation. Here the Manifesta stands out in particular as the first "European" biennial.

Manifesta

From its inception the Manifesta was intended *"to transgress the existing regional, social, linguistic and economic barriers in Europe"* While the umbrella organization has remained based in Holland[184] each biennial has been held and funded by a different city – as a "nomadic, pan-European event", as the "Foundation Manifest" [185] of 1994 states. A team of three curators, as the team for the 2011 biennial, has had the task of selecting young art with a special focus on Eastern Europe and the European periphery. The manifesto

182 The 15th Sydney Biennale opened in the summer of that year, followed in early September in quick succession by the 1st Singapore, the 6th Shanghai, then Gwanju, one week later by the South Korean Busan Biennale and the media biennale in Seoul; in early November the 6th Taipei Biennale in Taiwan and the 5th Asia Pacific Triennial in Australia.

183 Sabine B. Vogel, 6th Gwangju Biennale, NZZ (142) and www.artnet.de (143).

184 "However, it is intended that a permanent administrative base for Manifesta be established in the Netherlands, as a means of ensuring organisational continuity. For the necessary flow of information we use the most effective means of modern communication: electronic mail, access to the Internet and multimedia data carriers such as CD-ROM." (Press release Manifesta)

is supposed to underscore the pluralism of contemporary art and first and foremost to *"exemplify the important role that young artist can play in helping to make the new Europe a more exciting and culturally diverse place in which to live."* (the advisory board of MANIFESTA, summer 1994)

185 www.manifesta.org/index. asp?m=ifm (site last visited on October 11, 2008)

The 1st Manifesta took place in Rotterdam in the summer of 1996. Biennials followed in Luxembourg in 1998, Ljubljana in 2000, Frankfurt/M. in 2002, San Sebastian/Bilbao in 2004, and Trentino, South Tyrol in 2008. The fifth exhibition was to take place in Nikosia (Cyprus), but before the opening it was cancelled by the Greek government since creating an academy in the Turkish-occupied part of the island was seen as amounting to the recognition of the political conditions, even if the academy, like the exhibition, was only intended to be temporary.

Manifesta 2 Luxembourg 1998, Bjarne Melgaard

At the Manifesta there was also the hope of creating or asserting a European cultural identity. Yet as opposed to the first phase of the biennials, there was now no young nation backing the new biennial, but a region – one that a hundred years earlier had split into many, in part arbitrarily assembled nations. The Treaty of Maastricht, which was signed on February 7, 1992 and came into effect on November 1, 1993, to this day unites 27 European countries in an economic community with a coordinated foreign and security policy. However, there is still no a common cultural policy. An art exhibition can perhaps point to such a shortcoming but it cannot compensate for it. As opposed to the Asia Pacific Triennial in Southeast Asia the Manifesta has not succeeded in creating a cultural identity in the region and initiating a "European art", a European cultural identity.

A biennial cannot create political conditions ahead of its time, which would be problematic in both Ljubljana and in the divided capital of Cyprus. Slovenia and Cyprus were both integrated in the European Union as part of the first Eastern enlargement in 2004, but in Cyprus this only holds for the southern – Greek – part of the country. But also in the cities the Manifesta was driven by a desire for a unified Europe before local conditions allowed for such a reality to take hold. As a result, in 2000, the local art and culture

scene in Ljubljana massively distanced itself from the Manifesta and refused to engage in any cooperation. Looking back, Maria Hlavajava explained in a conversation that the Manifesta weakened or even destroyed Ljubljana's existing free institution scene. In the long run, however, an exciting new development was initiated. One can hardly imagine how this may have taken place without the intervention of the Biennale.

berlin biennale for contemporary art

Unlike the Manifesta, the Berlin Biennale does not aim at finding unity in diversity but, on the contrary, at using the multi-facetted potential of a city to take stock. Founded in 1998 on the initiative of Klaus Biesenbach, the Berlin Biennale[186] was conceived as a forum for the large number of international artists living there. In 1990, after Berlin's reunification as Germany's new capital, the city had only a few non-commercial forums for young art. Starting with the 3rd Biennale in 2004, the event was no longer limited to artists from the region. Under the direction of Ute Meta Bauer the focus shifted from biographical to topographical references. There were, on the one hand, direct references to Berlin such as Willie Doherty's photographs of the German capital, which he took during his DAAD-funded stay in the city. On the other hand, similar topographical situations were documented, for instance, by French artist Melik Ohanian who led the visitor through the docks of Liverpool or depicted as in Thomas Struth's early photographs of empty streets.

186 The 4th biennial in 2006 as well as the 5th biennial in 2008 were backed by the Federal Cultural Foundation with a budget of 2.3 million euros.

Berlin Biennale 2010, Adrian Lohmüller, Das Haus bleibt still

While at the 3rd Biennale in 2004, socio-critical contributions dominated, the team of the 4th Biennale in 2006 signaled with the title "On Mice and Men" that it "was deliberately breaking with the politically oriented predecessors", as Hortensia Völckers summed it up.[187] While biennials in Asia as well as in Moscow or Mercosur, Porto Alegro, Brazil (1990) were used to signal a new self-awareness of formerly marginalized regions to the inside and outside of the country, the berlin biennale began retreating to subjectivity from the 4th biennial on. "*We believe that art has to do with experiencing possible worlds, to let oneself be distracted from reality or to be drawn into a reality that we have not*

187 Von Mäusen und Menschen, brief guide to the exhibition, preface by Hortensia Völckers (59) p. 8.

previously perceived," the text of the curators[188] begins. Their goal was *"to give impulses revolving around questions of birth and loss, death and capitulation, suffering and nostalgia."* [189] *"It is time to embark on a retreat and to hide oneself on the inside."* [190] The 5th Biennale hardly deviated from this course. In an exhibition titled *"When things cast no shadow"* shown at the Nationalgalerie and the Schinkel Pavilion, artistic director Adam Syzmczyk together with Elena Filipovic attempted to link the political with the private, to reconcile the present with the past and the East with the West, with the Berlin Biennale being equally divided between the former East and the West.[191]

188 Von Mäusen und Menschen (59), brief guide p. 23.

189 Ibid.
190 Ibid., p. 25.

191 Sabine B. Vogel, 5th Berlin Biennale (123).

Biennials in the New Millenium

By the end of the 20th century the 'biennial' format had developed beyond the original model in Venice. Biennials were thematic and highly political, dominated by installations and documentary or docu-fictional videos. Biennial art had morphed into a world existing alongside the art market; painting and drawing could only be rarely found here.

The structure of the biennial has also taken on a life of its own. Artists can be selected via diplomatic channels as in Venice, Cairo and New Delhi or chosen by one permanent artistic director as at the Echigo-Tsumari Triennial and since 2005 at the Sharjah Biennale. A fixed organizational team can appoint a new curator every two years as in Sydney, Gwangju and Singapore or a team of national and international curators as in Taipei. The exhibitons now take place in an established institution as in Gwangju and São Paulo, they can travel through villages like the Skulptur Biennale Münsterland, Germany (1999), be mounted in outdoor space as the Beaufort Triennial for Contemporary Art at the Sea, Belgium (2003) or distributed throughout the entire city as in Busan, South Korea (1998). Some biennials focus on individual media as the Fototriennale Graz, Ausria (1993), the Contour Biennial for Video Art (Mechelen, Belgium, 2003) or "für bewegte Bilder" (for moving images) as Katerina Gregos renamed the 4th biennial in 2009, the Biennale der Kleinplastik (Biennial of Small Sculpture) in Fellbach, Germany (1983) or the Biennale der Papierkunst (Biennial of Paper Art) in Düren, Germany (1986).

In most of the new biennials the underlying motives are the same; reasons cited again and again include the desire to break cultural isolation and efforts to secure exhibitions for local artists in connection with international networks. This is also true for the most recently founded biennials in Athens, Greece (2007), Moscow, Russia (2005) and Singapore (2006) which have sought to position themselves as centers of contemporary art.

Athens Biennale 2009, Christodoulos Panayiotou, shredded paper banknotes

Thessaloniki Biennale, Athens Biennial

While in Cyprus the negotiations between the Manifesta and the Greek government failed, preparations for two new biennials in Greece began: the 1st Thessaloniki Biennale[192] and the 1st Athens Biennale.[193] Thessaloniki, a city in the Macedonian part of northern Greece, the native city of Mustafa Kemal Atatürk, the father of modern Turkey, is seen as the second capital of the country, next to Athens. According to the George V. Tsaras, President of the Board of Directors of the State Museum of Contemporary Art, the biennale serves to strengthen Thessaloniki as *"meeting point where artists and art theoreticians can collaborate" "to support cultural singularity"* and *"to equally accentuate local as well as universal qualities."*[194]

The Greek Ministry of Culture provided the incentive for establishing a biennale in the northern Greek city. The SMCA, the State Museum for Contemporary Art, which bought up George Costakis' collection of Russian avant-garde art in 1997, is responsible for organizing the event. The title of the biennale – "Heterotopias" – was inspired by Michel Foucault. Three curators put together exhibitions with a total of 82 artists from 38 countries to explore "other sites" as an alternative to real spaces, "to reevaluate the notions of centre and periphery" and "to imagine new spaces of the future."[195] In her introductory text Catherine David emphasized that she saw the TB as a possibility *"for presenting and discussing the aesthetic productions of these regions (non-European and/or non-western), in dialogue with the work of artists from more 'privileged' environments."*[196] Jan-Erik Lundström, by contrast, focused in his section on *"the care of the social", "the so-called war on terrorism"* and *"the notion of life itself"*[197], while the third curator Maria Tsantsaunouglou stated: *"It is the concept of globalization."*[198] The three main themes of the new millennium – questioning the hegemonic status of western culture; life itself and its dangers; and globalization – were thus all broached.

192 1st Thessaloniki Biennale, May 21 – September 30, 2007, exhibition venues: SMCA and Dependence "Warehouse", Museum of Byzantine Culture, Yeni Tzami, Institut Francais de Thessalonique, Bazaar Hamam.
193 1st Athens Biennale, September 10 – November 18 2007, exhibition venues: "Technopolis".

194 Catalogue of the Thessaloniki Biennale (87) p. 16.

195 Biennale Guide Thessaloniki Biennale (88) p. 5.

196 Catherine David (88) p. 9.

197 Jan-Erik Lundström (88) p. 14

198 Maria Tsantsanouglou (88) p. 18.

By opening three exhibitions at eight sites on four consecutive days, the opening of the 1ˢᵗ Thessaloniki Biennale was thus explicitly directed to a regional audience.

The 1ˢᵗ Athens Biennial was completely different from the Thessaloniki Biennale, which was still almost unknown when it took place for the second time in 2009. The new biennial was curated by a young team composed of Xenia Kalpaksoglou (at the time director of the DESTE Foundation), Poka-Yio (artist and curator), Augustine Zenakos (editor of the Greek daily "To Bima" and art critic). By sending out regular 'newsletters', first by e-mail, organizing a conference[199] in the spring and press conferences at the same time as the 10ᵗʰ Istanbul and the 9ᵗʰ Lyon Biennale , this biennial succeeded in attracting attention long before it even opened.

This biennale was not founded by a single entrepreneur, nor was it based on a political decision. The young team already had experience from working on smaller projects and decided to create an impulse for the Athens art scene, which was undeveloped in infrastructural terms. *"We had organized off-stream exhibitions for a long time. But we realized that we needed a point of reference. A central exhibition around which the many other artistic activities of the city could conglomerate like satellites and could hone their profile. For us the biennale is also a possibility to redefine Athens as a place of contemporary art production,"*[200] as Xenia Kalpaktsoglou summed up in an interview.

As one of Europe's oldest cities Athens looks back on a 5,000-year history of settlement. When the city was declared capital of the newly founded kingdom of Greece, it still had only 4,000 inhabitants. After the Greeks were defeated by the Turks in 1922 the population of Athens increased dramatically as a result of the population exchange exchange between Greece and Turkey – 1.5 mio Turks for 500,000 Greeks. Today some four million people live in greater Athens. Economically badly hit by two world wars, culturally isolated by the military dictatorship between 1967 and 1974 and saddled with high unemployment and illegal immigration today, the Greek state hardly contributes anything to backing contemporary art. Of the almost thirty museums in the Greek capital, none is dedicated to contemporary art. The vacuum was only filled in 1998 by the DESTE Foundation, which has built up a private collection on the basis of Dakis Joannou's collection.

Even if Greece has had its own pavilion in Giardini gardens of the Biennale di Venezia since 1934 and has taken part in the Biennale São Paulo since 1955, the new art is neither visible nor networked internationally. Athens as the cradle of democracy and the origin of our culture is much more a metaphor for the past than for a dynamic art city. Smog and the eternal traffic congestion, decaying historical buildings around the Acropolis and the crumbling facades of cheap modern architecture are all typical of everyday life in the Greek metropolis.

199 During the preparations for the 1ˢᵗ Athens Biennial the curatorial team organized the conference "Prayer for (passive?) resistance – 1ˢᵗ Athens Biennial 2007 Conference", February 17 and 18, 2007. The speakers were invited to address individual aspects of the central theme "Destroy Ahtens" such as "megapolitics", stereotypes but also on biennials. The roster included: Yiannis Stavrakakis & Kostas Stfylakis "Art in the Age of Metapolitics", Neil Mulholland "Party Fears Two: Social Network Theory, contemporary art and counter-cultures", Maria Theodorou "Architectural Resistance", Panayis Panaylotopoulos "Let's get out of this town – Political culture and authenticity in the right and left", Jeremy Valentine "Stereotypes, Causality and Ethics"; Catherine David "Building up a Biennial", Evelyne Jouanno "Emergency Biennial in Chechnya – When creation has to engage with destruction", Per Hasselberg "The Good Society and the Nuclear Option", Viktor Misiano "Resistance on stage?".
200 Xenia Kalpaktsoglou, (118).

The 1st Athens Biennale responded to a city confronted with maintaining a balancing act between clichés and reality with the provocative title "Destroy Athens" – not referring to the city, of course, but to stereotypes. And this began with the 'biennale' format. The criterion for selecting artists was not their country of origin; nationalities were not even mentioned. Decisive was whether the works fitted into the context of the exhibition, which has a rigid narrative structure.[201] Subdivided into six "days", the exhibition, featuring 57 artists, presented a sort of tabula rasa: the show opened with the explosions of buildings in "Detonation Deutschland" (Julian Rosefeldt & Piero Steinle) and ended with Elini Mylonas' video of a dead sheep which is washed onto land and then back to sea – there is no peace even in death. In between, on "day 2" Greek identity was addressed in Nikos Kessanlis' sculpture of 1963, a barrel of oil with a filthy rag below it – "Proposition for a New Greek Sculpture". Alongside the formerly censored series of interviews by the Otholith Group on cliché and reality in Greece there was Eva Stefani's video in which she gave the Akropolis a female body, a voice. On "day 3" and "day 5" danger, terror and aggression prevailed. Gregor Schneider's "White Terror", Aidas Berikis' horror cabinet, Kimberly Clark's garbage pile, John Bock's torture video, and Vassilis Patmios Karouk's apocalyptical pictures.

201 Sabine B. Vogel, 1st Athens Biennale, (117); Kalliopi Minioudaki (119).

The exhibition was staged as a long corridor, a one-way street and also intended as such. Even following the destruction of collective and individual clichés, "day 7" (not explicitly named) marks a pause and a new beginning. Athens was put back on the art map. For this the Biennale had opened a door also on an organizational level. During the preparation of the Biennale the Athens team agreed to cooperate on marketing ("tres biennial") with the Istanbul Biennale and the Lyon Biennale as an extension of the "Grand Tour", a trip leading to the three mega-art events – Biennale di Venezia, the Basle art fair and the documenta in Kassel.

Six curators were invited to the 2nd biennial in 2009. Titled "Heaven", this biennial featured six exhibitions at new locations. Cooperation with Istanbul and Lyon was no longer possible due to the new summer dates. However, in the meantime the AB had initiatied the European Biennial Network, to which the biennials in Athens, Berlin, Istanbul, Liverpool and Lyon belong, along with the associate partners Venice, Göteborg, Tirana, the Manifesta and the Periferic. The goal is to exchange knowledge and experience, and to this end practical workshops and exchange programs have been organized.

Logo Athens Bienniale 2009

Moscow Biennale

While the young team of the Athens Biennale continued to develop the possibilities of the biennial model in terms of organization, contents and form, the Moscow Biennale mainly served political purposes, namely backing democratic developments and maintaining political power. Alexander Sokolov,

2ⁿᵈ Moscow Biennale 2007, Dan Perjovski

Russia's minister of culture, declared the support of contemporary art to be *"the most important task of our country's cultural policy."* As the press release stated: *"And finally, this biennale would become the next step in developing the image of Moscow as one of the world's major cultural capitals, as well as to satisfy the very different economic, political and geopolitical interests of Russia."*

Following the scandal caused by the showing of abstract paintings in an exhibition in the Moscow Manege in 1962, a distinction was made between official, state-backed, and unofficial art. Thus Russian artists were forced into opposition for decades. The non-conformists received no state support, no opportunity to exhibit and no social integration.[202] In the course of Perestroika art was liberated from being consistently coopted ideologically but it was only with the emergence of a "new elite" with the 1990's, which included several nouveau-riche collectors, that there was a noticeable change. Following years of cultural isolation in which contemporary artists were for all practical purposes non-existent and institutions for young art received no funding, the Moscow Biennale suddenly had a budget of 2.5 million euros and enormous media interest. During the first biennial this unexpected situation was often criticized as being politically coopted as a pawn of the "new elite", which was only seeking *"to create an image of a strong, respectable and civilized nation"*, as Elena Sorokina[203] noted in her review published in "Artsmargins". In the same report Sorokina also mentioned that the name of the biennial – "Dialectic of Hope" – was identical with the eponymous publication by Marxist Boris Kagarlitsky who strictly opposed being coopted: *"The context of my work is now legitimizing a project supported by the Russian elite, whose sympathies with the leftist theories and practices were quite unnoticed before."*

Again and again it has been claimed that in the Soviet period culture was seen as a counterweight to politics, the fascinating "Other". Today, by contrast, art serves as a pawn of politics and part of 'lifestyle' as Julia Axjonowa sums up: *"Contemporary art in Russia has become fashionable. Artworks are featured as design elements at different presentations. Exhibitions often take place in specific restaurants, clubs and shops."*[204]

202 Cf. Julia Axjonowa, in: "Russland Aktuell" (217).

203 Elena Sorokina, in: "Artmagazin" (220).

204 Ibid.

The main exhibition of the 1ˢᵗ Biennale took place in the historical setting of the former Lenin Museum located on the Red Square; further venues were the metro station Vorobievi Gori, the Schusew Museum of Architecture, the Museum of Contemporary Art on Emolaewsky Street, the Pushkin State Museum of Fine Arts and the Tretyakov Gallery. The 2ⁿᵈ biennial, titled "Footnotes on Geopolitics, Markets and Amnesia", reflected the next step with amazing consistency. The five official exhibitions featuring 100 artists from 35 countries took place concurrently as individual exhibitions with different titles at two construction sites – on the half-completed 19ᵗʰ and 20nd floor of the Federation Tower and on the top floor of the "Tsum" luxury department store. The path leading to the exhibition led through three department store floors. On the top floor construction continued all around the exhibition – walled off by separate partitions. The venues selected could hardly be more symbolic: The new rich Russia in an unfinished construction or even "Reaching for New Heights", as the free paper "The Moscow Times" described it on March 2, 2007.

According to commissioner Joseph Beckstein the Biennale was supposed to address and win over politicians and also collectors for contemporary art. Dan Perjovschi responded to this public use of contemporary art for displaying a newly emerging national self-awareness, when he drew his commentaries on the pane of his office rooms: two heads, on one the hair covering the forehead as bangs and then on the other with hair standing on end, below it an arrow on which was written "reform". Next to it appeared the words sponsor, director, curator, artist in clearly descending order. Along with the two main venues, there were more than thirty parallel events, including one at a former wine production facility that was a shell of a building, located east of the city center where a gallery district is taking shape. Olek Kulik curated his first major group show titled "I believe" featuring mainly Russian artists in a former wine cellar.

The 2ⁿᵈ Moscow Biennale is exemplarey of the enormous backdrop of this biennial. They events are beacons of hope but also sources of friction, a cash cow and crown at once; they have to achieve a fine balancing act between a national and international art scene, often preparing the ground for a new infrastructure consisting of galleries and project spaces. They are highly official and serve as a national showcase but at the same time they are supposed to be rebellious. It can be difficult for the local art scene to stake its own ground. This became very evident in a discussion that took place two days after the opening. Artists, critics, philosophers and activists met at a small bookshop to reflect on the biennial. The event was put down as "vulgar", "obscene" and it was also claimed that the biennial legitimized the new capitalism and displayed an "artistic optimism" – but at the same time the biennial was extremely important as a means of positing oneself.[205] This aspect was not only significant for the intellectuals of Moscow, it also reflected a political decision. The curatorial team of both biennials was composed of international, mainly western experts. This meant that Russia was clearly set in a western, European context which was then continued at

205 Sabine B. Vogel, 2ⁿᵈ Moscow Biennale (221).

the 3rd biennial in 2009. This event, curated by Jean-Hubert Martin, had the title "Against Exclusion". Russia, however, could have used the Biennale to strengthen East European or Russian-Asian artists or could have created a role for itself as an interface. An exhibition of Chechenyan artists originally planned for the 1st biennial was cancelled during the preparation phase. Out of this Evelyne Jouanno developed the Emergency Biennale in Chechenya. Selected works travel in a suitcase to various cities where new artists are also featured.

Singapore Biennale 2008, Su-Mei Tse

Singapore Biennale

The Singapore Biennale was also created for political reasons. Similar to Moscow the government of the small city state located between Malaysia and Indonesia, with a population of 4 million, wanted to present itself to the outside world as an open and tolerant regime.

Singapore, which declared its independence on August 9, 1965, today has the world's second largest port and is seen as the "Switzerland of the Far East." It is Asia's bank metropolis and is known for its multi-religious society which lives in peaceful coexistence. Since there were no private or commercial institutions for exhibiting contemporary art, the local artists and art critics often thought about creating a biennial. In his essay "Calibratred Expectations" published in Broadsheet vol. 35, no. 3, Lee Weng Choy mentions that he already reported on such considerations in 2002. However, it was only a concrete occasion that motivated the government in 2006 to provide funding for such an art exhibition – in fall of 2006 the directors of the International Monetary Fund and of the World Bank met in Singapore.

As Singapore is a member with the right to vote and a paying member it does not take loans. For the repressive, almost dictatorial regime that is very interested in having the reputation of being an open "global city", the biennial served as a cultural side program for the members of the two major international institutions from 184 countries. At the same time the Biennale was to be a show of openness, which, however, was opposed on a different level. On June 29, 2006 the daily paper "The Straits Times" reported that during the IMF meeting, the government banned all protests and marches in public space and demanded that each theater group submit its scripts to the MDA (Media Development Authority) for approval.

The 1st Singapore Biennale, titled "Belief", was organized by Japanese curator Fumio Nanjo. Themes of the show were money and belief, freedom and religion. The selected exhibition venues were highly symbolic, including religious buildings (seven churches, mosques, synogogues, and temples) in which calligraphic and geometric patterns dominated as, for instance, Imran Qureshi's subtle floral ornamentation on the roof of the Sultan mosque or Charwei Tsai's miniature copy of the "Lotus Mantra" on lotus leafs. In such works tradition and the present come together, and sacral elements resurface in secular usages without losing their meaning. This clash is particularly striking in Bing Xu's carpet with its Chinese characters, which was placed in a Buddhist temple. The signs could be read in any direction – alluding to the many meanings of reality. An existing carpet was replaced by the artist's contribution but believers refused to walk on it. The new piece thus had to be moved to the National Museum.

Another part of the Biennale took place in government buildings, at the former Town Hall with its many courtrooms and at the Tanglin Camp, a former military training camp. Cyril Wong[206], a writer from Singapore, reported that all artists first had to sign an agreement to ensure that the organizing committee would not be liable if the artist's contributions were deemed controversial, that is to say, were subject to censorship. However, there were still critical contributions, such like Jason Wee's nineteen laptops, which he used to recall a political act of 1987. An internal police division of Singapore at the time arbitrarily accused a group of people of being part of conspiratorial communist group. The video "The Last Supper" by the Swedish artists Bilger & Bergström addressed the pressing issue of executions, Singapore being one of the countries with the highest numbers of executions. In the film a Texan and a Thai prison cook tell about the last meals they cook for death-row prisoners. The video is also interspersed with reports on last meals from the Middle Ages and other historical material and rituals.

The budget of the 1st Singapore Biennale amounted to 8 million Singapore dollars, half of which came from sponsors. 883,000 visitors saw the exhibition during the first ten weeks. One year later it was announced that the biennial was to be continued, once again under the direction of Fumio Nanjo. The title of the 2nd Biennale in 2008 was "Wonder" and this time the event was to serve as a side program for the first Formula 1 night race to take place

206 Cyril Wong, Broadsheet (103) p. 142.

worldwide. The artists invited by the curator and his team were mainly artists from Southeast Asia who this time responded less immediately to the context. "To experience wonder is to open one's mind," as Nanjo wrote; he also spoke about "discovering new truths." This Biennale also took place at historically symbolic locations (a former courthouse, a former South Beach military facility, an old military barracks, an officers' clubhouse and a police station) and in public space. The show featured a ferris wheel and a temporary container hall at the "Marina Bay", a piece of land that had just been reclaimed. Many of the 71 artists and artist groups worked with light, which is seen as being the essence of the immaterial: from Sue-Mei Tse's eery neon swing in the empty space of a former military facility to Leonid Tishkov's photo series, for which he draped his "private moon" once on a tree, then on his back, thus evoking a strange affinity between heaven and earth. This imagery was particularly striking when dream-like memories were conjured up as in Ling Nah Tang's wall drawings shown together with Willie Koh's videos which allude to the forgotten spaces in the former military facility and thus reinforce the repressive nature of the context.[207] Light is a major issue in urban space; for the Formula 1's night race 1,500 spotlights were mounted around the tracks of the racing course.

207 Cf. Sabine B. Vogel, 2nd Singapore Biennale 2008 (256), p. 53f.

With this 2nd Biennale Fumio Nanja broke with the tradition of critical and documentary biennials. Now art does not comment reality but reports on the many possibilities lying beyond what is actually visible, which can also be seen as being subversive in the repressive context of Singapore, as reflecting

a belief in change. But it is primarily the selection of artists at the 2nd Singapore Biennale which indicated a clear focus on Southeast Asian artists. At a press conference Fumio Nanjo stressed that the Western, international artists could easily exhibit their work, while the presence of Southeast Asian art still needed to be strengthened on the "map of contemporary art". As ten years before at the Taipei Biennale in 1998 Fumio Nanjo focused on an Asian region. He invited artists from the Southeast Asian region to participate in the 2nd Singapore Biennale; at a press conference he explicitly stated that Western artists already had sufficient opportunities to exhibit their work and that their work should not dominate the event. Nanjo thus backed the decision made in connection with the country's cultural policy to expand and transform the city state into a center of Southeast Asian art. To this end the National Council has now, for several years, been purchasing works from this region, which is to be part of a permanent collection from 2012. This collection will be exhibited at the Town Hall, which has now been converted into a museum – the region's first museum with a regional focus.

This regional focus could already be noticed at the 1st Biennale at the Singapore Art Museum, a former mission school, where an exhibition of Southeast Asian art took place. There was a

Singapore 2006, Imran Qureshi, Wuzu

panel in the entrance hall, which explained that the art history presented here began in the year 1962 – at a time when the Philippines took part in the Biennale di Venezia for the first time. The beginning of "contemporary art" is dated as coinciding with the biennale participation so that this type of art exhibition assumes much more importance than any other one as it presents not just art but also a nation.

Precisely in Singapore in 2008, but also in Sharjah 2009, the potential of the biennial is used in a similar way as in the first biennials in Venice, namely to strengthen a politically unified region and to give a growing sense of identity the opportunity to find political expression.

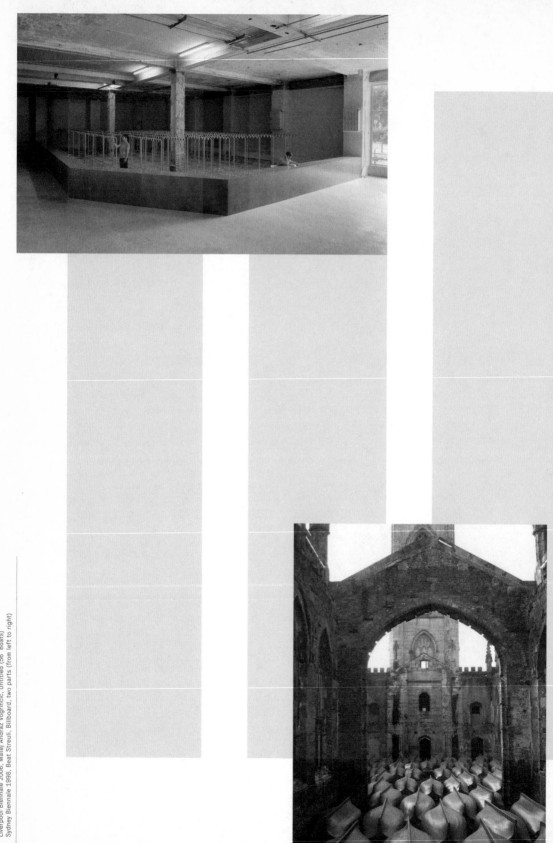

6ᵗʰ Berlin Biennale 2010, Roman Ondák, Zone
Liverpool Biennale 2006, Matej Andraž Vogrinčič, Untitled (56 Boats)
Sydney Biennale 1998, Beat Streuli, Billboard, two parts (from left to right)

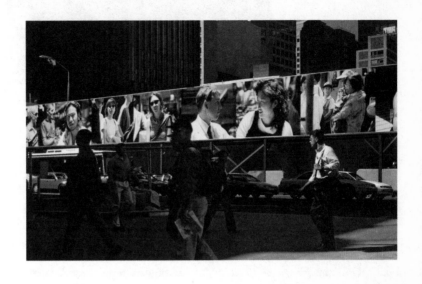

Conclusion: Potential and Limitations of Biennials

Taipeh Museum 2008

As the various portraits in this book have shown, new biennials are influenced by real political conditions and reflect political developments. In both phases of development, new biennials were founded for almost the same reasons. *"Sydney saw itself cut off from the (Western) centers and discourses of contemporary art and there was also a lack of possibilities for exhibiting recent art,"*[208] René Block described the situation in Australia. A similar situation can be found in many biennials that were created later as in Athens, Jakarta or Prague. Whereas Lima, Havana and Taipei manifest the desire to break the political isolation, the exhibitions in Moscow, Singapore and Luanda are used to show tolerance and democratization trends. The founders of the Liverpool Biennale and the Echigo-Tsumari Triennial hoped to strengthen the region with these exhibitions. Whereas the biennials in São Paulo, Taipei and Sharjah prompted the creation of a national art history, the Singapore Biennale led to the creation of regional art history. These biennials were mainly geared to a local audience, while Kassel and Gwangju tried to redefine the image of their country or city by linking up with international developments.

208 René Block (100) p. 125.

Biennials as a Marketing Tool

Can an exhibition of contemporary art that takes place every two years actually fulfill such enormous expectations? Or is the biennial simply a an inexpensive and effective marketing instrument in disguise, especially when lesser known towns like Esslingen or Fellbach, Busan, Brisbane or Sonsbeek are able to attain supraregional media presence with relatively little funding?

209 This and the following quotes: interview by Alan Cruickshank with Fumio Nanjo, Broadsheet (103), p. 137.

In an interview at the 1ˢᵗ Singapore Biennale 2006 artistic director Fumio Nanjo was asked whether biennials didn't run the risks of becoming *"cultural trade shows driven by non-art and/or commercial aspirations, with international curators circling the globe, 'biennale shopping' for artists?"*[209] Nanjo's response: *"Firstly, no major event such as a biennale or triennale occurs without other intentions such as city promotion or cultural tourism motivations, because nobody wants to invest so much funding and effort for purely artistic reasons."* Nonetheless, as he pointed out, a biennial can offer new experiences to new groups of people, while at the same time showing the most recent developments in art to those who are really interested: *"I think it is one of the roles of a biennale to introduce the young talent of the region to the international art world and bridge the two, to share new information. (…) Every biennale should have its own visions, agenda and representation"*, since biennials are not *"United Nations conferences."*

According to a press release 883,000 people visited the 1ˢᵗ Singapore Biennale, and the number of visitors to the documenta in Kassel and to the Biennale di Venezia continues to rise. Since the São Paulo Biennale stopped charging entry in 2004, the number of visitors has surpassed one million. This confirms Nanjo's observation that biennials create a new public which is also illustrated by the fact that biennials receive much more coverage in local press reports than comparable exhibitions of contemporary art. Nanjo, however, still seems to overestimate the importance of biennials as tourism attractions. Even if biennials, like world expositions and the Olympic Games, draw greater attention to the cities where they take place, only the documenta and the Biennale di Venezia have actually succeeded in garnering a broad audience on a continuous basis. Usually it is only the first edition of a biennial that attracts an overwhelming number of visitors. This number then

steadily drops and evens out at 50,000 visitors at best at a biennial which lasts, on average, about eight weeks. Only São Paulo and Sydney have attracted up to 1 million visitors. However, these events do not charge entry. Most biennials founded in the second phase take place in big cities with more than 1 million inhabitants and are usually required viewing for schoolchildren and students. Thus, unlike world expositions and the Olympics, biennials are mainly visited by experts.

Biennials still have the potential to be more than just an exhibition and their primary role is to provide information – this is very evident in the themes and works exhibited at the individual biennials. Unlike art fairs, there is hardly any painting to be seen at the biennials, only expansive installations, video and photography. According to Belting these media offer non-Western artists the possibility *"to subvert"* the static Western notion of art which is based on museum presentation and to overcome *"the old barriers of language and information."*[210] As he notes, what is decisive are the narrative qualities of the imagery – also in the installations that reconstruct the *"space of the narration."*[211] At the biennials this "space" extends beyond the works, as for instance the CAMP contribution at the port of Sharjah, which focused on the global context. This is possible because most biennials do not have any fixed spaces and thus select venues in settings that are rich in history and meaning.

210 Belting (8) p. 51f.

211 Ibid. (8) p. 52.

Alternative Biennial Sites

Biennials are often criticized for serving gentrification since they often resuscitate derelict buildings or city districts and thus contribute to an increase in rents, as was the case in Istanbul with vacant apartment buildings and stores in 2005 and with a shopping center in 2007. In Singapore this was true for a former military base in 2006 and the administrative building of the military in 1008. It is usually state-owned property that assumes a new function and value as a result of the Biennale. The Moscow Biennale, in contrast, functions very differently. Here a department store and the two floors of an office building still under construction were symbolic for social and political developments, and the emergence of an elite.

Biennials take place in – and with – a city. Curators deliberately seek out locations with a lively past to serve as the thematic backdrop of a biennial. Such contexts are addressed in the artists' works and/or clearly influence the perception of the exhibitions by directing attention to allusions, putting narratives in a context, and intensifying criticism by means of concrete references. At the biennials the works are always read in a context as opposed to Western museums – in a context that results directly from the location and the overarching political and cultural situation. By declaring and perceiving art here as part of the city and the related histories, the images that we each bring with us are enriched by new, local contexts that would disappear if the same works were shown in the Western context of exhibition institutions. Since 2007 the OK Centrum in Linz (Austria) has been holding the Biennale Cuvee once a year, in which a selection of exceptional works from various

Istanbul Biennale 2005

international biennials are shown. It would be interesting to explore which works are able to retain part of their original associations and meanings in the new context or completely lose them, developing a new field of meanings.

These different biennial sites are not just part of the organization but also one of the most exciting challenges of biennials since more than public visibility is expected. Here lasting changes begin to take place when familiar places are redefined by art and subsequently used as cultural centers. By the same token, the spaces familiar to us from everyday life contribute to reducing the visitor's initial skepticism in approaching contemporary art.

Biennials have triggered a further process. In each act of perception we look for the familiar in memories. *"With growing familiarity the pleasure for less captivating styles grow that are supposedly more interesting and stimulating. In a further stage of preparation then follows understanding that takes place in a constant exchange of cognitive explanations and emotional assessments. If the viewer has the feeling that s/he has met the challenge of an artwork there is then an aesthetic judgment ('I like that!') and a so-called aesthetic emotion which in the best case is pleasure, a pleasant feeling,"* Helmut Leder [212] explains the process of aesthetic perception. At biennials this process of perception encompasses not just artworks but also the venues or the context. This is an advantage when the local population is only beginning to beome familiar with the context and the contextual references. The small flock of traveling biennale-aficionados, by contrast, is often first taken aback by the only partially renovated spaces that are often a far cry from what the pristine white cube is expected to be. When they visit a setting the second time they become more open for the unfamiliar imagery – a process that does not take place in presentations in Western exhibition institutions. At biennials the danger of unconventional spaces is that the traveling art fans may jump to quick conclusions based on a "colonist" mode

212 Helmut Leder, (36).

Singapore Biennale 2008, Felice Varini, Drill Hall

of perception. "Colonist" here refers to an attitude of classifying the unfamil-
iar as "exotic", that is to say, categorizing and depreciating the unfamiliar as
familiarly unfamiliar.

Nationality Principle

Unlike the group shows at museums, the works shown at biennials always
also convey recent political changes. As I was able to show such conditions
were evident not only in the art featured at the Gwangju Biennale in 2006 as
the demonstrative self-consciousness displayed by a nation and in Singapore
in 2008 and in Sharjah in 2009 as indicators of a strengthened region. The
Sharjah Biennale in 2007 reflected a problem-oriented approach to the envi-
ronment, while the Shanghai Biennale in 2007 revealed a cautious process-
ing of the country's most recent history. At the Taipei Biennale in 2008 the
focus was on the international import of specific issues. While globally active
curators and artists who have been invited to participate in the biennial, the
actual changes are local.

While the retrospectives in the first phase of the biennials served to con-
struct national identity and to manifest the hegemony of modernity's West-
ern culture, the biennials in the second phase reflect the crisis of the prin-
ciple of nationalities and the emergence of a global art.

In the first phase the invitations, sent via diplomatic channels, and the list of
participating nations were of great political significance, since they reflected
a cultural openness as well as the host country's networking. In the second
phase this principle became ever less plausible, now that the fewest artists
could be ascribed to a nation since the country of birth is now no longer the
same as the country of residence. At the 45th Biennale di Venezia in 1993,

Liverpool Biennale 2006, Rigo 23

Achille Bonito Oliva questioned the nationality principle and several countries undermined the procedure of national selection when, for instance, Hans Haacke (Germany/USA) and Nam June Paik (Korea/USA) exhibited in German pavilion and Andrea Fraser (USA)/Christian Philipp Müller (Switzerland/USA) and Gerwald Rockenschaub at the Austrian and Louise Bourgeois (France/USA) at the French pavilion. But it remained an attempt with no consequences, since the artists' contributions referred directly to the pavilion country. And it remained inconsequential, since nothing changed in the competition on behalf of nations – the oldest biennial continues to adhere to the original concept dating from the period of nation states.

Nicolaus Schafhausen broke with this principle when he decided to show English artist Liam Gillick in the German pavilion at the 53rd Biennale di Venezia in 2009. This, however, was a one-time decision. By contrast the decision made by chief curator Lisette Lagnado at the 27th São Paulo Biennale in 2006 had more radical implications for the entire biennial scene. She abolished the nationality system, no longer inviting nations but only individual artists.[213] This decision reflected the continual criticism of representation but at the same time it raised new questions. Would the chief curator, like the national commissioner, be able to take into account countries like Kirgisistan and Usbekistan, Peru and Malaysia? Would artists in countries that lacked cultural infrastructure and had low international visibility have a chance to be invited? Didn't the selection depend on travel budget? And wouldn't what was exhibited be limited to the formal idiom of the discourses largely dictated by the West? Wasn't the representational model one worth maintaining in the ensemble of biennial models, since it was more democratic than the "monarchist" one which had a state curator backed by a team? So for all the necessary criticism of the nationality principle there is the question whether national representation as a political and cultural instrument is still important today for some nations to assert their cultural identity as it used to be in Europe. Artists from countries such as Palestine thus often insist on their national affiliation being cited as part of their identity and also as thematic backdrop of their art.

213 While Germany reacted with the ifa (Institut für Auslandsbeziehungen Stuttgart) nominating Ulrike Griss as the German commissioner as coordinating partner, the representative of the Austrian government decided to make free up the once reserved budget of 80,000 euros for the Biennale.

Points of Contention

The discussions regarding the nationality principle reflect a situation of far-reaching political and social change. This stiutation also points to the danger of the "process of global hegemonization" as described by Gerardo Mosquera in his essay "The World of Difference" (cited already in chapter II.1). In his catalogue text titled "Zones of Contamination – some random notes on the current state of contemporary art events" for the Sydney Biennale in 2006, Hou Hanru, too, criticizes the homogenizing and trivializing tendencies accompanying globalization, as follows: *"Social critique, utopian idealism and class struggle are now turned into beautifully decorated maxims that can upgrade the good taste of club lounges and gallery spaces. (…) Such a context makes us question the significance of contemporary art in society."*

Hou Hanru demands that biennials be not *"zones of contact"* but rather *"zones of confrontation, negotiation and exchange with the alien, or, biologically speaking, the virus."* (p. 139) In this metaphorical comparison he reveals a decisive difference between the biennials of the first and of the second phase. While those that took place until 1989 contributed to harmonizing and consolidating a site, this function is no longer in demand in the age of globalization. In the second phase problematic tendencies prevail which is reflected in the themes of the individual biennials. Now the focus lies on issues relating to globalization, migration, post-colonialism, and environmental threats, but also approaches to strengthening a specific region. Thus an awareness for problems in a local context is strengthened; it is not tainted by party politics but is simply there, unaffected by borders and territories – and this is where the importance of ontemporary art lies according to Hou Hanru.

Other criticisms were voiced in the period leading up to the 1st Singapore Biennale in 2006. In the magazine "Broadsheet, Contemporary Visual Arts + Culture"[214] four experts expressed their reservations, demands and hopes with regard to biennials.[215] Art historian Joan Kee who lives in New York, argued that biennials were a *"privileged mode"* for disseminating art in the 1960s and 1970s. *"The Asian biennales' main function therefore was seen as a means to gain membership into this international art world, or even as a pre-emptive confirmation of such membership"*; she noted that founding a biennial was no longer sufficient for appearing on the map of the art world or for being perceived by *"Others"*, *"read Euro-Americans"*. This crucial phenomeon underwent an unexpected development. On the one hand, easier and less expensive travel options have made both the visitors and the media coverage of the biennials more international, while, on the other hand, some biennials, no longer strive for this "affiliation with the West" but rather back a regional community. As we have seen, the Singapore Biennale spearheaded this development, trying to become the cultural center of Southeast Asia, along with Sharjah, which set itself the goal of strengthening the MENASA region. Kee also takes issue with the fact that, similar to small countries, biennials are seen as extra- or even ideal-territories, with the danger of the curators *"creating his/her own vision of the universe"* – as a result of which excessively

214 Broadsheet (103).

215 Lee Wenig Choy, "Calibrated Expectations. A Roundtable on the inaugural Singapore Biennale 2006", in Broadsheet (103), pp. 141-143.

high expectations may not be fulfilled. Apart from the fact that every human being creates his/her own little mental universe, biennials have from the beginning served as a mirror of the prevailing worldview – and this is one of the things that has made this exhibition format so fascinating. Unlike gallery exhibitions, biennials do not serve to create or to strengthen the career of individual artists. Biennials help raise an awareness as the curators of the 6th Taipei Biennale in 2008 and the 11th Istanbul Biennale in 2009 expressed in very clear terms.

A further criticism voiced was the fact that a small group of internationally active curators including a few female curators are engaged worldwide for one biennial after the other and that their own personal preferences dominate. The reproach that biennials are "fossilized into a standard form and function" has a similar message, namely that the biennials are merely a spectacle and that no further significant developments can be expected[216] – a contention which resulted in a radically different concept being implemented at the 28th São Paulo Biennale in 2008. Also due to enormous financial losses chief curator Ivo Mesquita decided to leave one floor of the building standing vacant, showing only a fraction of the exhibition and concentrating on lectures and a comprehensive library with worldwide biennial catalogues. Unexpectedly, there was a protest initiative by a local graffiti artist whose traces were painted over again. The empty white walls were certainly a crucial part of this biennial's program.

At the 9th Sharjah Biennale criticism of the overly standardized and arbitrary form of the biennial resulted in the decision that context-specific contributions be produced on location. *"Focusing on the region gives the Sharjah Biennale indispensable associations and affiliations with its own constituency,"* as Jack Persekian wrote in the preface to his catalogue, explaining in detail his doubts about the conventional biennial concept his ideas regarding change. *"It dawned on me that the telescopic themes we had been working with in fact narrowed down the way we perceived the work presented and filtered out the multitude of elements that form a whole world of readings and interpretations."*[217] One consequence was that the activities extended beyond the exhibition and the themes and participating artists became regional. Moreover, the biennial facilitated greater knowledge for the region which was to give Western curators and artists more independence – the Biennale as an triggering new developments.

Biennale Conferences

The growing number, and the increasing criticism, of biennials prompted the Institut für Auslandsbeziehungen (ifa for short) in Stuttgart, Germany to organize the first Biennale conference at the Museum Fridericianum in Kassel, which was attended by more than forty curators, artists and organizers of twenty biennials. The themes included "Biennials as Site Factor", the "Influence of Biennials on the Local Art Scene", the "Role of the Artist in the Global Context: Is the World a Studio?", "The Exhibition as Mega-Event: On the Ethics of Curating" and the future of biennials. For Jean-Hubert Martin

216 Ibid. (203), p. 141.

217 Catalogue of the 9th Sharjah Biennale 2009, Jack Persekian, (80) p. 10.

biennials provide a chance to liberate artists from the "favor of the art market", while artist <u>Alfredo Jaar</u> criticizes that *"everyone is in a setting that is so streamlined as a result of capitalism-influenced globalization that one can hardly even speak of the individuality of biennial sites anymore."* [218]

218 Quoted from: Regina Bärthel, Dialog der Weltkunst – Aufbruch aus der Isolation in: Das Fridericianum Magazin 5 (6) p. 10.

From this first conference the initiators placed their hopes in an umbrella organization and a biennial codex, which did not materialize, just as the regularly convening biennial committees failed to develop quality standards. Since then the ifa has continued to organize further conferences parallel to the biennials: "Biennials in Dialogue – Exchange or Global Incest?" at the Museum Moderner Kunst in Frankfurt in 2002 parallel to the Manifesta, the "Biennale Complex" parallel to the 1st Singapore Biennale in 2006 and the 4th parallel to the 7th Shanghai Biennale in 2008. Here organizational issues were deliberated on internally, while self-reflective aspects were discussed publically.

Such conferences have meanwhile become a fixed feature of biennials. While the biennial symposion "World Contemprary Art and International Biennials" at the 6th Gwangju Biennale in South Korea in 2006 Beck Jee-sook[219] warned that many of the Asian biennials would like to be different than others in the region, while having to conform with the modern Western biennale. Beck called for strategies *"that can create scenarios for diverse methods of intervention and realize them within the given circumstances."* Ute Meta Bauer[220] advocated inviting curators a second time so as to use knowledge already acquired a second time and to intensify it, and Charles Esche[221] endorsed *"thinking things otherwise within a given situation."*

219 Beck Jee-sook, biennial co-curator and project director of Insa Art Space, Seoul.

220 Ute Meta Bauer, director of the Visual Arts Program, MIT, artistic head of the Berlin Biennale 2004, co-curator of the 11th documenta.
221 Charles Esche, director of the Van Abbemuseum, Eindhoven, co-curator Istanbul Berlin 2005, curator of Gwangju Biennale 2002.
222 4th biennials in Dialogue Conference, Shanghai, Goethe Institut September 6 – 7, 2008, with Elke aus dem Moore (ifa Stuttgart), Rei Maeda (3rd Echigo-Tsumari Triennale), Ursula Zeller (4th Triennale of Contemporary Art, Oberschwaben), Dora Hegyi (curator of the 8th Periferic Biennale, Iasi, Romania), Sujud Dartanto (curator of the 9th Biennale Jogja, Indonesia), Jacopo Crivelli Visconti (Biennale Foundation, São Paulo), moderation Marieke van Hal.

At the 4th ifa-conference[222] at the Shanghai Biennale in 2008 two themes dominated: the question of sustainability, i.e., short- and long-term repercussions of biennials on hosting cities and exhibition venues and internationalism vs. regionalism or the possibility of exchanging factual knowledge regarding production, financing and organizing a biennial.

What was interesting about these conferences was the fact that almost all the questions and issues addressed apply to majority of international biennials, since one now finds almost the same political and economic conditions all over the world, even if there are still differences. The danger of the uniformity noted above is offset by the enormous diversity of biennials which has prompted more and more cities to consider organizing such an event – with the diversity depending on the different political conditions found at a given site.

Opportunities of Biennials

The directors of the 9th Istanbul Biennale in 2005, Charles Esche and Vasif Kortun were almost enthusiastic in formulating the opportunities of biennials. As they wrote in their introduction titled "The biennial as a tool" for the catalogue: *"Instead, its (of the biennial – note of the author) description as a tool through which art can shape the world and have purchase on its viewers has had*

much more influence on our use of the structure. (…) – a tool to energize vision and discipline the imagination." [223]

223 Esche/Kortum, catalogue 9th IB, (67), p. 25.

Thanks to biennials "art can shape the world", since they are a platform for global art which is only able to play a limited role in the largely nationally oriented art institutions such as museums or art centers. Biennials have come to embody the "new global culture" (Hou Hanru). One sign of this development is that the differences between center and periphery have become blurred. In global art there is also no hierarchy of 'local' and 'global'. The themes are global, the contexts local and the artists transnational. Biennials offer the possibility of using experimental and curatorial concepts to venture beyond the limits of exhibitions. Biennials are in no way dependent on the art market, are much more political than the usual mega-exhibitions and underscore process and collective projects as opposed to the presentation of stars. Biennials exhibit artists who given the lack of cultural infrastructure in their own countries find little or no possibility to exhibit their work and are still unknown in Western art institutions. Biennials present local themes in an international context and combine global issues with regional perspectives. In the global art of biennials, cultural hegemony and political boundaries are addressed, as it is here that political power forces are reflected and called into question. It is here, too, that national history is processed and a global history of art begun.

While the biennials founded in the first phase were under the sway of modernity and nationalism and served to consolidate political systems, the biennials founded in the second phase promise radical changes – both politically and culturally. 'Beyond' has become the key word in many a biennial title, indicating something beyond the dominance of Western art, beyond colonialism and also beyond academic and traditional art, now replaced by global art. Since the first biennial was founded, biennials have come to represent a process of individual and social emancipation, self-determination and social tolerance, cosmopolitanism and a faith in the role of a public forum in which different opinions can be discussed and criticism expressed. What comes to the fore now is less effectiveness and efficiency but rather a willingness to accept change and an openness for the new – and precisely this makes biennials so fascinating, significant and also necessary.

Appendix

IV. List of New Biennials

1895 Biennale di Venezia (Italy)

1932 Whitney Biennial New York (USA)

1949 Sonsbeek Triennale (Arnheim, the Netherlands)

1951 São Paulo Biennale (Brazil)

1952 Tokyo Biennale (Japan) (18th and last editions 1990)

1955 dokumenta (Kassel, Germany)
 Alexandria Biennale of the Arts of Mediterranean Countries (Egypt)

1958 Biennale Christlicher Kunst der Gegenwart (Salzburg, Österreich) (4th and last edition 1964)

1959 Biennale de Paris (France)

1963 Graphik Biennale (Brno, Czech Republic)

1965 Biennale der Ostseeländer (Rostock, former East Germany; 15th and last edition 1996)

1968 India Triennale (New Delhi, India)

1970 Bienal de San Juan del Grabado Latinoamericano
 (1970 – 2001, 2004 renamed as The San Juan Poly/Graphic-Triennial)

1973 Biennale of Sydney (Australia)

1975 Hong Kong Biennale (China)

1979 Baltic Triennale (Vilnius, Lithuania)

1980 Biennale der Kleinplastik (Fellbach, Germany)

1981 Asian Art Biennale Bangladesh

1983 Havana Biennale (Cuba)

1984 Cairo Biennale (Egypt)

1985 Biennale de l'Art Bantu Contemporain (Gabon, Africa)

1986 Bharat Bhavan Biennale of Contemporary Art (Bhoval, India)
 Biennale der Papierkunst (Düren, West Germany)

1987 Istanbul Biennale (Turkey)
 Biennale Cuenca (Ecuador)

1989 Biennale Nagoya (Japan)
 Internationale Foto Triennale (Esslingen, West Germany)

1990 Adelaide Biennale of Australian Art (Australia)
 Osaka Triennale (Japan) (10th and last edition 2001)
 Cetinje's Biennial (Montenegro)

1991 Biennale d'Art Contemporain de Lyon (France)
 Kitakyushu Biennale (Japan)

1992 DAK'ART (Senegal)
 Taipei Biennial (Taiwan)
 Biennale de Arte Panama

1993 Sharjah Biennale (United Arab Emirates)
 Werkleitz Biennale (Halle/Saale, Germany)
 Asia Pacific Triennale (Brisbane, Australia)
 Österreichische Triennale zur Fotografie (Graz, Austria)

1994 Medienbiennale Leipzig (Germany)

1995 Gwangju Biennale (South Korea)
 Saaremaa Biennale (Estonia) (only one edition to date)
 Johannisburg Biennale (South Africa, only 2 editions)
 SITE Santa Fe (New Mexico/Santa Fe, USA)
 Krasnoyrsk Museum Biennale (Russia)

1996 Manifesta (various cities, European Biennale)
 Mercosul Visual Arts Biennial (Porte Allegro, Brazil)
 Shanghai Biennale (China)

1997 Bienal Iberoamericana de Lima (Peru)
 Periferic Biennale, Bukarest, (Iasi, Romania)

1998 Berlin Biennale (Germany)
 La Biennale de Montréal (Canada)
 Busan Biennale (South Korea)
 Flerieu Biennale (South Australia)
 Goteborg International Art Biennale (Sweden)

1999 Liverpool Biennale (England)
 Melbourne International Biennial (Australia)
 Skulptur Biennale Münsterland (Germany)
 Fukuoka Asian Art Triennale (Japan)

2000 Echigo-Tsumari Triennial (Japan)
 Media City Seoul, Medienbiennale (South Korea)
 SCAPE, Biennial of art in public space (New Zealand)

2001 Tirana Biennale (Albania)
 Yokohama Triennale of Contemporary Art (Japan)
 Bienal de Valencia (Spain)
 Göteborgs Internationella Konstbiennal (Sweden)

2002 Guangzhou Triennale (China)
 Biennial Ceará América (Fortaleza, Brazil)

2003 Prag Biennale (Czech Republic)
 Beaufort – Triennale für zeitgenössische Kunst am Meer (Belgium)
 Countour Biennial for Video Art (Mechelen, Belgium)
 CP Open Biennale (Center Point) (Jakarta, Indonesia)
 Bamako Biennial für Fotografie (Mali, Africa)

2004 BIACS Sevilla Biennale (Spain)
 Ostseebiennale der Klangkunst (Wismar, Germany)

2005 Moscow Biennale (Russia)
 Bucharest Biennale (Romania)
 Bali Biennale (Indonesia)
 Riwaq Biennale (Ramallah, Palestine)

2006 Singapore Biennale (Singapore)
 Quadriennale Düsseldorf (Germany)
 Biennale Jakarta (Indonesia)

2007 Athens Biennale (Greece)
 Thessaloniki, Greece
 Bienal del Fin del Mundo (Argentina)
 Luanda Triennale (Angora)

2008 Folkestone Triennale (England)
 Shisha – Asia Triennale Manchester (England)
 Brussels Biennale (only one edition)

V. Titles and Directors / Curators

Athens Biennale

2007 "Destroy Athen", Xenia Kalpaktsoglou, Poka-Yio, Augustine Zenakos
2009 "Heaven", Dimitris Papaioannou & Zafos Xagoraris, Chus Martínez, Cay Sophie Rabinowitz, Nadja Argyropoulou, Diana Baldon, Christopher Marinos

Berlin Biennale

1998 Klaus Biesenbach, Hans Ulrich Obrist, Nancy Spector
2001 Saskia Bos
2004 Ute Meta Bauer, "Hubs" on "Migration" (Hito Steyerl), "Urbane Conditions" (Jesko Fezer und Axel John Wieder), "Sonic Landscapes" (The Sonic Team), "Fashion and scenes" (Regina Möller), "Other cinema" (Mark Nash)
2006 "Of Mice and Men", Maurizio Cattelan, Massimiliano Gioni, Ali Subotnick
2008 "When things cast no shadow", Adam Szymczyk, Elena Filipovic
2010 "Was draußen wartet", Kathrin Rhomberg

Documenta, Kassel

d1 1955 Arnold Bode, Werner Haftmann
d2 1959 Arnold Bode, Werner Haftmann
d3 1964 Arnold Bode, Werner Haftmann
d4 1969 documenta-Advisory Board with 24 members for different "working committee"
d5 1972 Harald Szeemann with Jean-Christoph Ammann, Bazon Brock
d6 1977 Manfred Schneckenburger with Wieland Schmidt
d7 1982 Rudi Fuchs
d8 1987 Manfred Schneckenburger
d9 1992 Jan Hoet
d10 1997 Catherine David, Assistent Hortensia Völkers, Consultant Jean-Francois Chevrier
d11 2002 Okwui Enwezor, Team: Carlos Basualdo, Ute Meta Bauer, Susanne Ghez, Sarat Maharaj, Mark Nash, Octavio Zaya
d12 2007 Roger M. Buergel with Ruth Noack
d13 2012 Carolyn Christov-Bakargiev

Gwangju Biennale

1995 "Beyond the Borders", Director Lim Young-Bang, artistic director Lee Young-Woo, Curators Young-Bang Lim for "Art as Witness", Nam June Paik and Cynthia Goodman for "Info Art", Stephen Vitiello for Video, Yoon Bummo "The Originality of Korean Modern Art" and 7 curators for regions: Jean de Loisy – Westeurope, Anda Rottenberg – Eastern Europe, Kathy Holbreich – North America, Sung Wan-kyung – South America, Oh Kwang-su – Asia, Clive Adams – Middle East and Africa, You Hong-June – Korea and Oceania
1997 "Unmapping the earth", artistic director: Lee Young-Chul, curators: Harald Szeemann "Speed/Water", Kyong Parak "Space/Fire", Richard Koshalek "Hybrid/Wood", Sung Wan-Kyong "Power/Metal", Bernard Marcade "Becoming/Earth"

2000 "Man + Space", director So Chong-Gol, Marie-Laure Bernadac
2002 "P.A.U.S.E.", artistic director Sung Wan-Kyung, curators Hou Hanru, Charles Esche
2004 "A Grain of Dust A Drop of Water", curator Kerry Brougher, Sukwon Chang
2006 "Fever Variations", artistic director Kim Hong-hee, Kuratoren Wu Hung, Binghui Huangfu,
 Shaheen Merali for "The First Chapter_Trace Root: Unfolding Asian Stories",
 "The Last Chapter_Trace Route: Remapping Global Cities"
2008 artistic director Okwui Enwezor, Kuratoren Ranjit Hoskotje, Hyunjin Kim
2010 "10.000 Lives" artistic director Massimiliano Gioni

Bienal de la Habana

1984 Lillian Llanes (and team)
1986 Lillian Llanes (and team)
1989 "Tradition and Contemporaneity", Lilian Llanes
1991 "The Challenge of Colonisation", Lillian Llanes
1994 5 themes: "Art, Power, Marginality", "The other shore", "Appropriations and Intercrossings", "Environment
 and circumstances", "Individual reflections, collective obsessions", Lilian Llanes
1997 "El individuo y su memoria" ("Individual and Memory"), Lillian Llanes, chiefcurator Nelson Herrera Ysla
2000 "Uno más cerca del otro" ("One closer to the other"), director Nelson Herrera Ysla
2003 "El Arte con la Vida" ("Art together with life"), curators Hilda María Rodríguez Enríquez (director of the Centro),
 José Manuel Noceda Fernández, Nelson Herrera Ysla, Ibis Hernández Abascal, Margarita Sánchez Prieto,
 José Fernández Portal
2006 "Dynamics of Urban Culture", director Ruben del Valle Lanteron, Margarita González, Nelson Herrera Ysla,
 José Manuel Noceda, Ibis Hernández Abascal, Margarita Sánchez Prieto, José Fernández Portal, Antonio Zaya
2009 "Integración y Resistencia en la Era Global" ("Integration and Resistance in the Global Age"),
 curators Margarita González, Nelson Herrera Ysla, José Manuel Noceda, Ibis Hernández Abascal,
 Margarita Sánchez Prieto, José Fernández Portal, Dannys Montes de Oca Moreda

International Istanbul Biennial

1987 general coordination Beral Madra
1989 general coordination Beral Madra
1992 "Producing Cultural Difference", director Vasif Kortun
1995 "ORIENT/ATION. The Image of Art in a World of Paradoxes", curator Rene Block
1997 "On Life, Beauty, Translations / Transfers and Other Difficulties", curator Rosa Martinez
1999 "The Passion and the Wave", curator Paolo Colombo
2001 "EGOFUGAL: Fugue from Ego for the Next Emergence", curator Yuko Hasegawa
2003 "Poetic Justice", curator Dan Cameron
2005 "Istanbul", curators Charles Esche, Vasif Kortun
2007 "Not only possible, but also necessary: Optimism in the Age of Global War", curator Hou Hanru
2009 "What keeps mankind alive?", curators What, How & for Whom (WHW; Ivet Curlin, Ana Devic, Natasa Ilic,
 Sabina Sabolovic)

Liverpool Biennial

1999 "Trace", curator Anthony Bond
2002 "International 2002", directors Lewis Biggs, Paul Domela, curators Eddie Berg, Brian Biggs,
 Christoph Grunenberg, Lewis Biggs
2004 "International 2004", directors Lewis Biggs, Paul Domela, curators resp. "Researchers": Sabine Breitwieser,
 Yu Yeon Kim, Cuauhtemoc Medina, Apinan Poshyananda; Liverpool Hosts: Adrian George, Eddie Berg, Bryan Biggs,
 Patrick Henry
2006 "International 2006", directors Lewis Biggs, Paul Domela, curaters resp. consultants: Manray Hsu,
 Gerardo Mosquera; Liverpool Hosts: Laurence Sillars, Patrick Henry, Bryan Biggs, Ceri Hand
2008 "International 2008: Made Up", artistic director Lewis Biggs; hosts: Laurence Sillars, Patrick Henry,
 Bryan Biggs, Mike Stubbs, Sorcha Carey
2010 "International 2010: Touched", artistic director Lewis Biggs, curator Lorenzo Fusi; hosts: Sara-Jayne Parsons,
 Mike Stubbs, Patrick Henry, Peter Gorschluete

Biennale de Lyon

1991 "L'amour de l'art", Thierry Raspail, Thierry Prat
1993 "et tous ils changent le monde", Thierry Raspail, Thierry Prat
1995 "Interactivité", Thierry Raspail, Thierry Prat, curator Georges Rey
1997 "L'autre", Thierry Raspail, Thierry Prat, curator Harald Szeemann
2000 "Partage d'Exotismes", Thierry Raspail, Thierry Prat, curator Jean-Hubert Martin
2001 "Connivence", Thierry Raspail, Thierry Prat, curator Guy Walter
2003/04 "C'est arrivé demain", Xavier Douroux, Franck Gautherot, Eric Troncy
2005 "Expérience de la durée", Thierry Raspail, curator Nicolas Bourriaud, Jerome Sans
2007 "00s – The history of a decade that has no name", Thierry Raspail,
 concept Stephanie Moisdon,Hans Ulrich Obrist
2009 "The Spectacle of the everyday", Thierry Raspail, curator Hou Hanru

Manifesta

1996 Rotterdam, curators: Rosa Martinez, Viktor Misiano, Katalin Néray, Hans-Ulrich Obrist, Andrew Renton.
1998 Luxemburg, curators: Francesco Bonami, Ole Bouman, Maria Hlavajova, Kathrin Rhomberg.
2000 Ljubljana, curators: Francesco Bonami, Ole Bouman, Maria Hlavajova, Kathrin Rhomberg.
2002 Frankfurt/M., curators: Iara Boubnova, Nuria Enguita Mayo, Stephanie Moisdon Trembley.
2004 San Sebastian/Bilbao, curators: Massimiliano Gioni, Marta Kuzma
2006 Zypern – canceled
2008 Trentino, curators: Adam Budak, Anselm Franke/Hila Peleg, RAQS Media Collective.
2010 "Dialogue with Africa", Marcia, Spain, Nordafrica, curator-teams: Alexandria Contemporary Arts Forum,
 Chamber of Public Secrets, Tranzit.org

Moscow Biennale

2005: "Dialectics of hope", curators: Daniel Birnbaum, Joseph Backstein, Iara Boubnova, Rosa Martinez,
 Hans-Ulrich Obrist.
2007: "Just Footnotes? (Art in the era of social Darwinism)", curators: Joseph Backstein, Daniel Birnbaum,
 Gunnar B. Kvaran; Hans Ulrich Obrist, "USA: American Video Art at the start of the third millennium";
 Iara Boubnova, "History in the present tense"; Nicolaus Bourriaud, "Stock Zero or the icy water of
 egoistical calculation"; Fulya Erdemci, Rosa Martinez, "After All".
2009: "Against Exclusion: 3. Moscow Biennale", Commissioner Joseph Backstein,
 curator Jean-Hubert Martin

São Paulo Biennale (selection)

1951 artistic director Lourival Gomes Machada
1952 – 57 artistic director Sergio Milliet
1961 artistic director Mario Pedrosa
1981 chiefcurator Walter Zanini
1983 chiefcurator Walter Zanini
1985 "Man and Life"
1987 "Utopia vs. Reality"
1994 chiefcurator Nelson Aguilar
1996 "The Dematerialization of the object of art at the end of the millennium", chiefcurator Nelson Aguilar
1998 "Anthropophagy", chiefcurator Paulo Herkenhoff
2002 "Iconografias Metropolitanas", chiefcurator Alfons Hug
2004 "Territorio Livre", chiefcurator Alfons Hug
2006 "Como viver junto", chiefcurator Lisette Lagnado
2008 "In living contact", chiefcurator Ivo Mesquita
2010 chiefcurator Moacir dos Anjos

Shanghai Biennale

1996 "Open Space"
1998 "Inheritance and Exploration"
2000/01 "Haishang – Shanghai" ("Spirit of Shanghai"), chiefcurator Fang Zengxian, curators: Li Yu,
 China; Hou Hanru, France; Toshio Shimizu, Japan; Zhang Qing, China
2002/03 "Urban Creation", chiefcurators Fan Di'an, China, Allan Heiss, USA; curators: Wu Jiang, China; Li Xu,
 China; Klaus Biesenbach, Germany; Yuko Hasegawa, Japan
2004 "Techniques of the Visible", director Xu Jiang, China; curators: Zheng Shengtian, Canada; Sebastian Lopez,
 Netherland; Zhang Qing, China
2006 "Hyperdesign", director Xu Jiang, curators: Zhang Qing, Huang Du, Shu-Min Lin, Wonil Rhee,
 Gianfranco Maraniello, Jonathan Watkinds, Xiao Xiaolan (assistent curator)
2008 "Translocalmotion", artistic director Zhang Qing, curators Julian Heynen, Henk Slager

Sharjah Biennale

1998 "Near", director Peter Lewis, curator Derek Ogbourne
2002 director Hoor Al Qasimi, curator Brigitte Schenk
2003 "Discourses between aesthetics and politics", director Hoor Al Qasimi, curator Peter Lewis
2005 "Belonging", directorin Hoor Al Qasimi, curator Jack Persekian, Ken Lum, Tirdad Zolghadr
2007 "Art, Ecology and the Politics of Change", directorin Hoor Al Qasimi, artistic director Jack Persekian,
 curators: Mohammed Kaziam, Eva Scharrer, Jonathan Watkins
2009 director Hoor Al Qasimi, artistic director Jack Persekian, curators: Isabel Carlos, Tarek Abou El Tetouh

Singapore Biennale

2006 "Belief", artistic director Fumio Nanjo, Japan; curators Roger McDonald, Japan; Eugene Tan, Singapore;
 Sharmini Pereira, Sri Lanka/London
2008 "Wonder", artistic director Fumio Nanjo; curators Joselina Cruz, Manila/Singapore; Matthew Ngui, Singapore
2011 artistic director Matthew Ngui, curators Russell Storer, Trevor Smith

Biennale of Sydney

1973 coordination Anthony Wintherbotham
1976 "Recent International Forms in Art", artistic director Thomas G. McCullough
1979 "European Dialogue", artistic director Nick Waterlow
1982 "Visions in Disbelief", artistic director William Wright
1984 "Private Symbol: Social Metaphor", artistic director Leon Paroissien
1986 "Origins, Originality + Beyond", artistic director Nick Waterlow
1988 "From the Southern Cross: A View of World Art c. 1940 – 1988", artistic director Nick Waterlow
1990 "The Readymade Boomerang: Certain Relations in 20th Century Art", artistic director René Block
1992/93 "The Boundary Rider", artistic director Tony Bond
1996 "Jurassic Technologies Revenant", artistic director Lynne Cooke
1998 "Every Day", artistic director Jonathan Watkins
2000 Chair of International Section Committe Nick Waterlow, Selection Committee: Fumio Nanjo, Louise Neri,
 Hetti Perkins, Nicholas Serota, Robert Storr, Harald Szeemann
2002 "(The World May Be) Fantastic", curator Richard Grayson, (advisory panel: Susan Hiller, Ralph Rugoff,
 Janos Sugar)
2004 "On Reason and Emotion", curator Isabel Carlos
2006 "Zones of Contact", artistic director Charles Merewether
2008 "Revolutions – Forms That Turn", artistic director Carolyn Christov-Bakargiev
2010 "The Beauty of Distance: Songs of Survival in a Precarious Age", artistic director David Elliott

Taipei Biennial

1998 "Site of Desire", curator Fumio Nanjo, team: Miki Akiko, Chang Fangwei
2000 "The Sky is the limit", Jerome Sans, Manray Hsu
2002 "Great Theatre of the world", Bartomeu Mari, Chia Chi Jason Wang
2004 "Do you believe in reality?", Barbara Vanderlinden, Amy Cheng
2006 "Dirty Yoga", Dan Cameron, Junjih Wang
2008 Manray Hsu, Vasif Kortun

Thessaloniki Biennale

2007 Heterotopias, curators: Catherine David "Heterotopias di/visions (from here and elsewhere)"; Jan-Erik Lundström
 "heterotopias – the society must be defended"; Maria Tsantsanouglou,
 "Heterotopias – beholders of other places"
2009 "PRAXIS: Art in Times of Uncertainty"; curator-team: Bisi Silva, Gabriela Salgado, Syrago Tsiara

<u>Venice Biennale</u> (selection)

1977 "Biennale of dissent", president Carlo Ripa Meana
1978 "Dalla Natura all'Arte e dall'Arte alla Natura" ("From nature to art, from art to nature"), director Enrico Crispoli
1980 director Luigi Carluccio, first time "Aperto" at Arsenale, curators: Achille Bonito Oliva and Harald Szeemann
1982 "Art as art: Persistence of the artwork" Gian Alberto Dell'Acqua, (Luigi Carluccio), "Aperto'82",
 curators: Tommaso Trini, Nanda Vigo
1984 "Art and Arts", director Maurizio Calvesi
1986 "Art and Science", director Giovanni Caradente
1988 "Il luogo degli artisti" ("The place of artists"), director Giovanni Caradente
1990 "Dimensione futuro" ("Future dimension")
1993 "Punti dell'Arte", director Achille Bonito Oliva
1995 "Identità e alterità" (Identity and Alterity), director Jean Clair
1997 "Futuro, Presente, Passato", director Germano Celant
1999 "APERTO Over All"
2001 "Plateau of Humankind", director Harald Szeemann
2003 "Dreams and conflicts – the Dictatorship of the viewer", director Francesco Bonami
2005 "The experience of art", director María de Corral; "Always a little further", director Rosa Martinez
2007 "Think with the senses – feel with the mind", director Robert Storr
2009 "Making Worlds", director Daniel Birnbaum
2011 director Bice Curiger

VI. List of literature

Books

(1) Sylviane Agacinski, "Time Passing: Modernity and Nostalgia", New York 2003 (Orig. "Le passeur de temps, Modernité et nostalgie", 2000), New York: Columbia Verlag 2003

(2) Arjun Appadurai, "Die Geographie des Zorns", Frankfurt: edition Suhrkamp, 2009

(3) Michael Asbury, The Bienal de São Paulo: Between nationalism and internationalism, in: Espaço Aberto/Espaço
Fechado, Sites for sculpture in modern Brazil, Henry Moore Institute 2006, S. 73 – 83.

(4) (294) Asian Art Archive, "Did you know?" www.aaa.org.hk/onlineprojects/bitri/en/didyouknow.aspx (zuletzt besucht am 10.11.2008).

(5) Bassam El Baroni, "Remodeling Required: Official Biennales in Egypt and international biennale culture",
in: AICA Press, Art Criticism & curatorial practices in marginal contexts, Paris, Januar 2006

(6) Regina Bärthel, "Dialog der Weltkunst – Aufbruch aus der Isolation", in: Das Fridericianum Magazin 5, Kassel,
Herbst 2000, S.7.

(7) Clive Bell, "Kunst", herausgegeben und eingeleitet von Paul Westheim, Dresden: Sibyllen Verlag 1922.

(8) Hans Belting / Lydia Haustein (Hrsg.), "Das Erbe der Bilder. Kunst und moderne Medien in den Kulturen der Welt", Verlag: C.H.Beck, München 1998.

(9) Hans Belting, "Eine globale Kunstszene? Marco Polo und die anderen Kulturen", in: nbk Bd. 4/5 1995.

(10) Hans Belting, "Hybride Kunst? Ein Blick hinter die globale Fassade", in: "Kunst-Welten im Dialog. Von Gauguin zur globalen Gegenwart", Hrsg. Marc Scheps, Yilmaz Dziewior, Barbara M. Thiemann. Köln: DuMont Verlag, 2000, S. 324 – 330.

(11) René Block, "Biennalen: lokale Kunst und globaler Kontext – ein Ausstellungsmodell auch für die Zukunft?" in: "ZukunftsFormen, Kultur und Agenda 21", Hrsg. Tina Jerman, Essen: Klartext Verlag, 2001, S. 124 – 130.

(12) Quartett. Vier Biennalen im Spiegel grafischer Blätter". Hg. René Block, Barbara Heinrich, Berlin: Edition Block 2008

(13) Gernot Böhme, "Einführung in die Philosophie. Weltweisheit – Lebensform – Wissenschaft", Suhrkamp: Frankfurt/M. 2001.

(14) Werner Busch, "Das sentimentalistische Bild. Die Krise der Kunst im 18. Jahrhundert und die Geburt der Moderne", München: C.H. Beck 1993

(15) T. J. Clark, "Der absolute Bourgeois. Künstler und Politik in Frankreich 1848 bis 1851", Deutsch von Jürgen Abel, Hamburg: Rowohlt 1981.

(16) Documenta Magazine No. 1, 2007, "Modernity?", Hrsg. Documenta und Museum Fridericianum Veranstaltungs GmbH, Kassel, Köln: Taschen Verlag, 2007.

(17) Ethnic Marketing, Hg. Tirdad Zolghadr, Zürich: jrp ringier 2004

(18) Peter E. Fäßler, "Globalisierung", Köln Weimar Wien: Böhlau Verlag, 2007.

(19) Margarete Garlake, "The São Paulo Biennial", in: Britain and the São Paulo Biennial 1951–1991, Hg. The British Council, London: The British Council, 1991.

(20) Johan Galtung, "Der Preis der Modernisierung. Struktur und Kultur im Weltsystem", Wien: Promedia Druck- und Verlags GmbH, 1997.

(21) "Globalisierung / Hierarchisierung. Kulturelle Dominanzen in Kunst und Kunstgeschichte", Hrsg. Irene Below u. Beatrix von Bismarck, Marburg: Jonas Verlag, 2005.

(22) Clement Greenberg, "Die Essenz der Moderne. Ausgewählte Essays und Kritiken", Hrsg. Karlheinz Lüdeking, Amsterdam/Dresden 1997.

(23) "Manifesta Decade", Hrsg. Barbara Vanderlinden, Elena Filipovic, Cambridge: MIT Press, 2005.

(24) Charles Harrison, "Modernismus", Reihe "kunst basics", Ostfildern: Hatje Cantz Verlag, 2001.

(25) Klaus Herding, "Im Zeichen der Aufklärung. Studien zur Moderne", Frankfurt: Fischer TB 1989.

(26) "Aufklärung anstelle von Andacht. Kulturwissenschaftliche Dimensionen bildender Kunst", Hrsg. Klaus Herding, Frankfurt: Peter Lang Verlag 1997.

(27) Max Horkheimer und Theodor W. Adorno, "Dialektik der Aufklärung, Philosophische Fragmente", mit einem Nachwort von Jürgen Habermas, Frankfurt/M.: S. Fischer Verlag 1986.

(28) Paloma F. de la Hoz, "Familienleben, Transnationalität und Diaspora", Österreichisches Institut für Familienforschung, Heft 21/2004, Wien: ÖIF 2004.

(29) Heinz Hürten, Hürten, "Die Epoche der Nationalstaaten und der Erste Weltkrieg", Studienbuch Geschichte Heft 9, Stuttgart: Klett Cotta, 1981.

(30) Winfried Kretschmer, "Geschichte der Weltausstellungen", Frankfurt: Campus Verlag, 1999.

(31) "Kulturelle Globalisierung und regionale Identität. Beiträge zum kulturpolitischen Diskurs", Hrsg. Karin Hanika/Bernd Wagner, Edition Umbruch, Texte zur Kulturpolitik 17, herausgegeben für die Kulturpolitische Gesellschaft e.V. von Eva Krings, Norbert Sievers und Bernd Wagner, Essen: Klartext Verlag, 2004.

(32) "Kulturelle Globalisierung. Zwischen Weltkultur und kultureller Fragmentierung", Hrsg. Bernd Wagner, Hessische Gesellschaft für Demokratie und Ökologie, Landesstiftung der Heinrich-Böll-Stiftung e.V., Bd. 13, Essen: Klartext Verlag, 2001.

(33) "Kunst/Theorie im 20. Jahrhundert", Hrsg. Charles Harrison und Paul Wood, Bd. I 1895–1941, Bd. II 1940–1991. Ostfildern: Verlag Hatje Cantz, 1998.

(34) "Kunstgeschichte und Weltgegenwartskunst. Konzepte, Methoden, Perspektiven", Hrsg. Claus Volkenandt, Berlin: Dietrich Reimer Verlag, 2004.

(35) "Kunst-Welten im Dialog. Von Gauguin zur globalen Gegenwart", Hrsg. Marc Scheps, Yilmaz Dziewior, Barbara M. Thiemann. Köln: DuMont Verlag, 2000.

(36) Helmut Leder, Wem Schönheit nützt. Psychologische Ansätze zur Ästhetik. Antrittsvorlesung am 18.3.2005 an der Universität Wien, www.dieuniversitaet-online.at/pdf/2005/AntrittsVO_Leder.pdf (zuletzt besucht am 20.2.2009).

(37) Niklas Luhmann, "Weltkunst", in: ders. / Frederick D. Bunsen / Dirk Baecker (Hgg.), Unbeobachtbare Welt: über Kunst und Architektur, Bielefeld 1990, S. 7 – 45.

(38) Michael Mann, "Geschichte der Macht. Die Entstehung von Klassen und Nationalstaaten", Band 3, Teil II. Frankfurt/New York: Campus Verlag, 2001.

(39) Erik Mattie, "Weltausstellungen", Stuttgart: Belser Verlag, 1998.

(40) Richard Münch, "Globale Eliten, lokale Autoritäten. Bildung und Wissenschaft unter dem Regime von PISA, McKinsey & Co", Frankfurt: edition suhrkamp, 2009

(41) Dorinda Outram, "Aufbruch in die Moderne. Die Epoche der Aufklärung", Basel: Belser Verlag, 2007.

(42) J. G. A. Pocock, "The Enligthenments of Edward Gibbon", in: Barbarism and Religion, Vol. 1, Cambridge: Cambridge University Press 1999.

(43) Werner Plum, "Weltausstellungen im 19. Jahrhundert: Schauspiele des sozio-kulturellen Wandels". Hefte aus dem Forschungsinstitut der Friedrich-Ebert-Stiftung, Bonn – Bad Godesberg 1975.

(44) Simon Schama, "The Enlightenment in the Netherlands", in: "The Enlightenment in national context", Hg. Roy Porter and Mikalas Teich, S. 54ff, Cambridge: Cambridge University Press 1981.

(45) Theodor Schieder, "Handbuch der europäischen Geschichte", Bd. 6 "Europa im Zeitalter der Nationalstaaten und europäische Weltpolitik bis zum Ersten Weltkrieg", Stuttgart: Union Verlag, 1973

(46) Theodor Schieder, "Nationalismus und Nationalstaat, Studien zum nationalen Problem im modernen Europa", Hrsg. Otto Dann und Hans-Ulrich Wehler, Göttingen: Vandenhoeck & Ruprecht Verlag, 1991.

(47) "Staatsgründungen und Nationalitätsprinzip. Studien zur Geschichte des 19. Jahrhunderts", Abhandlung der Forschungsabteilung des Historischen Seminars der Universität Köln, Bd. 7, Hrsg. Theodor Schieder unter Mitwirkung von Peter Alter, München Wien: R. Oldenbourg, 1974.

(48) Hagen Schulze, "Staat und Nation in der europäischen Geschichte", München: Beck, 1994.

(49) Michael Seidlmayer, "Geschichte Italiens. Vom Zusammenbruch des Römischen Reiches bis zum Ersten Weltkrieg", 2. erw. Auflage, Stuttgart: Alfred Kröner Verlag, 1989.

(50) Jutta Ströter-Bender, "Zeitgenössische Kunst der ‚Dritten Welt'", Köln: DuMont Verlag, 1991.

(51) Marta Stypa, "Möglichkeiten und Grenzen der Globalisierung. Geschichte, Ideologie, Ökonomik", Saarbrücken: VDM Verlag 2006.

(52) Anne-Marie Thiesse, "Grundelemente für den sozialen Zusammenhalt", in: Le Monde Diplomatique, Nr. 5881 vom 9.7.1999, S. 12f., dt. von Bodo Schulze.

(53) Eduard Trier (geb. 1921), "Moderne Plastik von Auguste Rodin bis Marino Marini", Berlin: Gebr. Mann 1954.

(54) Martin Wörner, "Die Welt an einem Ort – illustrierte Geschichte der Weltausstellungen", Berlin: Reimer Verlag, 2000.

(55) Karl Woermann (1844 – 1933), "Die Geschichte der Kunst aller Völker und Zeiten", 6 Bd., Wien/Leipzig: Bibliographisches Institut 1904 – 1911

(56) Beat Wyss, "Die Kunst auf der Suche nach ihrem Text", in: Mythologien der Aufklärung. Geheimlehren der Moderne.", Jahresring 40, Konzeption und Redaktion Beat Wyss, München: Verlag Silke Schreiber 1982.

(57) Bundeszentrale für politische Bildung, www.bpb.de/veranstaltungen/VUPFLA,0,0,Globalisierung%3A_Geschichte_und_Dimensionen_eines_Begriffs.html (zuletzt besucht am 10.11.2008).

Biennial Catalogues

(58) Echigo-Tsumari-Triennale 2000

(59) 4. Berlin Biennale, Hrsg. Maurizio Cattelan et al., "Von Mäusen und Menschen", Stuttgart: Hatje Cantz 2006 (Katalog und Kurzführer).

(60) 5. Berlin Biennale 2008, Hrsg. Adam Szymczyk & Elena Filipovic, "When Things Cast No Shadows", Zürich: jrp ringier 2008.

(61) 5. Gwangju Biennale, "A Grain of Dust, A Grap of Water", 2 Bd., Gwangju 2004.

(62) 6. Gwangju Biennale, "Fever Variations", Gwangju 2006. International Biennales", Gwangju 2006.

(63) 5. Biennale von Havana, "Kunst – Gesellschaft – Reflexion. Eine Auswahl". Ludwig Forum für Internationale Kunst, Aachen, September 1994, mit Beiträgen von Wolfgang Becker, Lilian Llanes, Nelson Herrera Ysla, Eugenio Valdés Figueroa, Hilda Maria Rodriguez, Ibis Hernández und Margarita Sánchez Prieto, Magda I. González-Mora, Juan Antonio Molina.

(64) 6. Istanbul Biennale 1999, "The Passion and the Wave", 2 Bd.,Istanbul: Istanbul Foundation for Culture and Arts 1999.

(65) 7. Istanbul Biennale 2001, "Egofugal", Hg. Hüseyin Karagöz, Istanbul: Istanbul Foundation for Culture and Arts 2001.

(66) 8. Istanbul Biennale 2003, "Poetic Justice", 2 Bd., Istanbul: Istanbul Foundation for Culture and Arts 2003.

(67) 9. Istanbul Biennale 2005, "Art, City and Politics in an expanding world – Writings from the 9th Istanbul Biennial", Istanbul: Istanbul Foundation for Culture and Arts 2005.

(68) 9. Istanbul Biennale 2005, Ausstellungsführer, Istanbul: Istanbul Foundation for Culture and Arts 2005.

(69) 10. Istanbul Biennale 2007, "Not only possible but also necessary – Optimism in the age of global war", Istanbul: Istanbul Foundation for Culture and Arts 2007.

(70) 10. Istanbul Biennale 2007, The Guide, Istanbul: Istanbul Foundation for Culture and Arts 2007.

(71) 11. Istanbul Biennale 2009, The Guide, Istanbul: Istanbul Foundation for Culture and Arts 2009

(72) Liverpool Biennale 2004, Hrsg. Paul Domela, Liverpool 2004.

(73) Liverpool Biennial 2006, Hrsg. Paul Domela, Liverpool 2006.

(74) São Paulo Biennale, São Paulo 1961.

(75) 26. Bienal de São Paulo, 2 Bd. (invited artists; national representations), Hrsg. Alfons Hug, São Paulo: Fundaçao Bienal de São Paulo 2004.

(76) 6. Shanghai Biennale 2006, "Hyperdesign", Hrsg. Fang Zengxian, Xu Jiang, Shanghai: Shanghai Fine Art Publisher 2006.

(77) 7. Shanghai Biennale 2008, "Trans Local Motion", Shanghai 2008.

(78) Sharjah Biennial 7, "Belonging", Sharjah: Information Department, Art Museum-Sharjah 2005.

(79) Sharjah Biennial 8, "Art, Ecology & The Politics of Change – Still Life", Sharjah 2007.

(80) Sharjah Biennial 9, Book 1: "Provisions", Sharjah Biennial and Bidoun, New York, 2009.

(81) CAMP, Katalog Wharfage, Sharjah Creek 2008 – 2009, Mumbai 2009.

(82) 1. Singapore Biennale 2006, "Belief", Exhibitions Shortguide.

(83) 2. Singapore Biennale 2008, "Wonder", Exhibitions Shortguide.

(84) Broschüre Historisches Museum Arnheim, Sonsbeek – 10 × Sonsbeek, Arnheim 2008.

(85) Sydney Biennale 2006, "Zones of Contact", Hg. Charles Merewether, Sydney 2006.

(86) Taipei Biennial, Vasif Kortun, Manray Hsu, Besucherführer, Taipei: Taipei Fine Arts Museum 2008.

(87) Thessaloniki Biennale: 1, "Heterotopias", Ministry of Culture 2007

(88) Biennale Guide Thessaloniki Biennale: 1, Ministry of Culture 2007

Publications of the Biennale di Venezia

(89) Carl Aigner, "Im Angesicht des Löwen. Österreich und die Biennale di Venezia",
Wien: Christian Brandstätter Verlag 2009

(90) Lawrence Alloway, "From salon to goldfish bowl", in: "The Venice Biennale 1895 – 1968", 1. publ.,
London: Faber& Faber, 1969.

(91) "Die deutschen Beiträge zur Biennale Venedig 1895 – 2007", Hrsg. Ursula Zeller,
Stuttgart: ifa (Institut für Auslandsbeziehungen), 2007.

(92) Robert Fleck, "Die Biennale von Venedig. Eine Geschichte des 20. Jahrhunderts."
Hamburg: Philo Fine Arts, Fundus-Bücher 177, 2009

(93) Annette Lagler, "Biennale Venedig. Der deutsche Beitrag und seine Theorie in der Chronologie von Zusammenkunft
und Abgrenzung", Promotion 1992, Philosophische Fakultät der Rheinisch-Westfälischen Technischen Hochschule
Aachen, 1992.

(94) "Biennale Venedig, Der deutsche Beitrag 1895 – 1995", Stuttgart 1995, Christoph Becker, Annette Lagler,
Hrsg. ifa, Stuttgart: Hatje Cantz Verlag 1995.

(95) "Garten der Künste. Hundert Jahre Biennale – Souvenir de Venise", Jahresring 42, Jahrbuch für moderne Kunst,
Hrsg. B. Von Loeffelholz, B. Oetker, Konzeption Laslo Gloser, Köln: Oktagon Verlag, 1995.

(96) "50 Jahre österreichischer Pavillon Biennale Venedig", Wien 1984.

(97) "Britain at the Venice Biennale 1895 – 1995", Hrsg. Sophie Bowness and Clive Phillpot,
London: The British Council 1995.

(98) Catalogue of Venice Biennale, Venedig 1905

(99) Catalogue of Venice Biennale XXVIII, Venedig 1956.

Journals

(100) "Das Lied von der Erde", Katalog-Zeitschrift zur gleichnamigen Ausstellung,
Hrsg. Rene Block, Museum Fridericianum, Kassel 2000.

(101) Alfred Nemeczek, Jedem Dorf seine Biennale?, in: Art 8/00, S. 54.

(102) Michael Fried, "Art and Objecthood", in: Artforum, New York, Sommer 1967, S. 12 – 23.

(103) Thomas McEvilley, "Arrivederci Venice: the Third World Biennials – reviews of Third World international art survey
exhibitions", in: Artforum Nov. 1993.

(104) Broadsheet, Contemporary Visual Arts + Culture, Neuseeland, Vol. 35, Nr. 3, Sept. Nov. 2006.

(105) Framework, Special Nordic Issue, Nationality in Context, Nr. 7/June 07, Helsinki 2007

(106) "Weltkunst – Globalkunst", Hrsg. Paolo Bianchi, Kunstforum Bd. 118, 1992.

(107) Guy Brett, "Venedig, Paris, Kassel, São Paulo und Havana – Über die Biennalen,die Documenta und
Les Magiciens de la Terre", in: Kunstforum, Köln, Bd. 124, Nov./Dez. 1993, S. 337ff.

(108) "Biennalen der Welt", Kunstforum Bd. 124, Nov./Dez. 1993, S. 236–355.

(109) Homi K. Bhabha interviewt von Ria Lavrijsen, "Nord- & Süd-Kunst im Dialog? Über die Idee interkultureller Ausstellungen", in: Kunstforum Bd. 124, Nov./Dez. 1993, S. 355ff.

(110) Susanne Boecker, "Biennalen im Dialog: Internationale Konferenz in Kassel 3.– 6.8.2000", in: Kunstforum Bd. 152, 2000.

(111) Interview Heinz-Norbert Jocks mit Simon Njami, Kurator "Afrika Remix", in: Kunstforum Bd. 156, 2001.

(112) 2. Konferenz "Biennalen im Dialog" in Frankfurt, "Austausch oder globaler Inzest?", in: Kunstforum Bd. 161, August/Oktober 2002.

(113) Anton Henze, "Biennale als Utopie", in: Das Kunstwerk, Zeitschrift für moderne Kunst, Stuttgart Berlin Köln Mainz: Verlag W. Kohlhammer, 5/1976.

(114) Gerardo Mosquera, "Die Welt des Unterschieds. Anmerkungen zu Kunst, Globalisierung und Peripherie", in: neue bildende kunst, Zeitschrift für Kunst und Kritik, "Das Marco Polo Syndrom", 4/5 1995

Articles on Biennials in Journals

(115) 3. Asia Pacific Triennale, Charles Green, in: Art in America (kurz: AiA), New York, Winter 1999, "Beyond the Future: The Third Asia-Pacific Triennial".

(116) 4. Asia Pacific Triennale, Felicity Fenner, in: AiA July 2003, "Diversity Down Under: the most recent Asia Pacific Triennial highlighted three internationally acclaimed artists, along with a selective sample of talents from across the region – Report From Brisbane".

(117) 1. Athen Biennale, Sabine B. Vogel, in: Spike 14, Wien, Dezember 2007.

(118) Xenia Kalpaktsoglou, in: Deutschlandradio 12.9.2007, Alkyone Karamanolis, www.dradio.de/dlf/sendungen/kulturheute/669328 (zuletzt besucht am 10.11.2008).

(119) 1. Athen Biennale, Kalliopi Minioudaki, "Destroy Athens, Reinvent Athena: A view of the first Athens Biennial", October 4th, 2007, in: www.artfairsinternational.com (zuletzt besucht am 10.11.2008).

(120) 2006Beaufort – Triennale für zeitgenössische Kunst am Meer, Damian Zimmermann, in: www.artnet.de/magazine/authors/vogel.asp , Berlin, "Meer Kunst!".

(121) Beaufort03, Sabine B. Vogel, in: www.artnet.de/magazine/reviews/vogel/vogel08-21-09.asp

(122) 5. Berlin Biennale, Sabine B. Vogel, "Wenn Dinge keine Schatten werfen", in: Die Presse, 9. April 2008

(123) Interview von Hendro Wiyanto mit Jim Supangkat zur 2. CP Biennale 2005, in: www.universes-in-universe.de, Berlin.

(124) 1. Dak'Art Biennale, Senegal 1992, Ines Anselmi, in: Kunstforum Bd. 124, Nov./Dez. 1993, S. 351f, "Ein Anfang mit Mühen".

(125) Gespräch mit Amadou L. Sall, Dak'Art 1992, von Ines Anselmi & Paolo Bianchi, in: Kunstforum Bd. 124, Nov./Dez. 1993, S. 353f.

(126) 3. DAK'ART Biennale, Senegal 1998, Lydia Haustein, in: nbk 3/1998 (neue bildende kunst), Berlin, S.74f.

(127) 4. DAK'ART Biennale, Senegal 2000, Sabine Vogel, in: Berliner Zeitung 29.5.2000, Berlin, "Abschied von der Authentizität".

(128) 4. DAK'ART Biennale, Senegal 2000, Thomas McEvilley, in: AiA Jan. 2001, "Towards a creative reversal – 2000 Dakar Biennale of contemporary African art".

(129) 7. DAK'ART Biennale, Robert Storr, in: Artforum Oct. 2006, XLV No. 2, S. 91.

(130) Quadriennale Düsseldorf, Sabine B. Vogel, in: www.artnet.de/magazine/authors/vogel.asp

(131) 2. Guanghzou Triennale, Saskia Draxler, in: TAZ, Berlin, 25.11.2005, S. 15, "Chinesische Fantasien".

(132) Press Release 2. Guangzhou Triennale, Guangzhou Triennale.

(133) 1. Kwangju Biennale 1995, Eleanor Heartney, in: AiA April 1996, "20th century AD".

(134) 1. Kwangju Biennale, Jason Edward Kaufman, in: The Art Newspaper, London, 1995, S. 9, "Kwangju Biennial opens in Korea".

(135) 2. Kwangju Biennale 1997, Richard Vine, in: AiA Juli 1998, "Asian futures: status of South Korea in art world – includes related article on contemporary Korean art".

(136) 2. Kwangju Biennale, Mary Anne Staniszewski, in: Artforum Sept. 1997, "1997 AD" (Kwangju und 2. Johannesburg Biennale).

(137) 2. Kwangju Biennale, Thomas Wulffen, in: Kunstforum Bd. 139, Dez. 1997 – März 1998, S. 415ff.

(138) 3. Kwangju Biennale, Frank Hoffmann, in: AiA Nov. 2000, "Monoculture and its Discontents: Kwangju Biennale 2000 – Statistica Data Included".

(139) 3. Kwangju Biennale, Birgit Mersmann, in: Kunstforum Bd. 152, 2000, "Kunstraum Korea – East meets West".

(140) 4. Gwangju Biennale, Jonathan Napack, in: AiA Nov. 2002, "Alternative Visions: in a provocative curatorial gesture, this year's Gwangju Biennale was largely dedicated to – and determinded by – independent artist groups and alternative spaces – Report From Gwangju".

(141) 5. Gwangju Biennale, Notiz in "Biennale Nachrichten", Kunstforum Bd. 172, 2004.

(142) 6. Gwangju Biennale, Sabine B. Vogel, in: Neue Zürcher Zeitung, Zürich, 16.10.2006, Nr. 240, S. 25, "Asiatisches Fieber".

(143) 6. Gwangju Biennale, Sabine B. Vogel 2006 www.artnet.de/magazine/authors/vogel.asp (zuletzt besucht am 2.4.2009)

(144) 1. Havana Biennale, Jutta Guerra Valdes, in: Bildende Kunst, Berlin, 12/1984, S. 568.

(145) Havana Biennale, Llilian Llanes, "Tradition und Zeitgemäßheit. Die Biennale von Havana – ein offener Raum für die bildende Kunst aus drei Kontinenten", in: Bildende Kunst 4/1989, S. 31f.

(146) Havana Biennale, Llilian Llanes im Gespräch mit Ines Anselmi, in: Kunstforum Bd. 124, Nov./Dez. 1993, S. 342ff.

(147) Auszüge aus Rundschreiben zur 5. Havana Biennale 1994, "Nachdenken über Kunst und Gesellschaft", in: Kunstforum Bd. 124, Nov./Dez. 1993, S. 346f.

(148) 5. Havana Biennale, in: nbk 4/1994.

(149) 5. Havana Biennale, Interview Isabel Rith-Magni mit Wolfgang Becker, Ludwig Forum Aachen, in: Kunstforum Bd. 128, 1994.

(150) 5. Havana Biennale, Ines Anselmi, in: Kunstforum Bd. 128, 1994, "Kunst, Macht und Marginalität".

(151) 5. Havana Biennale, Betty Klausner, in: AiA Oct. 1994, "U.S. contingent in Havana – U.S. artists represented in the Havana Biennial V – Report from Cuba".

(152) 5. Havana Bienniale, Kurt Hollander, in: AiA Oct. 1994, "Art, emigration and tourism: works by Cuban artists in last spring's fifth Havana Biennial foreshadowed the country's current massive exodus of boat people – Report from Cuba".

(153) 5. Havana Bienniale, Gerhard Haupt, "Endzeitstimmung", in: nbk 4/1994.

(154) 6th Biennial of Havana, Press-Release-Auszug in www.universes-in-universe.de, "Individuum und Gedächtnis".

(155) 6. Havana Biennale, in: nbk 4/1997.

(156) 6. Havana Biennale, Rachel Weiss, in: Art Nexus Nr. 26/1997.

(157) 6. Havana Biennale, Paolo Bianchi, in: Kunstforum Bd. 139

(158) 7. Havana Biennale, Grady T. Turner, in: AiA Okt. 2003, "Sweet Dreams – 7th Havana Biennial exhibition, Cuba".

(159) 7. Havana Biennale, Dermis P. Leon, in: Art Journal Winter 2001, "Havana, Biennial, tourism: the spectacle of utopia".

(160) 7. Havana Biennale, Nico Israel, in: Artforum Feb. 2001, VII Bienal De La Habana.

(161) 7. Havana Biennale, Walter Robinson, in: www.artnet.de/magazine/authors/vogel.asp, "Havana, Art Capital".

(162) 8. Havana Biennale, www.universes-in-universe.de/car/habana/bien8/index.htm (zuletzt besucht am 2.4.2009).

(163) 8. Havana Biennale, Henky Hentschel, in: Kunstforum Bd. 168, 2003.

(164) 9. Havana Biennale, Sabine B. Vogel, 2006, in: www.artnet.de/magazine/authors/vogel.asp .

(165) "Havana, Biennial, tourism: The spectacle of utopia", Dermis P. Leon, in: AiA Winter 2001.

(166) 10. Havana Biennale 2009, www.universes-in-universe.de/car/habana/index.htm (zuletzt besucht am 2.4.2009).

(167) Istanbul Biennale, Beral Madra, in: nbk 4/4 1995, "Kollison vor Ort – Über die Anfänge der Istanbul-Biennale".

(168) 2. Istanbul Biennale, Angelika Stepken, in: Kunstforum Bd. 105, Jan./Feb. 1990, S. 306ff.

(169) 2. Istanbul Biennale, Angelika Stepken, Kunstforum Bd. 105, Jan./Feb. 1990, S. 306ff.

(170) 3. Istanbul Biennale, Sarah McFadden, in: AiA June 1993, "Report from Istanbul: Bosporus dialogues – Third International Istanbul Biennial exhibition".

(171) 3. Istanbul Biennale, Christian Kravagna, in: Kunstforum Bd. 121, 1993.

(172) 4. Istanbul Biennale, Gregory Volk, in: AiA Mai 1996, "Between east and west – The Fourth International Istanbul Biennial, Antrepo, Hagia Irene and Yerebatan, Istanbul, Turkey".

(173) 4. Istanbul Biennale, Harald Fricke, in: TAZ, Berlin, 20.11.1995, S. 15/16, "Der Westen geht im Osten auf".

(174) 5. Istanbul Biennale, Angelika Stepken, in: nbk 6/1997.

(175) 5. Istanbul Biennale, Fritz von Klinggräff, in: TAZ 17.11.1997, S. 19, "Das Verschwinden des Barbiers".

(176) 6. Istanbul Biennale, in: ART. Das Kunstmagazin, Hamburg, 9/99.

(177) 6. Istanbul Biennale, Necmi Sönmez, in: nbk 6/1999, S. 65f., "Gemischtwaren".

(178) 7. Istanbul Biennale, Angelika Richter, in: TAZ 31.10.2001, "Das Ego als Insel".

(179) 7. Istanbul Biennale, Gregory Volk, in: AiA März 2002, "Back to the Bosphorus: the 2001 Istanbul Biennial was titled ‚Egofugal', a term invented by the curator to suggest diffusion of the individual ego into broader systems and networks – Report from Istanbul".

(180) 8. Istanbul Biennale, Berin Golonu, in: www.stretcher.org 29.2.2004, "The 8th International Istanbul Biennial" www.stretcher.org/archives/r4_a/2004_02_29_r4_archive.php (zuletzt besucht am 1.2.2009).

(181) 8. Istanbul Biennale, Ingo Arend, in: Freitag, Berlin, 45. Woche, 31.10.2003, "Sind Sie gerecht?".

(182) 9. Istanbul Biennale, Sabine B. Vogel, in: Die Presse, Wien, 24.9.2005, "Der andere Blick".

(183) 9. Istanbul Biennale, Sabine B. Vogel, in: www.artnet.de/magazine/authors/vogel.asp , "Hospitality Zone?".

(184) 9. Istanbul Biennale, Samuel Herzog, in: NZZ 28.9.2005, "Eine Frage der Perspektive – Die 9. Kunstbiennale von Istanbul".

(185) 9. Istanbul Biennale, "Istanbul City Report", Jörg Heiser, Erden Kosova, Jan Verwoert, in: Frieze, London, Nov./Dez. 2005 www.frieze.com/issue/article/istanbul_city_report (zuletzt besucht am 1.2.2009).

(186) 10. Istanbul Biennale, Sabine B. Vogel, in: Spike Nr. 13, Sept. 2007

(187) 10. Istanbul Biennale, Sabine B. Vogel, http://universes-in-universe.org/deu/nafas/articles/2007/istanbul_biennial_2007 (zuletzt besucht am 1.2.2009).

(188) 11. Istanbul Biennale, Sabine B. Vogel, in: Die Presse, 5.10.2009, http://diepresse.com/home/kultur/kunst/513003/index.do?_vl_backlink=/home/kultur/index.do

(189) 1. Johannesburg Biennale, Thomas McEvilley, in: AiA Sept. 1995, "Towards a world class city? – first African Biennale in Johannesburg, South Africa".

(190) 2. Johannesburg Biennale, Armin Medosch, in: Telepolis, München, 29.10.1997, "Die Zweite Biennale von Südafrika. Digitale Diaspora am Kap der Guten Hoffnung".

(191) 2. Johannesburg Biennale, Manthia Diawara, in: Artforum XXXVI März 1998, S. 87 – 89, "Moving company: The Second Johannesburg Biennale".

(192) 8. Kairo Biennale, Marilu Knode, in: AiA Jan. 2002, "Local conditions, western forms: the 8th international Cairo Bienniale presented an uncommon opportunity to study the intersection of Middle Eastern culture and contemporary art – exhibition Egypt"

(193) 9. Kairo Biennale, Lilly Wei in: AiA Mai 2004, "The Cairo Effect: during the 9th Cairo Biennale a striking contrast prevailed between the staid official event and several lievlier satellite exhitions",

(194) 9. Biennale Kairo, Iolanda Pensa, in: www.universes-in-universe.de, Aktuelle Kunst aus der islamischen Welt, Ausgabe 5, Januar 2004, "9. Biennale Kairo: Gib mir einen Luftballon",

(195) 9. Kairo Biennale, Carey Lovelace, in: www.artnet.com, "Cairo Blues".

(196) 1. Liverpool Biennial, Tom Lubbock, in: The Independent, London, 28.9.1999, "When bigger isn't better".

(197) 3. Liverpool Biennial, Thomas Wulffen, in: Kunstforum Bd. 173, 2004.

(198) 4. Liverpool Biennale 2006, Sabine B. Vogel, in: Kunstbulletin, Zürich, 11/06, S. 88.

(199) 4. Liverpool Biennale 2006, Sabine B. Vogel, www.artnet.de/magazine/authors/vogel.asp , "Stadt im Käfig".

(200) 1. Biennale Lyon, Armina Haase, in: Kunstforum Bd. 116, 1991.

(201) 2. Biennale Lyon, Maribel Königer, in: Kunstforum Bd. 124, 1993.

(202) 3. Biennale Lyon, Maribel Königer, in: Kunstforum Bd. 134, 1996.

(203) 3. Biennale Lyon, Miriam Rosen, in: Artforum, April 1996.

(204) 5. Biennale Lyon, Armina Haase, in: Kunstforum Bd. 152, 2000.

(205) 6. Biennale Lyon, Fabian Stech, in: Kunstforum Bd. 156, 2001.

(206) 7. Biennale Lyon, Martin Herberg, in: Artforum Dez. 2003.

(207) 7. Biennale Lyon, Stephanie Cash, in: AiA März 2003

(208) 8. Biennale Lyon, Fabian Stech, in: Kunstforum Bd. 178, 2005.

(209) 10. Biennale Lyon, Samuel Herzog, in: NZZ 14.12.2009

(210) Manifesta2, Luxembourg, Sabine B. Vogel, in: Der Standard, Wien, 5.8.1998.

(211) Manifesta3, Jochen Becker, in: TAZ 12.7.2000, S. 13, "Und wer entdeckt Slowenien?".

(212) Manifesta5, Gregor Janssen, in: TAZ 14.7.2004, S. 16, "Architektur der Grenze".

(213) "Manifesta No More", Augustine Zenakos, in: www.artnet.de/magazine/authors/vogel.asp .

(214) La Biennale de Montréal 1998 Press Release

(215) Skulpturbiennale Münsterland 2003 Press Release

(216) 1. Moskau Biennale, Samuel Herzog, in: NZZ 5.2.2005, "Hoffen auf ein farbiges Wunder –
Die erste Moskauer Biennale für zeitgenössische Kunst".

(217) 1. Moskau Biennale, Julia Axjonowa, in: Russland Aktuell, 12.5.2006. www.russlandonline.ru/mos0010 (zuletzt
besucht am 11.4.2007).

(218) 1. Moskau Biennale, Meike Jansen, in: www.artnews.info, "Diskursfreie Zone".

(219) Kunstmesse Art-Moscow im Zentralhaus der Künstler, in: Russland Aktuell,
www.russland.ru 19.5.2006, "Dies ist keine Bombe".

(220) The Moscow State Biennial, Elena Sorokina, in: Artmargins, New York, 19.1.2005
www.artmargins.com/content/review .

(221) 2. Moskau Biennale 2007, Sabine B. Vogel, in: www.artnet.de/magazine/authors/vogel.asp .

(222) 2. Prag Biennale, Sabine B. Vogel in: www.artnet.de/magazine/authors/vogel.asp .

(223) Prag Biennale II, Sabine B. Vogel, in: www.artnet.de/magazine/authors/vogel.asp .

(224) 2. Prag Biennale, Richard Vine, in: AiA Sept. 2005, "Biennale gamble: doubling down: spawned by a curatorical
feud, two international biennials now vie for viewer attention in the Czech capital".

(225) 3. Riwaq Biennale, Sabine B. Vogel www.artnet.de/magazine/reviews/vogel/vogel11-04-09.asp

(226) 23. São Paulo Biennale, Edward Leffingwell, in: AiA März 1997, "1996 AD".

(227) 25. São Paulo Biennale, Nico Israel, in: Artforum Sommer 2002.

(228) 26. São Paulo Biennale, Sabine B. Vogel, in: Spike 02, Dez. 2004.

(229) Interv. Mit Alfons Hug, Goethe Institut, "Gegen den Eurozentrismus in der Kunst",
www.goethe.de/prs/int/de27347.htm (zuletzt besucht am 10.11.2008).

(230) Die Biennale als Territorio Live, 26. São Paulo Biennale, Alfons Hug Juli 2004, www.universes-of-universe.de

(231) 1. Guangzhou Triennale und 4. Shanghai Biennale, Richard Vine, in: AiA Sept. 2003, "The wild, wild East: the
first-ever Guangzhou Triennale and the fourth Shanghai Biennale, in their concurrent runs, caught the energy of
the entrepreneurial New China and its art – Report From China".

(232) "Shanghai – Stadt der geplanten Zukunft", ZDF-Sendung vom 3.8.2006, 22.15.

(233) Gespräch Klaus Biesenbach über die 4. Shanghai Biennale 2002, Brigitte Werneburg,
in: TAZ 9.12.2002, S. 15, "Kataloge als Kopiervorlage".

(234) 5. Shanghai Biennale, Richard Vine, in: AiA Feb. 2005, "Shanghai accelerates: bringing together over 100 Chinese
and international artists, the fifth Shanghai Biennale examined methods of visual representation, old and new, in
the context of the PRC's most beguiling and progressive city".

(235) 6. Shanghai Biennale, Sabine B. Vogel, in: www.artnet.de/magazine/authors/vogel.asp .

(236) 6. Shanghai Biennale, Samuel Herzog, in: NZZ 2.10.2006,
"Ein Huhn im Glückspfeffer und bald ein Himmel ohne Wolken".

(237) 7. Shanghai Biennale 2008, Sabine B. Vogel, in: Die Presse, 19.9.2008, "Scheitern in China".

(238) Interview mit Julian Heynen, Kurator der 7. Shanghai Biennale, v. Sabine B. Vogel,
in: www.kunstundbuecher.at (zuletzt besucht am 1.2.2009).

(239) 6. Sharjah Biennale, Grady T. Turner, in: AiA, Nov. 2003, "Fast forward on the Persian gulf: the youthful director
of the Sixth Sharja International Biennial, Sheikha Hoor Al-Qasimi, expanded the event's scope to include cutting
edge-art from over 24 countries – Report from the U.A.E.".

(240) 6. Sharjah Biennial, Christopher Kuhl, in: www.stretcher.org 13.8.2004, "Through the Arabic Window: Evidence of
Human Values", www.stretcher.org/archives/r8_a/2004_08_13_r8_archive.php
(zuletzt besucht am 10.11.2008).

(241) 7. Sharjah Biennale, Sabine B. Vogel, in: Spike 04 Sommer 2005.

(242) 7. Sharjah Biennale, Sabine B. Vogel, in: www.artnet.de/magazine/authors/vogel.asp.

(243) 7. Sharjah Biennale, Samuel Herzog, in: NZZ 16.4.2005/43, "Künstlerische Testbohrungen am Golf".

(244) 7. Sharjah Biennale, www.universes-in-universe.de.

(245) 8. Sharjah Biennale, Werner Bloch, Süddeutsche Zeitung, München, 18.4.2007, S. 11.

(246) 9. Sharjah Biennale, Sabine B. Vogel, Die Presse, Wien, 29.3.2009, "Schatzgrube für Idealisten"

(247) 9. Sharjah Biennale, Sabine B. Vogel, in: NZZ 6.6.2009, "Weltgemeinschaft aus Regionen"

(248) 1. Singapore Biennale, Interview mit Fumio Nanjo von G. Haupt u. Pat Binder, www.universes-in-universe.de, Januar 2006, "SB2006 im Zeichen des ‚Glaubens'".

(249) 1. Singapore Biennale, Interview mit Fumio Nanjo von Alan Cruickshank, S. 136ff, in: Broadsheet, Contemporary Visual Arts + Culture, Vol. 35, No. 3 Sept. – Nov. 2006.

(250) 1. Singapore Biennale 2006, Thomas Wulffen, in: TAZ 13.9.2006, "Ein Gebet für die Kunst".

(251) 1. Singapore Biennale 2006, Sabine B. Vogel, in: Süddeutsche Zeitung, 7./8.10.2006, Nr. 231, S. 17, "Allein der Glauben zählt".

(252) Singapore Biennale, Shanghai Biennale, Gwangju Biennale 2006, Sabine B. Vogel, in: Der Standard, Wochenendbeilage "Album", 16.9.2006, S. A2, "Der kopflose Buddha".

(253) 1. Singapore Biennale 2006, Sabine B. Vogel, in: Monopol Nr. 6/2006 Dez.

(254) 1. Singapore Biennale 2006, Samuel Herzog, in: NZZ 21.11.2006

(255) 1. Singapore Biennale 2006, The Straits Times, 29. Juli 2006.

(256) 2.Singapore Biennale 2008, Sabine B. Vogel, in: Kunst und Kirche – Religion im öffentlichen Raum, Wien: Springer Verlag, 04/2008, S. 53f.

(257) 1. Site Santa Fe, "Longing and Belonging", Christine Hoffmann, in: nbk 4/5 1995, S. 136f.

(258) 9. Sydney Biennale, 1992/93, Interview mit Anthony Bond von Terence Maloon, in: Kunstforum Bd. 124, Nov./Dez. 1993, S. 348ff.

(259) 10. Sydney Biennale und 2. Asia-Pacific-Triennale, Judith E. Stein, in: AiA, Juni 1997, "Pacific Basin futures Sydney Biennale, Art Gallery of New South Wales, Sydney, Australia; Asia-Pacific-Triennale, Queensland Art Gallery, Brisbane, Australia; various artists".

(260) 13. Sydney Biennale, Michael Duncan, in: AiA Oct. 2002, "Self-created worlds: last summer's Biennale of Sydney gave free rein to complex, often offbeat works predicated on alternate realities – Report from Sydney".

(261) 14. Sydney Biennale, Jeff Gibson, in: Artforum Mai 2004.

(262) Sydney Biennale, Pressetexte und "Artistic Director's Report" www.biennaleofsydney.com.au (zuletzt besucht am 10.11.2008).

(263) 15. Sydney Biennale, Spezialausgabe Broadsheet, Vol. 35, No. 3, Sept. – Nov. 2006

(264) Triennale India, New Delhi, Sabine B. Vogel, in: NZZ 2.2.2005, "Zwischen Kitsch und Kunst", 22.2.2005.

(265) Sabine B. Vogel, "New Spirit: Indien", in: Spike, Wien, Juni 2008, S.98 – 105.

(266) 4. Taipei Biennale, Noemi Smolik, in: Kunstforum Bd. 174, 2005.

(267) 6. Taipei Biennale, Sabine B. Vogel, in: NZZ 27.9.2008, "Zornig und problembewusst", S. B3.

(268) Biennale Venedig, in: Das Kunstwerk Juli – September 1965.

(269) 6. Biennale Venedig, in: Kunstchronik 1907.

(270) 35. Biennale Venedig, in: Das Kunstwerk 11 – 12 XXIII 1970 Okt. – Nov., Robert Kudielka, "Plädoyer für Venedig", S. 6f., Enrico Crispolti, "Wie kann die Biennale von Venedig gerettet werden?", S. 8f., Klaus Jürgen-Fischer, "Kunstkritisches Tagebuch", S.76f.

(271) 37. Biennale Venedig, in: Das Kunstwerk 5 XXIX 1976 September; Barbara Catoir "Biennale Venedig 1976"; Anton Henze, S. 23ff., "Biennale als politische Utopie", S. 47f.

(272) 40. Biennale Venedig, in: Das Kunstwerk, Heft 3, XXXV Jg. Juni 1982, "Nicht steuern, nicht gegensteuern – Ein Gespräch zwischen dem deutschen Kommissar der Biennale Venedig, Johannes Cladders, und Heiner Stachelhaus", S. 29f.

(273) 40. Biennale Venedig, Rolf-Gunter Dienst, in: Das Kunstwerk 4 XXXV 1982, August, S. 53ff.

(274) 45. Biennale Venedig, Ulf Erdmann Ziegler, in: TAZ 14.6.1993, S. 13/14, "Kunst als Beispiel und Windspiel".

(275) Aperto 93, XLV. Biennale di Venezia, Giancarlo Politi Editore, Flash Art International, Special Aperto '93, Project by Achille Bonito Oliva, Milan 1993.

(276) 46. Biennale Venedig – 100 Jahre Biennale, Ulf Erdmann Ziegler, in: TAZ 10.7.1995, S. 15/16, "Venezianische Miniatur".

(277) 46. Biennale Venedig – 100 Jahre, Roland H. Wiegenstein, "Hundert Jahre Kunstbiennale in Venedig", in: Die Neue Gesellschaft, Frankfurter Hefte Sept. 1995, Nr. 9,42. Jg., S. 780.

(278) 48. Biennale Venedig, Sabine B. Vogel, in: Camera Austria, Graz, 67/1999.

(279) 48. Biennale Venedig – chinesische Kunst, Stefanie Tasch, in: TAZ 12.7.1999, S. 13, "Identität durch Entblößung".

(280) 49. Biennale Venedig, Beitrag Portugal, Sabine B. Vogel, in: Kunstbulletin 9/2001.

(281) 49. Biennale Venedig, Harald Fricke, in: TAZ 4.11.2001, S. 13, "Prada in Hüttendorf".

(282) 50. Biennale Venedig, Harald Fricke, in: TAZ 12.6.2003, S. 16, "Die Welt ist eine Flasche".

(283) 50. Biennale Venedig, Harald Fricke, in: TAZ 16.6.2003, S.15, "Jeder ist anders, deshalb sagt er ich".

(284) 51. Biennale Venedig, Sabine B. Vogel, 2003, in: www.artnet.de/magazine/authors/vogel.asp .

(285) 51. Biennale Venedig, Hajo Schiff, in: TAZ 2.7.2005, S. 22, "Marco Polos Erzählungen".

(286) 53. Biennale Venedig, Sabine B. Vogel, "Palestine c/o Venice" und Beitrag Vereinigte Arabische Emirate, in: www.artnet.de/magazine/reviews/vogel/vogel06-18-09.asp (zuletzt besucht am 12.8.2009).

(287) Yokohama Triennale trouble, Stephanie Cash, in: AiA Feb. 2005.

(288) 1. Yokohama Triennale, Christopher Philips, in: AiA June 2002, "Crosscurrents in Yokohama: the art world's newest international event debuted with an enviable budget, an impressive waterfront site and a sobering mission: to jump-start Japan both culturally and economically – Yokohama Triennale".

(289) 1. Yokohama Triennale, Reinhard Ermen, in: Kunstforum Bd. 157, 2001.

List of Biennials

www.ifa.de/links/kunst/dbiennalen.htm

www.aaa.org.hk Asian Art Archive

www.universes-in-universe.de

VII. List of keywords

Singapore 2006, N.S. Harsha, Cosmic Orphans,
Sri Krishnan Temple, photo: Sabine B. Vogel

Sonsbeek 2008, Fernando Sánchez Castillo,
Spuckende Diktatoren, photo: Sabine B. Vogel

Venice Biennale 2009, Bruce Naumann,
The true artist helps the world by revealing mystic truth,
photo: Lisa-Marie Edi

Venice Biennale 2009, Elmgreen and Dragset,
The Collectors, photo: Lisa-Marie Edi

Liverpool Biennale 2006, Humberto Vélez,
Out of the Bluecoat 2, performance

India Triennale 2005,
photo: Saeid Afzali

Art Dubai 2004, Subodh Kerkar,
The Sea Remembers, photo: Sabine B. Vogel

Photos on the front of the dust jacket

52th Venice Biennale 2007,
Hans Schabus, Das letzte Land,

Sharjah Biennale 2009, Laurenz Grasso,
The wider the vision the narrower the statement, photo: Sabine B. Vogel

Shanghai 2008, Yin Xiuzhen,
Flying Machine, photo: Sabine B. Vogel

São Paulo 2004,
photo: Wolfgang Träger

Taipeh Museum, photo: Sabine B. Vogel

Istanbul Biennale, Antrepo,
photo: Serkan Taycan

Gwangju Biennale 2006,
Michael Joo, Bodhi Obfuscatus

Singapore Biennale 2008, Felice
Varini, Drill Hall, photo: Sabine B. Vogel

Johannesburg, National Gallery, South Africa

Liverpool Biennale 2006, Rigo 23

10th Havana Biennale 2006, Kcho (Alexis Levya), photo: Sabine B. Vogel

Pavillon Nordic countries, photo: Wolfgang Träger

14th Biennale of Sydney 2004, Jimmie Durham, Still Life with Stone and Car, photo: Jenni Carter

Berlin Biennale 2010, Adrian Lohmüller, Das Haus bleibt still, photo: Uwe Walter

1st Athens Biennale 2007, Temporary Services & Angelo, Prisoners Inventions, photo: Vassilis Polychronakis

Liverpool Biennale 2007, Priscilla Monge, Untitled

São Paulo Biennale 2004, Leo Schatzl, Autorotation São Paulo, photo: Norbert Artner

Manifesta 2 Luxembourg 1998, Bjarne Melgaard, photo: Roman Mensing

6th Gwangju Biennale, Chiharu Shiota, In Silence, 2006, photo: Sabine B. Vogel

Sydney Biennale 1998, Beat Streuli, Billboard, two parts

List of illustrations

We would like to apologize if the author was unable to ascertain the exact origin of all illustrations in the book in spite of careful research and we would appreciate any information that could be used in future editions.

Norbert Artner, p. 40
Lisa Marie Edi, pp. 27, 28
Roman Mensing, p. 90
Serkan Taycan, pp. 53, 109
Wolfgang Träger, pp. 24, 25, 27, 28, 29, 42
Sabine B. Vogel, pp. 1, 2, 3, 12, 13, 32, 39, 44, 49, 50, 55, 60, 61, 79, 80, 83,
 84, 88, 97, 99, 101, 104, 106, 110
Uwe Walter, pp. 91, 104
Greg Weight, p. 45

Sabine B. Vogel

Institute of Fine Arts and Media Art,
University of Applied Arts Vienna, Austria

© 2010 Springer-Verlag/Wien
Printed in Austria
SpringerWienNewYork is a part of
Springer Science + Business Media
springer.at

Graphic Design: bauer konzept & gestaltung, erwinbauer.com
 Erwin K. Bauer, Tobias Schererbauer
Translation: Camilla R. Nielsen, Vienna, Austria
 Editorial support (English): Sir Anthony Hornby
Druck/Printed by: Holzhausen Druck GmbH, 1180 Wien, Austria

Printed on acid-free and chlorine-free bleached paper

SPIN: 80014579
Library of Congress Control Number: 2010932019
With numerous illustrations in color

ISSN 1866-248X
ISBN 978-3-7091-0250-3